ARTISTES POMPIERS
French Academic Art in the 19th Century

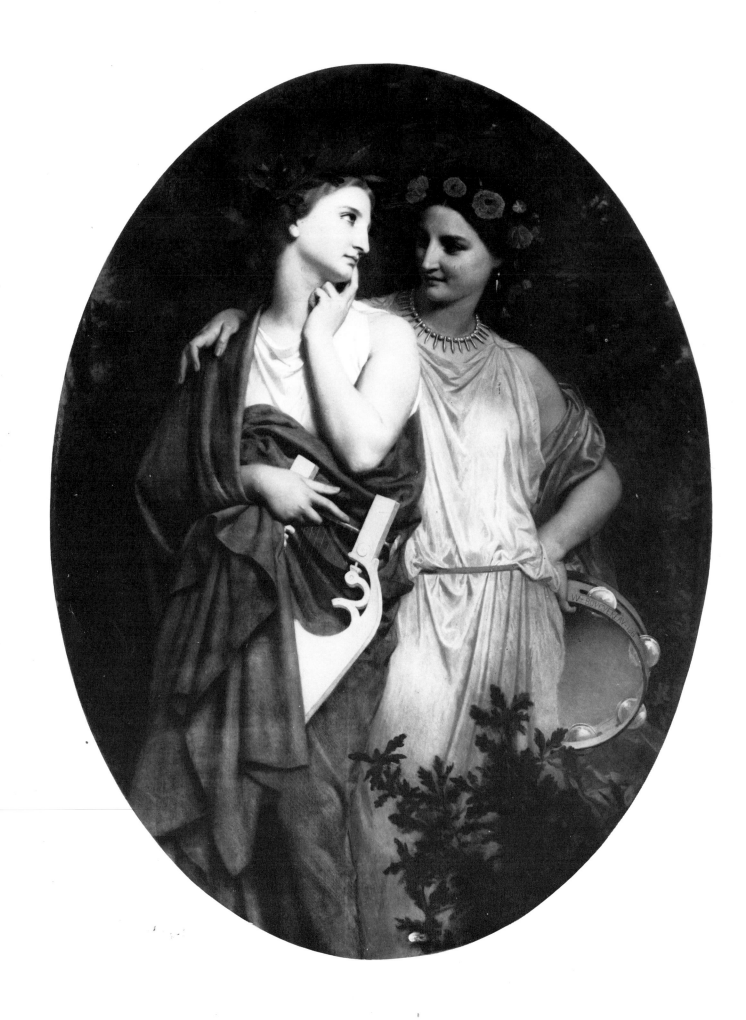

ARTISTES POMPIERS
French Academic Art in the 19th Century

James Harding

6200

79999

ACKNOWLEDGEMENTS

I would like to thank the many museums and galleries whose works are illustrated in this book. In particular I acknowledge the help of the Musée du Louvre and the Wallace Collection. Special thanks are also due to Robert Cecil and Dennis Dalby of the Wallace Collection; Peyton Skipwith of the Fine Art Society and Guy Sainty of M. Newman Ltd. for their cooperation and interest.

Front cover
J. J. A. Lecomte de Noüy *Rhamsés dans son harem*/ Rameses in his Harem (detail of side panel), 1886.
Oil on canvas 129.5 × 77.4 cm.

Back cover
G. Clairin *Les Danseuses de l'Opéra*/The Dancers at the Opera, n.d.
Oil on canvas 90 × 116 cm.
(Alain Lesieutre collection)

Frontispiece
W.-A. Bouguereau *Philomène et Prochné*/Philomena and Procne, 1861.
Oil on canvas 176 × 134 cm.

First published in the United States of America in 1979 by
RIZZOLI INTERNATIONAL PUBLICATIONS, INC.
712 Fifth Avenue/New York 10019

Library of Congress Catalog Card Number: 78–66215
ISBN: 0–8478–0209–4

Printed and bound in Great Britain

Contents

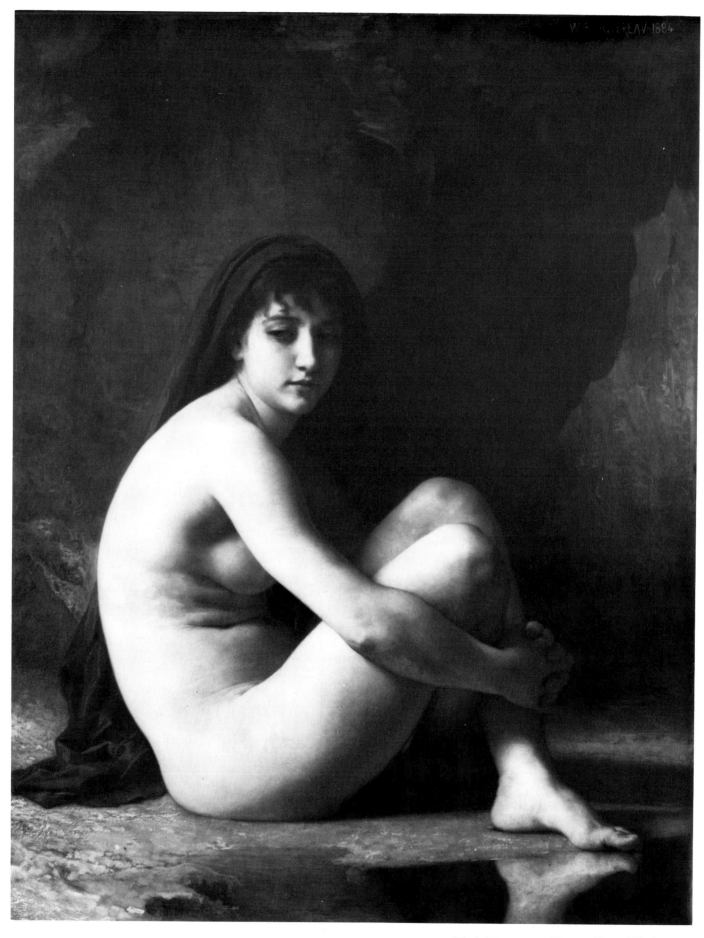

W.-A. Bouguereau *Nu assis*/Seated Nude,1884.
Oil on canvas 116.5 × 89.8 cm.

1. Introduction

No form of art has ever been so widely and enthusiastically admired as the academic painting of the nineteenth century. The eager crowds thronging to the openings at the Salons in Paris or at the Royal Academy in London, the heated discussions of the exhibits in the press, the caricatures based on the more controversial works and the public adulation of the painters themselves – all these different ways of recognising the importance of the art establishment have no counterpart in the present day except in relation to the cinema and were equally unknown in the eighteenth century when the enjoyment of art and the exercise of patronage were the privileges of the Court and the aristocracy. In the nineteenth century the circle of patronage was enormously widened by the participation of the growing and newly affluent middle class and for these new connoisseurs the seal of success was the acceptance of the Salon. The opening of an exhibition was so crowded with eager members of the public that the most notorious pictures had to be protected by a barrier in order to prevent them from being damaged. Napoleon III was reputed to have struck Courbet's *Baigneuse* – exhibited at the Salon in 1853 – with his riding crop, but pictures were more usually at risk from over-enthusiastic appreciation rather than malicious attack.

A successful artist could expect to make large sums of money. For example, a gold medal at the Salon was worth 4000 francs, a second-class medal 1500 francs. Furthermore, success at the Salon ensured success with the buying public. Indeed, one patron agreed to pay 1000 francs for his portrait with a further 2000 francs to be added if the portrait was accepted by the Salon. Conversely, it was not unknown for a picture rejected by the Salon jury to be refused by the original buyer.

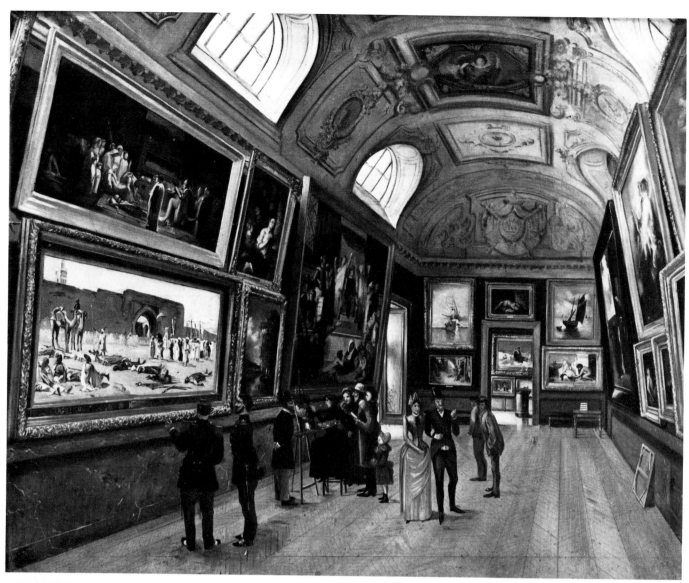

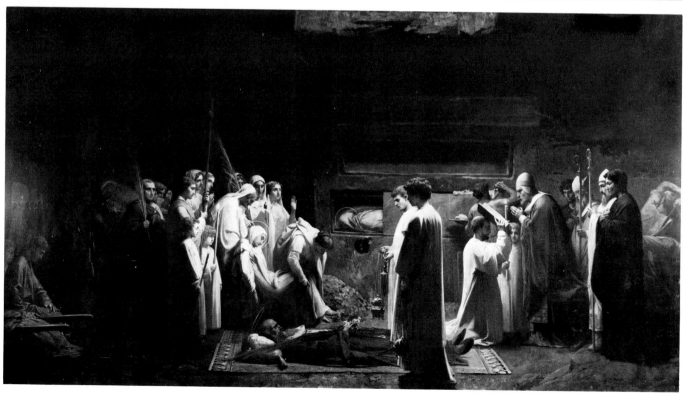

French School *Vue d'une salle du Musée du Luxembourg*/View of a Room in the Musée du Luxembourg, c. 1880.
Oil on canvas 81 × 100 cm.

J.-E. Lenepveu *Les Martyrs aux catacombes*/Martyrs in the Catacombs, 1855.
Oil on canvas 170 × 336 cm.

When Couture achieved great public acclaim with his *Romains de la décadence* at the Salon in 1847 Manet's parents withdrew their opposition to their son's wish to become a painter and consented to allow him to become a pupil of Couture, secure in the belief that a brilliant and profitable future awaited him under the tutelage of such a successful master. The most popular academic painters of the period also made a great deal of money from the sale of their works; Vernet, Meissonier, Bouguereau, Cabanel and Carolus-Duran all achieved a position where they were able to charge very high prices for their pictures. With the proceeds Meissonier, for instance, built himself a Neo-Renaissance palace in the place Malesherbes; Léon Bonnat, one of the most successful portrait painters of the epoque, made an important collection of works of art which he left to the city of Bayonne, while at the height of his success Bouguereau is alleged to have said to the young Orthon Friesz 'Chaque minute me coute cent francs' (Each minute costs me one hundred francs).

The public were not averse to paying enormous prices for these pictures since the widely-known fact of the huge cost of a Bouguereau or a Meissonier added greatly to the prestige of the purchaser. M. Alfred Chauchard, the draper who founded the Grand Magazin du Louvre, was an enthusiastic patron of the academic art of his time. He was notorious for having paid 800,000 francs for Millet's *L'Angélus* (a picture for which the wretched artist had received only 1000 francs) and many of his other purchases were almost equally extravagant. He was a great admirer of Meissonier and, like William Walters of Baltimore, of the *animalier* sculptor Antoine Barye. Chauchard's recreation was the planning of his funeral. He dreamed of having his most expensive pictures carried at the head of his funeral cortège, in order of cost, by his friends – his greatest friend to carry the most expensive picture and so on down the scale – but the idea presented so many problems of precedence that, reluctantly, he had to abandon it. The Chauchard collection was left to the Louvre, a bequest of one hundred and forty pictures, as well as the Barye sculptures.

There is another side to the coin, however. Success of this order exacted its own sacrifices, and a popular academic painter of the nineteenth century was forced to live virtually as a recluse. There are no short cuts in producing a highly finished painting of this kind – even the historical research necessary already demanded much time – and the execution of a major work took months of unremitting toil. Bouguereau was nicknamed 'Sisyphus' while he was at the Villa Medici in Rome and lived up to this model of supreme effort throughout his career.

Not every bourgeois household was sufficiently prosperous to own an original work of art. During the nineteenth century methods of reproduction of both pictures and sculptures were developed which brought the work of the great popular names of the period within the reach of all but the most poverty stricken. The engraving of pictures was developed into a thriving business by one or two enterprising dealers, notably Goupil and Ernest Gambart, who would buy a work for the purpose of exhibiting it and selling engraved reproductions. An artist who had begun to make his mark with the public could expect ample rewards from the sale of the engraving rights of his most popular Salon pictures. A further source of income was also provided by making replicas of his pictures. Many of the paintings discussed in this book exist in a number of versions. Indeed, Charles Landelle's record book has notes of no less than thirty-two canvases which were replicas or variants of his immensely successful *Femme Fellah*, exhibited at the Salon in 1866. State purchases and commissions were another valued source of support, which usually depended on the kind of official recognition which was almost never accorded to those artists who are now accepted as having been the great masters of the nineteenth century.

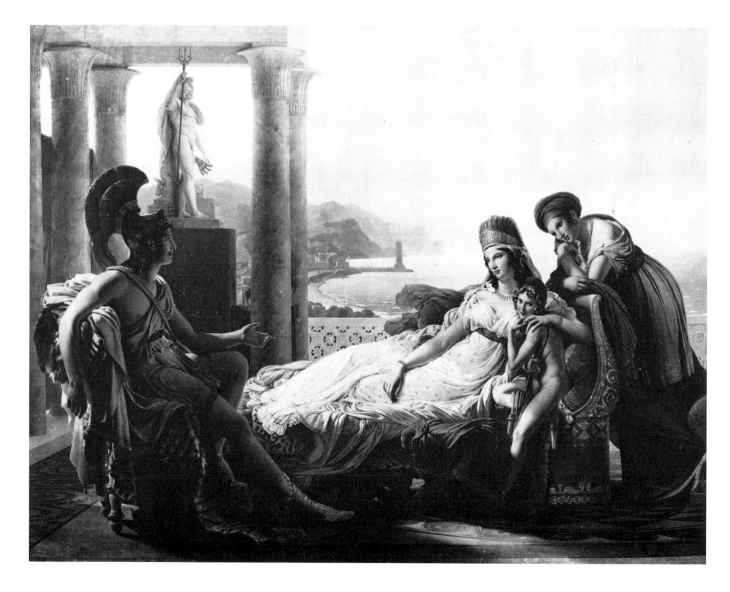

P.-N. Guérin *Enée raconte à Didon les malheurs de la ville de Troie*/Aeneas tells Dido of the Misfortunes of Troy, 1815.
Oil on canvas 295 × 390 cm.

With the exception of Ingres, there is no outstanding talent among the winners of the coveted Prix de Rome during the whole of the nineteenth century. Of the artists chosen to decorate the public rooms in the Louvre, only Delacroix is now accepted as an artist of major importance. With such a momentous commission at the disposal of the authorities it is pitiful to see in each successive decade another minor artist adding his uninspired mite to the decoration of this great palace. Charles Meynier, J.-B. Mauzaisse, Francois-Edouard Picot, C.-L. Müller, Abel de Pujol, François-Joseph Heim, J.-V. Schnetz, and H. Leroux (who in 1889 was still working in the same manner as the artists who had completed their decorations at the beginning of the century) cannot be said to make up a very impressive list.

There were virtually no independent exhibitions in the first half of the nineteenth century. Dealing in works of art was often a side-line for the owner of a shop. The famous dealer Durand-Ruel, for instance, originally ran a stationer's which sold artists' materials and his dealing activities began largely as a result of taking pictures and prints in lieu of payment. A whole complex network of agents for the sale of pictures and dealers, often with a secondary interest in publishing engravings after the most successful works of their artists, grew up during the Second Empire and expanded throughout the remainder of the nineteenth century. As well as Goupil and Ernest Gambart, both Calamatta and Henriquet-Dupont, (who spent six years engraving Delaroche's Hemicycle decoration at the Ecole des Beaux-Arts) made considerable

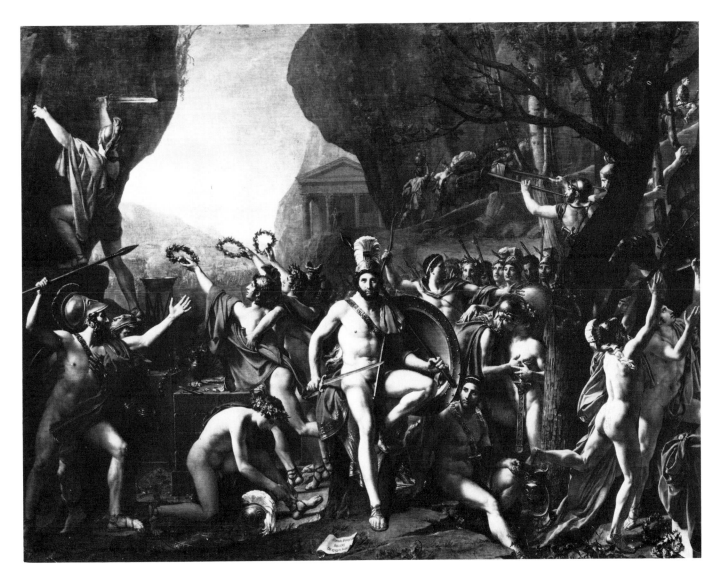

J. L. David *Léonidas aux Thermophyles/*
Leonidas at Thermopylae, 1814.
Oil on canvas 392 × 533 cm.

reputations for themselves and for their artists in this way. Before this type of fame was established, however, acceptance by the Salon assumed enormous importance for the artist. This inevitably resulted in the perpetuation of an academic style which the Salon jury was known to favour long after it had any relevance to the mainstream of artistic development. The jury-less Salon of 1848 resulted in an exhibition of over 5000 works of art, many of them below the required standard. The experiment was not repeated, but public dissatisfaction with the way in which the successful pictures were chosen reached the point where Napoleon III felt obliged to institute a Salon des Refusés.

In 1863 the death of Horace Vernet had left a gap in the ranks of the jury, but the remaining thirteen members – Ingres, François Heim, François Picot, Victor Schnetz, Auguste Couder, J. R. Brascassat, Léon Cogniet, Joseph Robert-Fleury, Jean Alaux, Hippolyte Flandrin, Emile Signol, and Meissonier – constituted a strong defending force for the supremacy of the academic tradition with Delacroix as a lone liberating influence. Of these thirteen neither Ingres nor Delacroix concerned themselves with the selection for the Salon, thus leaving the whole matter in the hands of a group of artists judged by history to be second-rate. Less than half the 5000 works submitted to the jury were accepted. In recognition of the growing public dissatisfaction with the process of selection Napoleon III decreed that the Salon des Refusés should be set up to offer the public an alternative possibility of viewing those artists whose work had failed to please the jury. Many of the unsuccessful

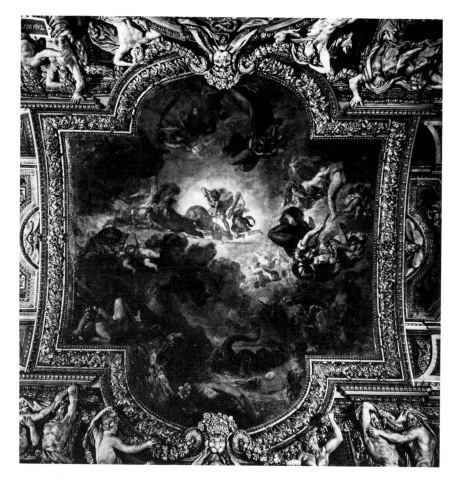

E. Delacroix *Apollon vainqueur du serpent*/Apollo, Conqueror of the Serpent, 1850–1.
Ceiling of the galerie d'Apollon, Musée du Louvre, Paris.

artists were thus thrown into a quandary, as they had no wish to alienate the members of the Salon jury and so prejudice their chance of success in the future.

In the event this cautious attitude was proved to be wise. Whereas the official Salon 'presented to the world an almost ideal of all that an exhibition ought to be' (P. G. Hamerton), the Salon de Refusés attracted, predictably enough, the most violent criticism. Hamerton, the English critic and author of *Contemporary French Painting* (his critical writings were the subject of Henry James' first published art review in 1868) was in no doubt about the low quality of the exhibits and wrote: 'It always happens in every country, that there are many persons quite ignorant of the rudiments of drawing and painting, but who nevertheless boldly send things which have nothing to do with art, to the public exhibitions of pictures.... On entering the present exhibition of refused pictures, every spectator is immediately compelled, whether he will it or no, to abandon all hope of getting into that serious state of mind which is necessary to a fair comparison of works of art. The threshold once past, the gravest visitors burst into peals of laughter.' Amongst the despised *refusés* were Manet and Whistler; Fantin-Latour and Alphonse Legros, who were to find appreciative patrons in England; Camille Pissarro, J. B. Jongkind and Henri Harpignies, all of whose work is now appreciated more than that of those artists who were actively engaged in rejecting them from the official Salon. The Salon des Refusés was such a failure with both critics and public that the experiment was, like the jury-less Salon of 1848, not repeated and the official Salon retained its place of supreme importance to the artists of the period, still exerting a considerable influence on the subject-matter and style of those artists who wished to succeed within the framework of the artistic establishment.

Gustave Courbet was well aware of the corrupting effect of de-

12

F.-E. Picot *L'Etude et le Génie dévoilent l'antique Egypte à la Grèce*/Learning and Genius reveal Ancient Egypt to Greece, 1827. Ceiling of the hall of Egyptian antiquities, Musée du Louvre, Paris.

pendence on the patronage of the State or the artistic establishment. He refused both election to the Academy and the Cross of the Légion d'honneur, the first being in 1868 when it was proposed that he should succeed to the chair recently vacated by the death of the history-painter, Francois-Edouard Picot (who had, ironically, been instrumental in keeping Courbet's work out of the Salon for many years). Courbet's reason for turning down this offer was that the Academy was an obstacle to artistic progress. The Légion d'honneur was offered to him in 1870, and again he declined this official recognition of eminence, pointing out in an open letter to Maurice Richard, then Minister of Fine Arts, that his egalitarian principles prevented him from accepting. He went on to say:

'Mon sentiment d'artiste ne s'oppose pas moins à ce que j'accepte une récompense qui m'est octroyée par la main de l'Etat. L'Etat est incompétent en matières d'art. Quand il entreprend de récompenser, il usurpe sur le goût public. Son intervention est toute démoralisante, funeste à l'art qu'elle enferme dans les convenances officielles et qu'elle condamne à la plus stérile mediocrité; la sagesse pour lui serait de s'abstenir. Le jour où il nous aura laissés libres, il aura rempli vis-a-vis de nous ses devoirs. J'ai cinquante ans et j'ai toujours vécu libre; laissez-moi terminer mon existence libre'.

(My feelings as an artist oppose it simply because I would be accepting a

reward which is bestowed on me by the hand of the State. The State is incompetent in matters of art. When it undertakes to distribute rewards, it trespasses on the field of public taste. Its intervention is totally demoralising, fatal to art which it confines within official conventions and which it condemns to the most sterile mediocrity; the only wise thing for it to do would be to abstain. The day when it decides to leave us our freedom it will have done its duty by us. I am fifty years old and I have always lived freely; leave me to end my days in freedom.)

Courbet was fortunate in having the patronage of Alfred Bruyas, a rich connoisseur from Montpellier, and was thus in a position to disdain the support of the State, the Academy or the Salon. Benjamin Constant spoke for those in a less fortunate position when he said,

> Le Salon est notre seul moyen d'édition, par lui nous acquérons l'honneur, la gloire, l'argent. C'est le gagne-pain pour beaucoup d'entre nous et, sans lui, plus d'un des grands maîtres que nous admirons aujourd'hui serait mort misérable, et sans être soupçonné.

> (The Salon is our only means of becoming known, the way to honour, glory and money. It is the breadwinner for many of us, and without it many of the great masters whom we admire today would have died a miserable death without recognition.)

The result of pandering to official and popular taste was that the most adulated artists of the nineteenth century were to be the most ridiculed in the twentieth. Few schools of painting have been so thoroughly execrated in decline, and few have taken so long to attract critical reassessment. Only recently have the great Salon pieces of the mid-century been viewed with a seriousness appropriate to the sentiments expressed in them and without the mirth which greeted even the names of some of the most admired painters, notably Bouguereau and Gérôme. No laughter was provoked by the mention of Delaroche, Baudry, or J. P. Laurens, and innumerable other artists who were widely, even passionately, admired during their careers; these had sunk so far out of sight during the years of obscurity that incomprehension rather than ridicule was the only reaction. Gleyre and Couture were remembered only as teachers, Cabanel as the author of a notorious piece of sublimated eroticism masquerading as a classical subject which was bought by Napoleon III, and Ary Scheffer as a sentimentalist. It is, however, extremely rare for great reputations to be made by artists who are entirely without merit and a renewal of interest in the work of these painters has revealed much of value.

The so-called 'Pompier' paintings of the nineteenth century are generally defined as being in the style known as academic, by those artists accepted by the 'official' (by extension, ignorant and insensitive) art establishment of the period. In other words, the artists who found favour with those officials responsible for handing out State benefits of one kind or another, either in the form of commissions for the decoration of public buildings or in making acquisitions for public galleries, notably the Luxembourg (which pursued a remarkable policy regarding contemporary painting unmatched by any other official body of the time). At this point it might be sensible to make the distinction between 'academic' and 'official' as applied to art.

The policy of patronage followed by the State from the time of the establishment of the 'July' monarchy in 1830 throughout the nineteenth century, while it was by definition 'official' was by no means exclusively 'academic'. It is, after all, no part of academic policy to set up a rival exhibiting system to the Salon, and it should be remembered that the Salon des Refusés of 1863 was set up by official, that is to say, Imperial,

J.-J. Henner *Suzanne au bain*/Susanna bathing, 1865.
Oil on canvas 185 × 130 cm.

14

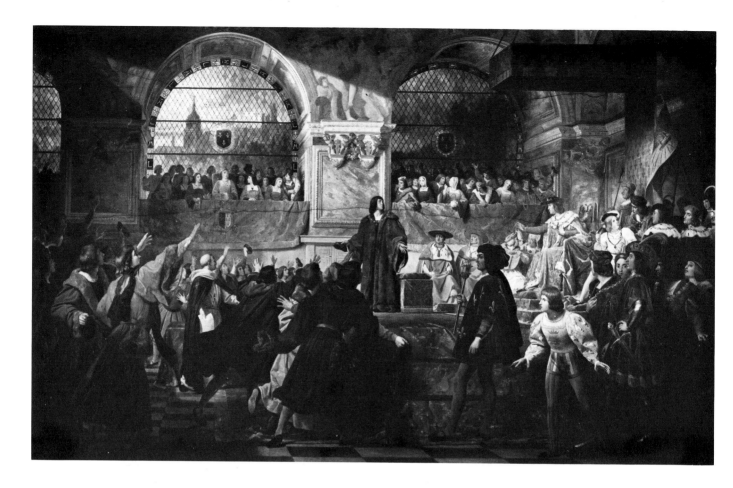

decree. It should also be remembered that Delacroix, one of the great artistic innovators of the period, received both official and academic recognition, and critical acclaim. He remains the refutation of all the charges levelled against the lack of sensibility which is consistently detected in nineteenth-century criticism and patronage – mainly as a result of the failure of the public and the critics to recognise the importance of realism or of landscape and painting (and more precisely Impressionism) in the development of the modern style. It may be that the judgement of history will produce some surprises in the process of reassessing the official art of the nineteenth century. Meanwhile the subject of this present work might be described as an unprejudiced look at some of the neglected academic painters of the mid-nineteenth century.

During the past seventy years it has been customary to see the history of nineteenth century painting in terms of a series of revolutionary movements, succeeding one another in an inevitable progress towards the making of the Modern Movement. Classicism is superseded by Romanticism, Romanticism by Realism, followed by Impressionism, then Symbolism, Cubism, Expressionism, and so on. The existence of a powerful academic tradition which provided the framework and the basis of training from which these movements were able to evolve is frequently ignored, or hurriedly dismissed as of little significance. It has been demonstrated repeatedly that it is possible to write a history of painting in the nineteenth century without mentioning the names of some of the most successful artists of the period: Gérôme, Bouguereau, Delaroche, Horace Vernet, Detaille and Clairin, as well as a hoard of Orientalists whose contribution to the genre of travel painting (which began in the eighteenth century with evocations of Rome made for the benefit of the Grand Tourist) was eventually recognised by the establishment of the Société des Peintres Orientalistes in 1893. They are

M.-M. Drolling *Louis XII proclamé père du peuple*/Louis XII proclaimed Father of the People, 1828.
Ceiling of the hall of 14th century ceramics, Musée du Louvre, Paris.

A. Scheffer *Marguerite à la fontaine*/Margaret at the Fountain, 1858.
Oil on canvas 163 × 103 cm.

16

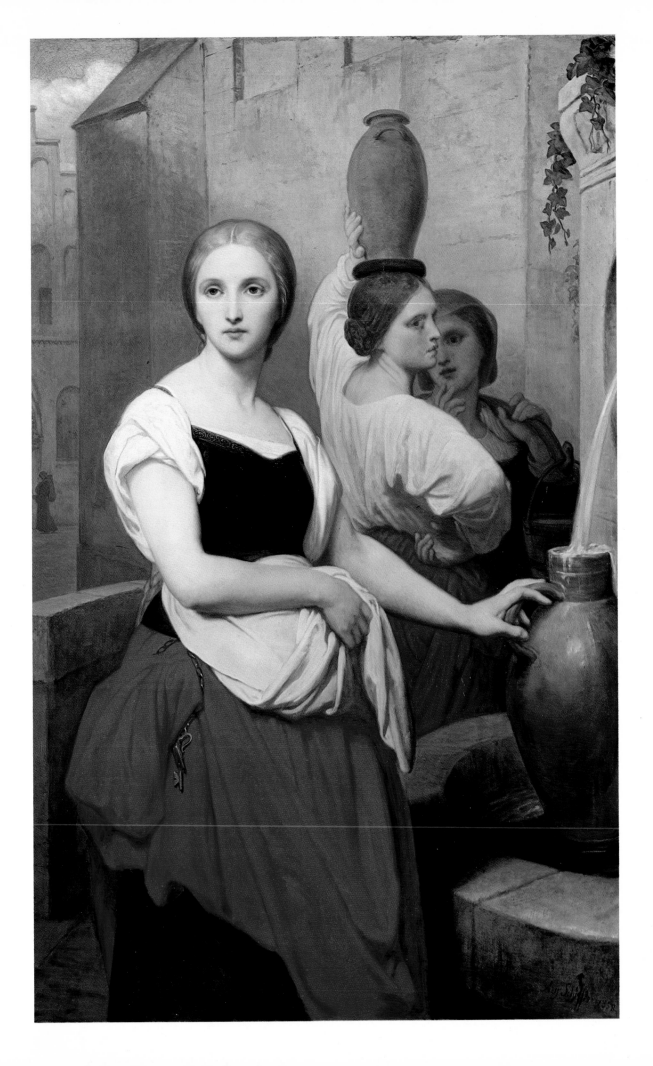

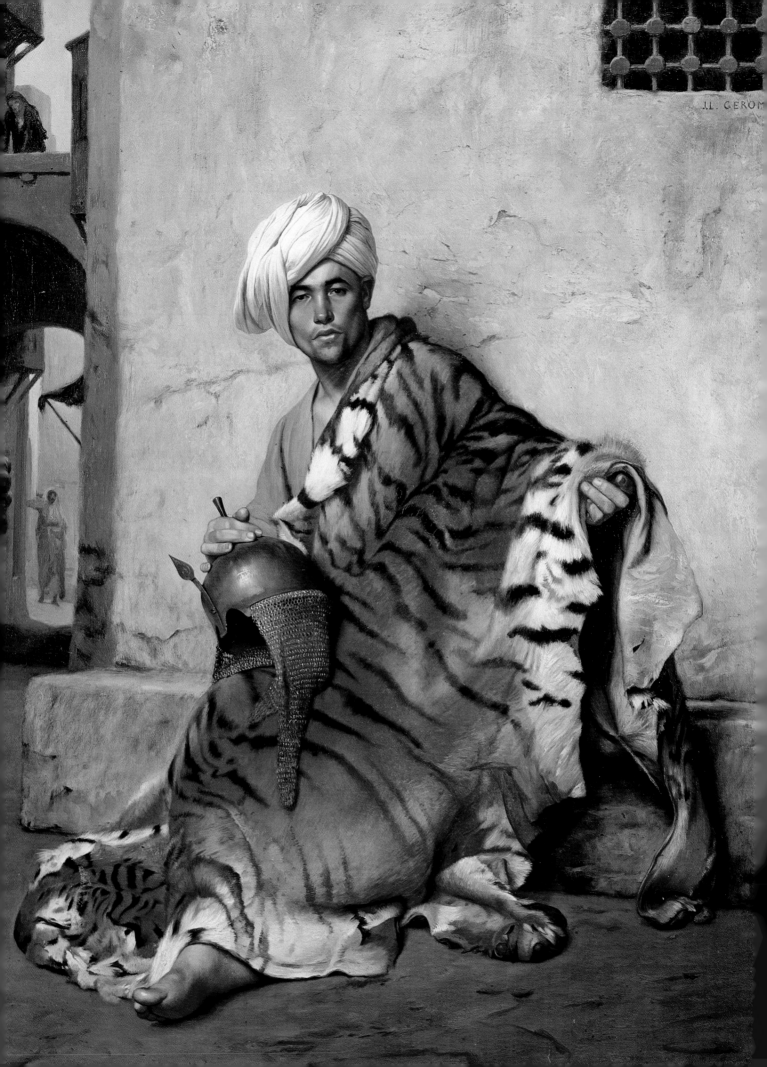

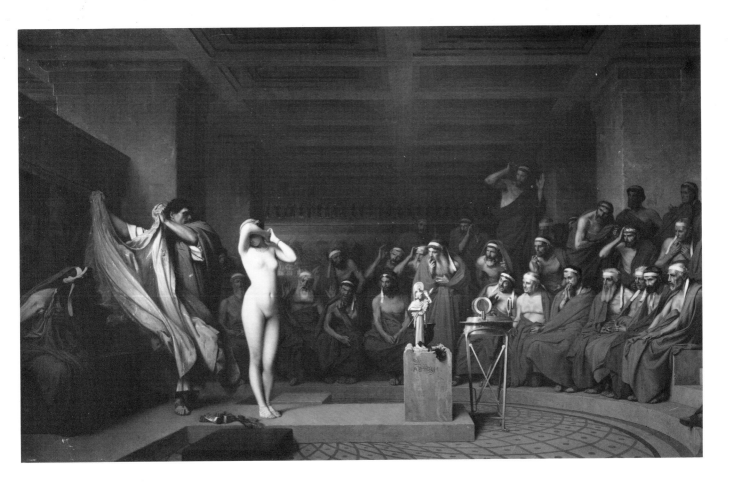

J.-L. Gérôme *Phryné devant les juges*/Phryne in front of the Judges, 1861.
Oil on canvas 80 × 128 cm.

J.-L. Gérôme *Marchand de peaux (au Caire)*/Skin Merchant (in Cairo), n.d.
Oil on canvas 61.5 × 50.1 cm.

often passed over as if they had never existed. Yet these artists were the backbone of the Salons.

The Impressionists, by contrast, were little respected in their own time and they encountered implacable opposition in their attempts to gain official acceptance, notably from Gérôme, whose reaction to the announcement in 1893 that Caillebotte, the wealthy patron of the Impressionists, had left his collection of paintings to the State on the condition that they should hang in the Louvre, was obstinately hostile. He said:

'Je ne connais pas ces messieurs et de cette donation je ne connais que le titre. Il y a là-dedans de la peinture de M. Monet, n'est pas? de M. Pissarro et d'autres? Pour que l'Etat ait accepté de pareilles ordures, il faut une bien grande flétreissure morale'.

(I do not know these gentlemen, and the only thing I recognise in this donation is the title. It contains paintings by M. Monet, by M. Pissarro and others, doesn't it? For the government to accept such filth would be the sign of great moral decline).

Quoted in *Histoire de la peinture française*, 1801–1933, by A. Leroy, Paris 1934.

The reaction of both public and critics to the *avant-garde* is notoriously unfriendly and the advent of Realism, no less than Impressionism and the later Symbolism, Futurism and Surrealism, was greeted with amused derision. The natural inclination to scoff at the new, which is to be expected in an entrenched academic artist like Gérôme, was echoed on almost every side, often by men of considerable sensibility and intelligence, who supported the academic stand against the stylistic changes brought about by the influence of photography or Japanese art, both of which revealed a world of pictorial concepts totally removed from the academic ideals of compositional organisation. Even Rutherford Alcock, an admirer of Japanese art who wrote one of the

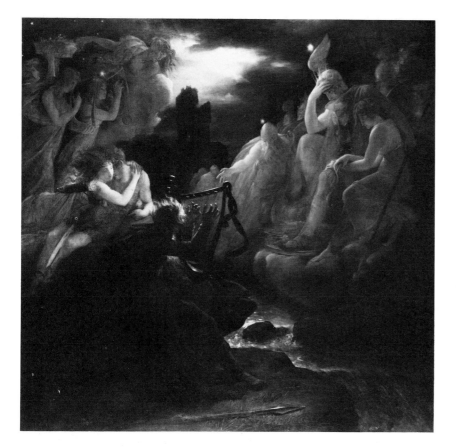

first books about this newly rediscovered land said: 'No Japanese can produce anything to be named in the same day with the work from the pencil of a Landseer, a Roberts, or a Stanfield, a Lewis or a Rosa Bonheur'. It is now difficult to imagine the degree to which the abandonment of the heroic viewpoint and the dramatising source of light would seem to trivialise the uplifting purpose of great art. In this sense the academic artists occupied a very strong position in that they were seen to be protecting the place of the arts in the scheme of civilisation, rather than debasing their values with the crude depiction of everyday reality.

In spite of the apparently unassailable position (in their own time) of artists like Gérôme and Bouguereau, D. S. MacColl's great work on the history of painting in the nineteenth century, published in 1902, passed over almost the entire academic establishment without a word of discussion, even though this book was published in Gérôme's own lifetime. Indeed, one of the few occasions when an academic painter of this period is discussed by E. H. Gombrich (in *Psychoanalysis and the History of Art*, a lecture given in 1953, which was printed in *Meditations on a Hobby Horse* ten years later) it is in terms of such searing criticism that it is possible to feel reproved for taking these artists seriously even a quarter of a century later. In this passage Gombrich, discussing Bouguereau's *Vénus Anadyomède*, speaks of the central figure in the composition as 'a pin-up girl rather than a work of art', a view that was widely shared at that date.

When these artists first began to attract critical reassessment ten years ago they were still apt to be regarded very much as a good joke; their serious intentions were ridiculed and the meticulous finish dismissed as 'mere' technical facility. More recently there has been a growth of serious interest in this type of painting. Forgotten names have been dredged up from the archives, from the documents relating to the Salon exhibitions, to the annual Prix de Rome competition, and to the collection once housed in the Luxembourg Museum. This was dispersed

F. Gérard *Ossian*, 1801.
Oil on canvas 184.5 × 194.5 cm.

P. Baudry *La Toilette de Vénus*/The Toilet of Venus, 1859.
Oil on canvas 136 × 84 cm.

W.-A. Bouguereau *Nymphes et un satyre*/Nymphes and a Satyr, 1873.
Oil on canvas 260 × 180 cm.

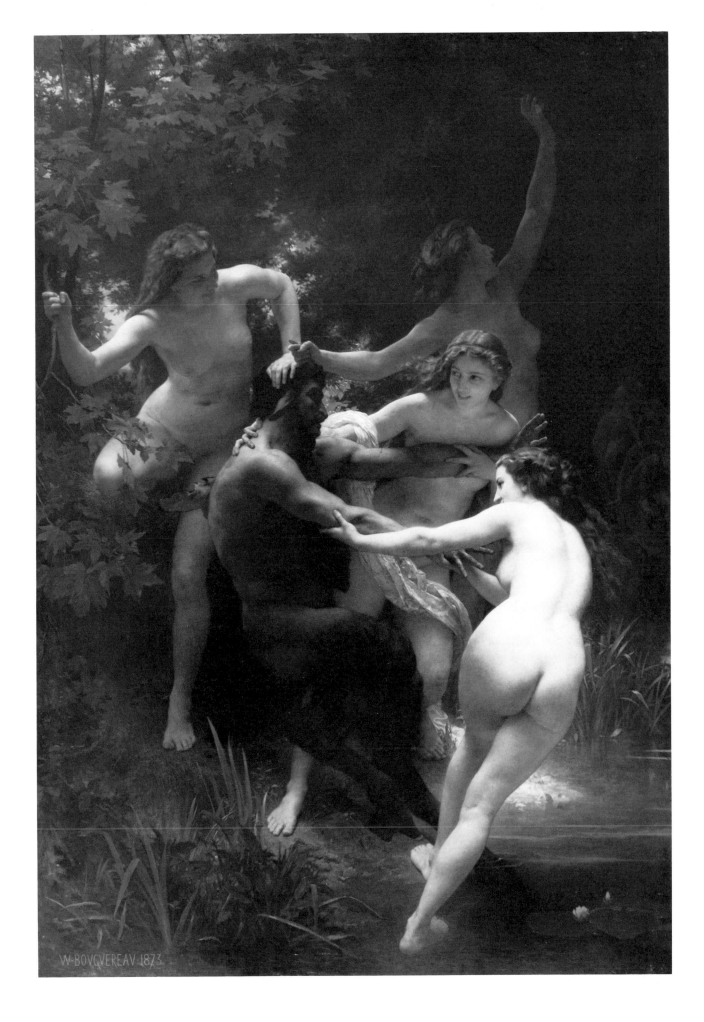

W·BOVGVEREAV·1873·

P.-N. Guérin *Le Retour de Marcus Sextus*/The Return of Marcus Sextus, 1799. Oil on canvas 217 × 244 cm.

in 1937 – mainly amongst the provincial museums of France since few of the pictures were deemed to be worthy of the Louvre. Exhibitions have been mounted, one of them devoted (ironically enough) to recreating the collection as it had existed in the Luxembourg in 1874. Others have shown Salon pictures and a number of exhibitions in the U.S.A. have concentrated on various aspects of nineteenth-century popular taste. These have included shows devoted to the great 'Pompier' masters, Bouguereau and Gérôme, and a large scale exhibition in Switzerland showing the work of Charles Gleyre whose studio produced such diverse talents as Gérôme, Renoir, Lecomte du Noüy, Alfred Sisley, Jean-Louis Hamon and Claude Monet.

A fresh look at these artists has done little to alter the verdict of history as far as the great masters of the period are concerned. It is doubtful whether anyone will quarrel with the general proposition that Ingres and Delacroix were greater artists than Bouguereau and Delaroche. One can, however, view their work in a spirit of Jamesian enquiry, and learn something of interest about the development of taste. In his book on the American sculptor, William Wetmore Story, Henry James returns repeatedly to the proposition that the taste of the past is illuminating even in its aberrations. It was, after all, through the teaching and example of these academic painters that the great masters of the nineteenth century were formed, selecting or rejecting from the rigorous academic discipline the material of their own expression. Very few of the most original innovators of the period maintained a teaching *atelier*. This chore was left to the academic painters, almost all of whom accepted their obligation to instruct their successors. Courbet's experiment with organising an *atelier* lasted for barely two months – although he had taken the precaution of refusing to undertake any actual instruction of the students – whereas Gérôme's *atelier*, where Odilon Redon was so unhappy, was set up in the Ecole des Beaux-Arts in 1863 and maintained by him for thirty-nine years in an undeviating academic tradition. It is the inability to transmute the academic discipline into an individual perception of the thing seen which is one of the great

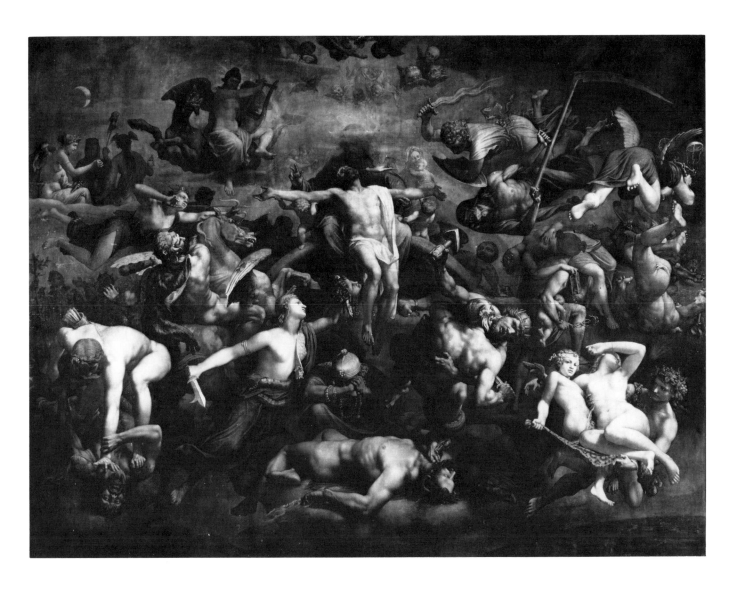

P.-M.-J. Chenavard *Divina Tragedia*, 1869.
Oil on canvas 400 × 550 cm.

limitations of the academic artist. On the other hand, it is the impossibility of transmitting this gift that makes the great artist into a less effective teacher than the second-rate artist. What the academic discipline did transmit was technical ability of the highest order, that which Gombrich (*op. cit.*, above) calls 'the fault of faultlessness', where professional expertise has become an end in itself.

A taste for academic art has traditionally been ascribed to the rich, usually to the 'nouveau' rich, with all the pejorative connotations that such a qualification implies. It is certainly true that, after the State, the most important patrons of the academic establishment in the nineteenth century were the newly rich American industrialists. In a fever of collecting activity started by Luman Reed, a retired wholesale grocer from upstate New York in 1830, the American industrialists strove to build up collections which would rival the age-old accumulations of the European aristocracy. Many of these tyro collectors started their buying careers with the work of their contemporaries, choosing with an understandable caution the works which had been sanctified by official acceptance either at the Salon or at the Royal Academy. The extent to which contemporary French academic painting was collected in America in the mid-nineteenth century can be gauged from various sources, notably the lists of paintings in American private collections, published by Edward Stranan in *The Art Treasures of America* in 1879. Bouguereau (his pictures outnumber those of any other artist), Gérôme and Meissonier feature largely in these lists.

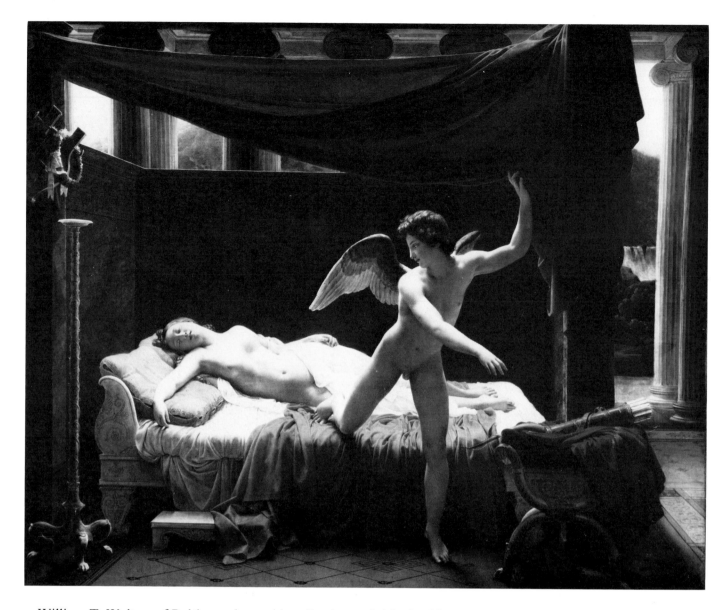

William T. Walters of Baltimore began his collecting activities in this way. The Walters Art Gallery can therefore boast several masterpieces of the genre, including the 1853 reduction of Delaroche's *Hemicycle* of the Triumph of the Arts, originally commissioned for the Ecole des Beaux-Arts and completed in 1841; a version of Gérôme's *Le Duel après le bal*, as well as his monumental *La Mort de César*; *L'Attaque à l'aube* by Alphonse de Neuville, and a number of the Barbizon pictures which were so much admired in America. John G. Johnson, the lawyer, and William P. Wilstach, who made a fortune out of saddlery, both bought extensively in the realms of fashionable contemporary painting. The Wilstach collection was left to the Fairmount Park Art Association in Philadelphia which Wilstach had himself founded, and Johnson was put in charge of it, chosen because he was a prominent collector himself in the same field. But he was about to move on into the tricky realms of Old Master collecting and in the process disposed of a number of his contemporary pictures, including Bouguereau's *Le Vœu*, which went to the Wilstach collection.

William Randolph Hearst and Henry Huntingdon both bought contemporary Salon paintings, as did A. T. Stewart, the department store owner. Stewart conforms to the mythology surrounding the American millionaire collector by having notoriously bought a picture from Meissonier for 76,000 dollars, by cable, without even having seen it. This was the famous *Friedland, 1807*, a picture of comparatively large

F.-E. Picot *L'Amour et Psyché*/Cupid and Psyche, 1817.
Oil on canvas 234 × 291 cm.

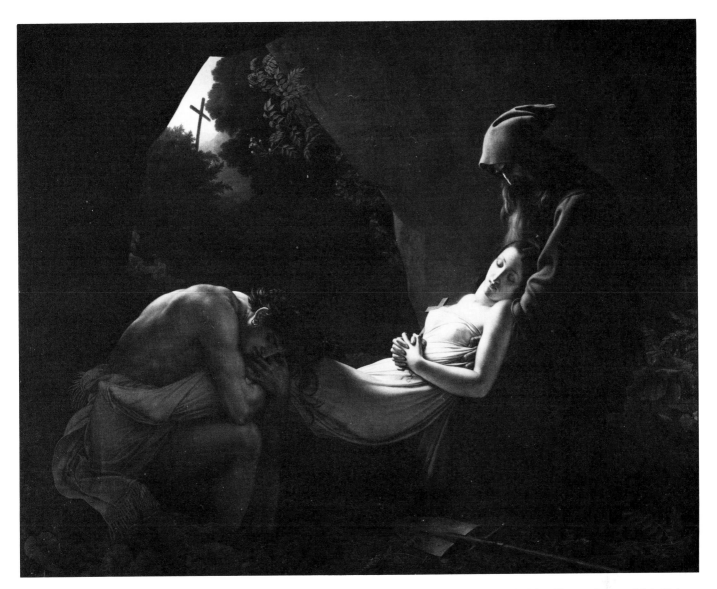

A.-L. Girodet de Roucy-Trioson *Atala au tombeau*/Atala at the Tomb, 1808.
Oil on canvas 207 × 285 cm.

dimensions for Meissonier, who was called by Henry James 'this Prince of miniaturists'. The circumstances of this extraordinary transaction are described in some detail by James in one of his *Parisian Sketches*, written for the New York Tribune in 1876. The picture (which is now in the Metropolitan Museum) was originally bought, before it was completed, by Sir Richard Wallace and only offered to Mr Stewart when Sir Richard withdrew from the transaction. It must be seen as an act of considerable courage to take over a reject from so formidable a connoisseur of the genre, but in James's eyes Mr Stewart was well vindicated by having secured one of 'the highest prizes of the game of civilization'.

Later in the same year Stewart bought Gérôme's *Les courses de char*, described by James as a 'less brilliant acquisition'. He also patronised Bouguereau, buying the 1874 Salon picture, *Homère et son guide* (now in the Milwaukee Art Centre). He is recorded in the Stewart sale catalogue (1887) as having stipulated that the other picture he commanded from Bouguereau should be 'the artist's greatest work'. Stewart died before receiving the picture – the *Retour des moissons* – which Bouguereau obligingly described as his masterpiece. So many of Bouguereau's pictures were bought by American patrons that it was found to be impractical to mount the retrospective exhibition of his work which was planned to coincide with the Exposition Internationale in Paris in 1878. In fact, so few pictures were accessible to the organisers that only twelve could be shown. The results of this patronage of the successful Salon

painters can be judged by the number of these pictures now in public galleries in the U.S.A.

The preference of the newly rich for these artists has been taken as evidence of their untutored and uncultivated taste. E. H. Gombrich suggests in *Psychoanalysis and the History of Art* (*op. cit.* above) that the defects in the work of a painter like Bouguereau arise from the fact that 'the image is painfully easy to read, and we resent being taken for such simpletons. We feel somewhat insulted that we are expected to fall for such cheap bait – good enough, perhaps, to attract the vulgar, but not such sophisticated sharers in the artist's secrets as we pride ourselves on being.' In these pictures we have none of the problems of iconography that confront the historian of the Renaissance or even, for that matter, of the Neo-Classical art of the eighteenth century, much having altered in the content of the Neo-Classical picture in the space of fifty years. There are none of the complex suggestions of the interaction of light and space with which the Impressionists confused their public, nor the difficult conceptualism with which the admirer of all forms of abstraction has had to make himself familiar. It is accepted as axiomatic that the appreciation of a great work of art demands the active intellectual participation of the viewer, but this presupposes an élite instructed in the mysteries of artistic expression and not the vast public who awaited with eager anticipation the opening of the Salon or the Royal Academy.

It is significant that most of the rich American collectors who started their buying activities at the Salons under the guidance of Lucy Hooper, Paris correspondent for the *Art Journal* in the 1870s and 1880s, or Sarah Hallowell, who selected the cream of the Salon pictures for exhibition in her native Chicago in the final years of the nineteenth century, should eventually choose to move on to more demanding fields of artistic connoisseurship. Edith Wharton propounded the theory in her book, *The Decoration of Houses*, written in collaboration with the architect Ogden Codman in 1897, that if the taste of the rich could be improved the level of taste in general would be raised. This suggests – correctly – that the taste of the rich is widely shared and, where possible, imitated. It also suggests that what the rich admire is usually in poor taste. On this assumption the work of the French academic painters stands condemned, but perhaps it would be instructive to canvass some other contemporary opinions on the subject before coming to any final conclusion.

We have already seen that Henry James admired Meissonier. He was not alone, since this opinion was shared by Degas and John Ruskin, the great nineteenth-century critic. Ruskin owned Meissonier's *1814* (portraying Napoleon), which he bought in 1871. Arthur Severn records, in his memoir of Ruskin (*The Professor*, edited by J. S. Dearden and published 1967), that the great man used to examine it with a magnifying glass, continually astonished by the meticulous finish. Ruskin paid 1000 guineas for the picture and sold it sixteen years later for 6000 guineas, an indication of the high prices that were paid for works by successful painters of the period. Some idea of relative values can be gained from comparing the prices paid by John G. Johnson for two of his pictures, Manet's *L'Alabama et Kersearge*, which cost $1,500 and a Rosa Bonheur picture of a yellow dog which cost over $15,000, a startling but instructive difference.

Ruskin, like most of his contemporaries, admired Meissonier for his undoubted professionalism. Here was a highly trained artist showing the greatest skill in the exact rendering of even the smallest detail, the sort of skill that could be evaluated readily in financial terms. To show less ability in the actual execution of a picture was considered offensive to the public. Ruskin was highly critical of English artists on the grounds that they were less professional than their French contemporaries and it is perhaps significant to note that among the few English artists who were

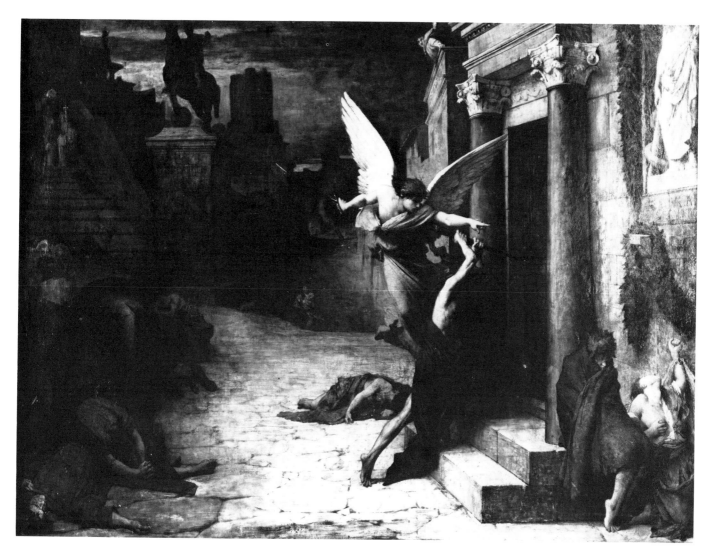

E. Delaunay *La Peste à Rome*/The Plague in
Rome, 1869.
Oil on canvas 131 × 176 cm.

conspicuously successful in the academic Neo-Classical genre, three had
been trained on the continent. Frederick Leighton was trained in
Germany, Lawrence Alma-Tadema in Antwerp, and Edward Poynter in
Paris in the studio of Charles Gleyre, who was the master of Jean-Léon
Gérôme. Ruskin's taste in contemporary art was curiously unreliable.
Contrasted with his noble and thoroughly vindicated championship of
Turner we find an unexpectedly ardent admiration for the work of
Edouard Frère, a minor French genre painter of small merit. Similarly,
Ruskin's views on Whistler, which resulted in a ludicrous and humiliat-
ing court case too well known to need repetition here, demonstrate the
notorious difficulty of judging the art of one's own time.

These examples of Ruskin's inconsistencies are matched by many
others, notably Baudelaire's failure to recognise the importance of
Manet. Again, Baudelaire was not alone in this since Manet's work was
fairly widely execrated even, rather surprisingly, by Rossetti who wrote
in a letter to Jane Morris of 'a French idiot named Manet, who certainly
must be the greatest and most uncritical ass who ever lived'. This adverse
view of Manet's work dates from 1864 when Rossetti was visiting Paris.
At the time he wrote to his mother saying 'The new French school is
simple putrescence and decomposition. There is a man named Manet (to
whose studio I was taken by Fantin), whose pictures are for the most
part mere scrawls, and who seems to be one of the lights of the school'.
(Letter published in the edition of Rossetti's letters by Doughty and
Wahl, 1965). However, it was not impossible for a collector to admire
the work of both the Impressionists and the more academic artists. This
is shown by the taste of Charles Ephrussi, a great patron of the arts who

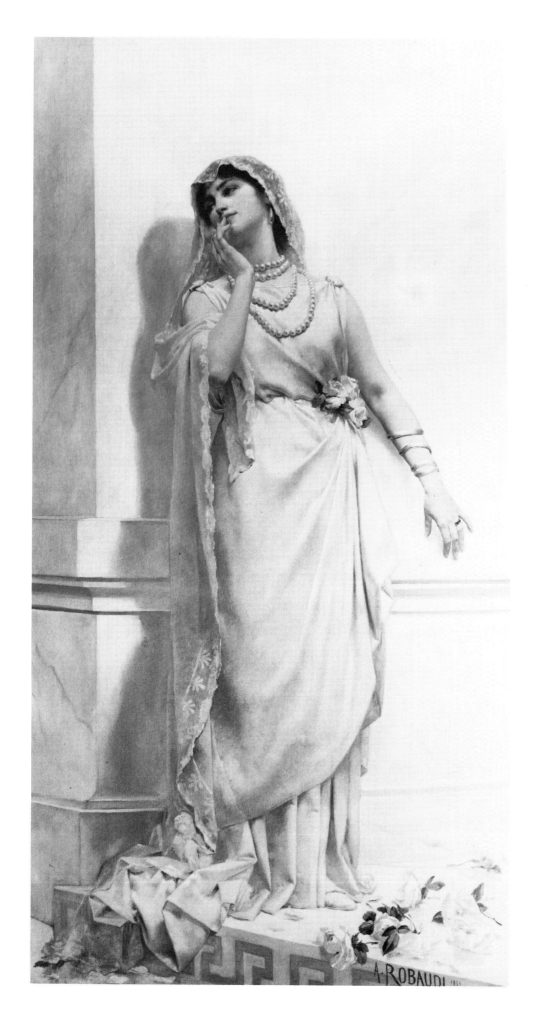

is said to have been one of the models for Proust's Charles Swann. While being a champion of the still underrated Impressionist painters he was also, at the same time, an admirer of Léon Bonnat and Paul Baudry and wrote a useful monograph on the latter which appeared in 1878.

There is no justification for suggesting that the taste of any of these people – including Lord Hertford – was untutored. Lord Hertford who, in fact, fulfils Edith Wharton's main criterion for having bad taste in that he was very wealthy (reputedly enjoying an annual income of £240,000) owned a collection of paintings, now housed in the Wallace Collection in London, which was rich in the work of his contemporaries. It included pictures by Léon Cogniet, Thomas Couture, Alexandre Decamps, J.-L. Gérôme, Prosper Marilhat, Meissonier, Isidore Pils, Camille Roqueplan, Ary Scheffer and Horace Vernet. The four large battle pieces by Vernet now in the National Gallery in London once belonged to him. In 1855 he was made a member of the jury selecting the pictures for the Salon which was timed, by Imperial decree, to complement the Exposition Internationale of that year. Two of the pictures eventually became part of his own collection – L'Exécution du Doge Marino Faliero by Delacroix, acquired in 1868, and Moïse sauvé des eaux by Decamps, which he bought in 1861. Amongst forty-four pictures from his collection Delaroche's La Vierge et l'Enfant, Scheffer's Marguerite à la fontaine and Horace Vernet's L'Arabe, diseur de contes were all shown at the Manchester Art Treasures Exhibition in 1857. After Lord Hertford's death his heir, Sir Richard Wallace, moved the collection to London, where it was installed for a period in the Bethnal Green Museum and there reputedly visited by 5,000,000 people. Henry James visited the exhibition and wrote, not for the first time, with great admiration for the work of Decamps, whom he regarded as one of the best of the Orientalist painters. He wrote equally warmly of Meissonier but records his disappointment with Delaroche – 'he was the idol of our youth' – Gérôme and Horace Vernet. This seems to reflect modern taste since the more unpretentious in subject matter and scale has more readily found new admirers.

The decline of the academic tradition in popular esteem dates from the 1880s. Many American collectors had already begun, cautiously, to buy Impressionist pictures. The first indications of a new direction could be seen in literature and by 1888 the Symbolist movement had a visible presence. Jules Castagnary had pronounced the Orientalist genre dead some ten years earlier and the relevance of the academic discipline was being widely questioned. The old guard was gradually fading into the shadows. Meissonier died in 1891, loaded with honours, including the Légion d'honneur. Paul Baudry had already died in 1886 while still in the middle of planning his Joan of Arc series which was to have decorated the Panthéon. Rosa Bonheur, the first woman to become an officier of the Légion d'honneur, died in 1899. Pierpoint Morgan had bought Rosa Bonheur's most famous picture, Le Marché aux chevaux (completed in 1855, and widely known through engraved copies), in the 1880s for £12,000 and presented it to the Metropolitan Museum. Bouguereau and Gérôme both survived until after the turn of the century, outliving their great reputations made in the middle years of the century by some years. From the turn of the century until now these artists have been consigned to oblivion.

A. T. Robaudi *Une nouvelle mariée*/The Young Bride, 1883.
Oil on canvas 220 × 120 cm.

2. The Olympians and Historians

The critic Jules Castagnary, writing in 1868, was content to adopt Constable's wide definition of history painting which excluded only landscape and still-life and included both portraits and modern life subjects. This clearly defined the area in which an artist working in the first half of the nineteenth century could expect to be taken seriously. The subject matter which was suitable for a dedicated artist covered, in diminishing order of importance, episodes from classical history and mythology, events from national history, from military and naval engagements, noble or moving modern-life subjects (medicine and scientific pictures were popular in this aspect of historical genre), religious subjects, portraits showing a heroic aspect of the sitter and last – the least respected – landscape and still-life.

The establishment of a Prix de Rome awarded for Historical Landscape in 1817 marks the belated and reluctant recognition of the importance of landscape painting while still denying the pure landscapist acceptance as an artist of consequence in the established hierarchy. The subject matter for the Historical Landscape competition remained relentlessly Neo-Classical throughout the half-century of its existence and it is significant that none of the important landscape painters of the period, with the exception of Michallon, feature amongst the winners of the competition. Pure landscape was to remain a minor branch of painting in the eyes of the critics and the public well into the second half of the nineteenth century. History painting, in the widest sense of the word, was considered the most important and the highest form of artistic endeavour. All the nineteenth-century artists who made great reputations for themselves in their own time practised history painting in some form. Théophile Gautier pointed out in his review of the great retrospective of Delaroche's work held after his death in 1858, that the painter of *La Mort de la reine Elisabeth*, *Jeanne d'Arc en prison*, *Les Princes dans la tour* and *La Mort de Jane Grey* was more popular with the public than either Ingres or Delacroix. With his incident packed canvases Delacroche was fulfilling, in the most elaborate detail, the condition that every picture should tell a story.

The academic system of artistic training continually reinforced the position of history painting since the acknowledged pinnacle of success for the student at the Ecole des Beaux-Arts was to win the Prix de Rome. The subjects for the competition were taken either from classical history and mythology or from the Bible. A wide and detailed knowledge of both these possible areas of choice was presumed in the students, which meant that during the years of preparation the aspirant competitor had to restrict himself almost exclusively to history painting of a very specialised kind. Most official and State commissions for the decoration of public buildings were for historical subjects – either classical subjects

J.-L. Gérôme *Une Idylle (Daphnis et Chloe)/* An Idyll (Daphnis and Chloe), 1852.
Oil on canvas 212 × 156 cm.

31

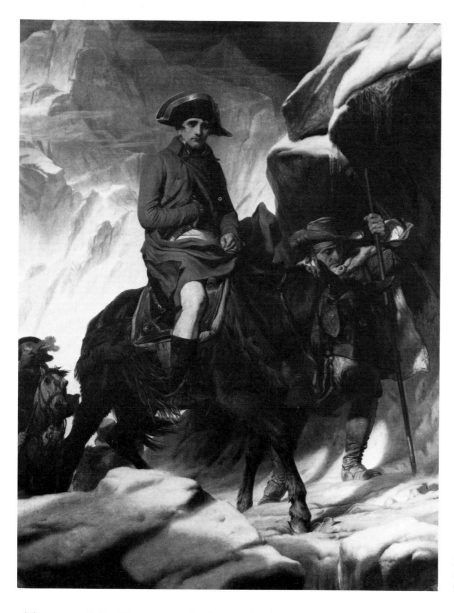

P. Delaroche *Napoléon traversant les Alpes*/Napoleon crossing the Alps, 1850. Oil on canvas 279.4 × 214.5 cm.

with a moral significance or glorious episodes from French history, the latter being a branch of history painting that was explicitly encouraged by Louis-Philippe. Artists were sent to follow the military campaigns of the period to record events for posterity. The renowned military painter, Horace Vernet, visited Algeria in 1833 to follow the French army, a trip which also marked the beginning of his fascination with the East.

The pupils and admirers of Jacques-Louis David dominated the Neo-Classical school at the beginning of the nineteenth century. The most important amongst them was J.-A.-D. Ingres, whose influence on the history painting of the period was all-pervasive. The Ingrist tradition persisted in France throughout the whole of the nineteenth century. In the 1920s Paul Helleu, the successful society portrait painter, told Lady Mosley with pride that he was a 'petit fils d'Ingres' indicating that his master had been a pupil of Ingres (see *A Life of Contrasts*, by Diana Mosley, London 1977, p.50). Ingres' success with both branches of history painting, classical and post-classical, made his work the starting point for the 'Troubadour' painters who specialised in Medieval and Renaissance subjects, as well as the admired prototype of the proponents of the second wave of Neo-Classicism in the mid-nineteenth century. Various pupils reinterpreted the Ingrist preoccupation with line and form into the full-blown Neo-Classicism of the Second Empire. These included Ingres' favourite student, Amaury-Duval, who pub-

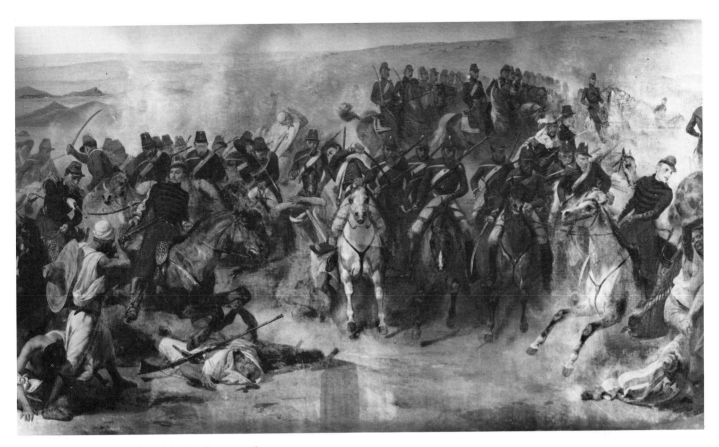

E. J. H. Vernet *Prise de Smalah*/The Capture of
Smalah, 1845.
Oil on canvas 489 × 2139 cm.

E. Meissonier *Campagne de France, 1814*/The
French Campaign, 1814.
Oil on canvas 51 × 76 cm.

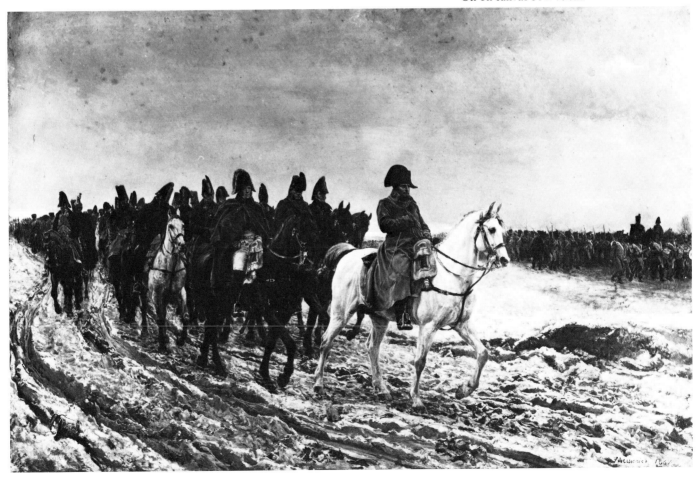

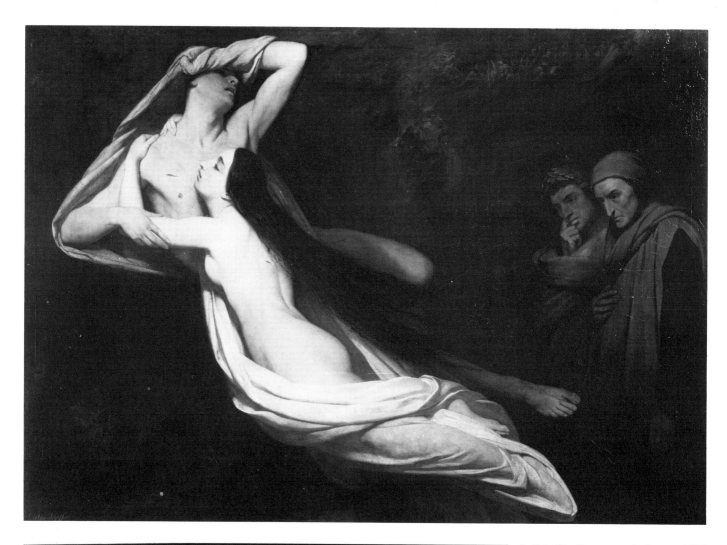

A. Scheffer *Francesca da Rimini*, 1835.
Oil on canvas 170 × 238 cm.

Left
P. Delaroche *Les Princes dans la tour*/
The Princes in the Tower, (Reduction
of picture in the Louvre), 1831.
Oil on canvas 44 × 52 cm.

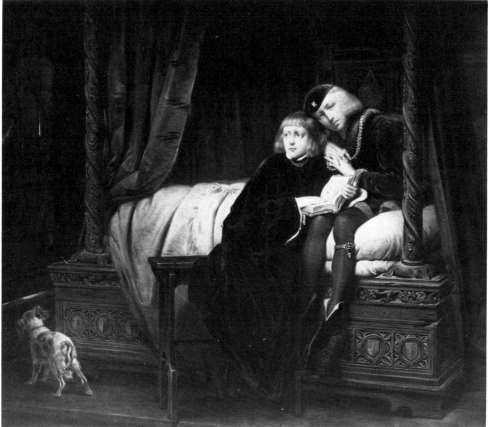

Opposite
P. Delaroche *Jeanne d'Arc en prison*/
Joan of Arc in Prison, c. 1843.
Oil on canvas 22 × 19 cm.

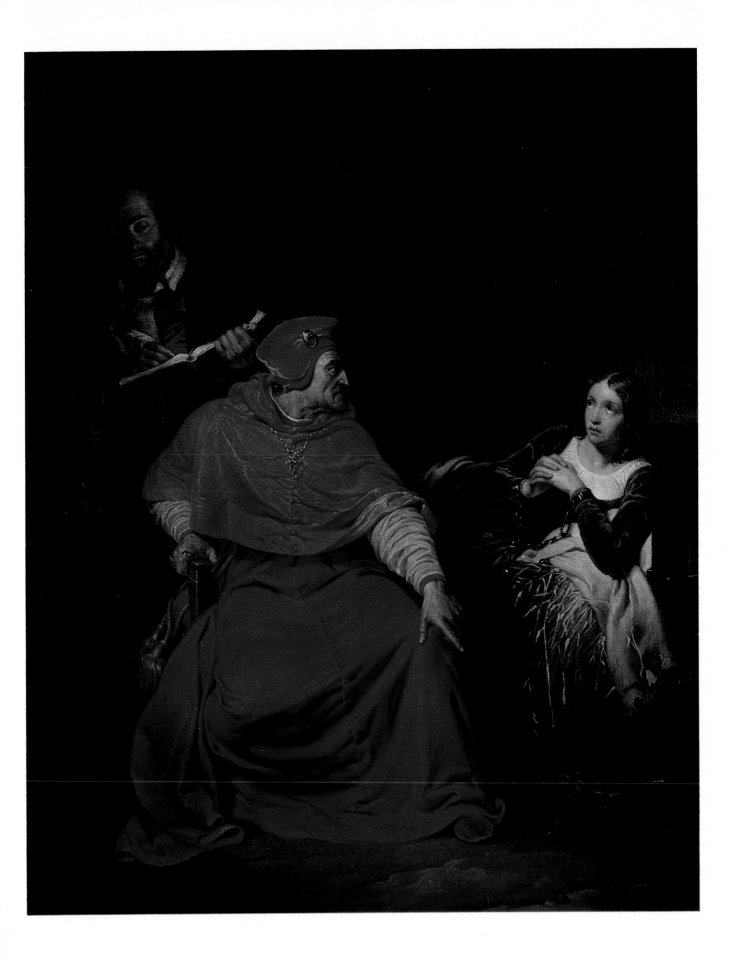

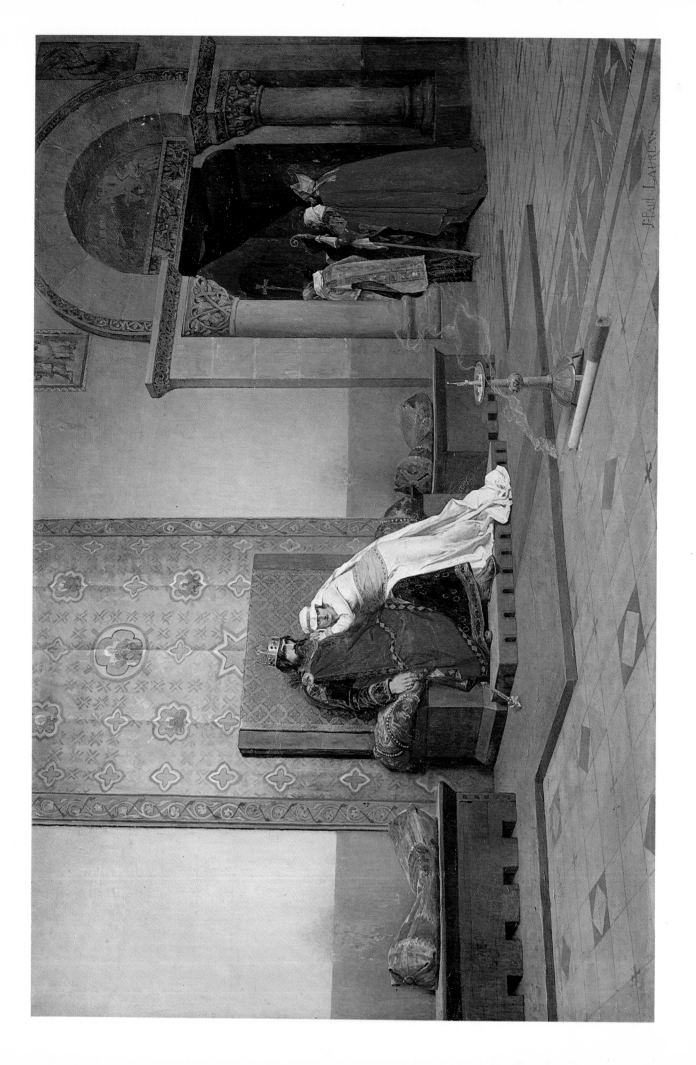

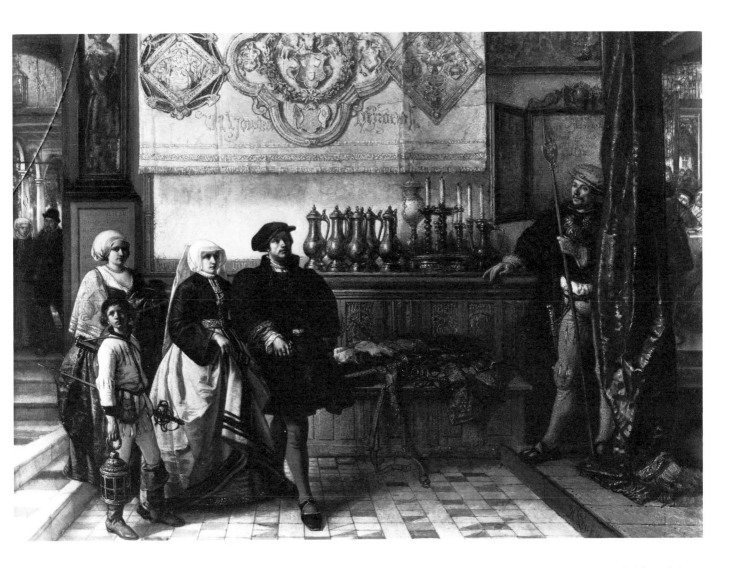

Baron H. Leys *Frans Floris se rendant à une fête du Serment de St Luc*/Frans Floris going to a Painters' Feast, 1853.
Oil on canvas 66 × 90 cm.

Opposite
J.-P. Laurens *L'Excommunication de Robert le Pieux*/The Excommunication of Robert the Pious, 1875.
Oil on canvas 130 × 218 cm.

lished an account of Ingres' studio and pupils in 1872 and Chassériau, one of Ingres' most successful students, who achieved the difficult feat of combining the linear discipline learnt from his master with the romantic intensity of colour which he observed in the work of Delacroix. Hippolyte Flandrin also became one of the most respected religious painters of the period, executing several important church cycles including the decoration of the church of St.-Germain-des-Prés in Paris.

Louis-Philippe was firmly convinced of the importance of establishing history painting as an identifiable national style. He greatly assisted the prolongation of the history-painting tradition in the nineteenth century by his establishment of the Musée Historique at Versailles. The interminable suite of rooms on the first floor of the palace was intended to be a shrine to hold great canvases depicting the glories of the history of France. During the years of neglect, when the work of almost all the artists represented at Versailles was forgotten, the museum turned into a kind of elephants' graveyard, full of enormous corpses of dead reputations and derided pictures. The whole project was originally conceived, from every point of view, on too large a scale. Not only were the galleries seemingly unending, but many of the works were huge. Two of Horace Vernet's battle scenes were so large that a floor had to be removed to accommodate them. By portraying systematically the whole history of France, many pictures had been admitted which were almost without artistic merit. A considerable number of artists whose work was exhibited at the Musée were not in the first rank even in their own time. Now they are completely forgotten. Amongst such relatively well-known names as Horace Vernet and Charles Müller were interspersed

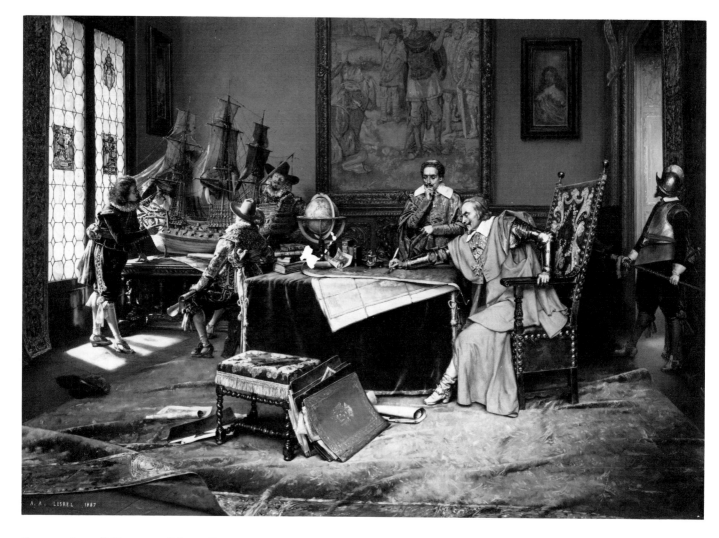

A.A. Lesrel *Cardinal de Richelieu considérant les plans du siège de la Rochelle/* Cardinal Richelieu surveying the plans for the siege of La Rochelle, 1887.
Oil on canvas 85 × 117.5 cm.

the works of Beauce, Rigo, Baume, Gautherot and Steuben. The paintings of Gros, Delacroix and David were heavily outnumbered by those of the Prix de Rome winners of the period of the Bourbon monarchy restoration (1818–1848).

At Versailles, as at Louvre, where the redecoration of the State Rooms was largely carried out by artists of a similar standing the weight of official patronage, instead of stimulating and encouraging the development of a relevant modern style of history-painting, stifled and atrophied an outworn tradition. Into this artistic stalemate the work of the Néo-Grecs (Gérôme, Hamon and Picou, all pupils of Charles Gleyre who evolved a cool, 'every-day life' style of Neo-Classical subject painting which Gautier dubbed 'Néo-Grec' from its supposed stylistic debt to Greek vase-painting) shone like a ray of hope. This new style seemed to open the way to further development in the Neo-Classical vein, but the essential triviality of the treatment of subjects, without moral or heroic significance, condemned this departure as a journey down yet another artistic cul-de-sac.

With hindsight it is easy to see the ways in which triviality debilitated the academic tradition. Delaroche and Meissonier left an unfortunate legacy and the Ingrist tradition persisted only in a method of compositional organisation and in the technique of line and cool colour. The use of meticulously accurate archaeological settings for scenes reduced rather than intensified the heroic impact of the subject, making for instance, a cosy domestic reunion out of the return of Ulysses, where the mechanics of the loom are of more interest than the facial expressions of the protagonists.

This is the moment of decline of Neo-Classicism. It marks a change,

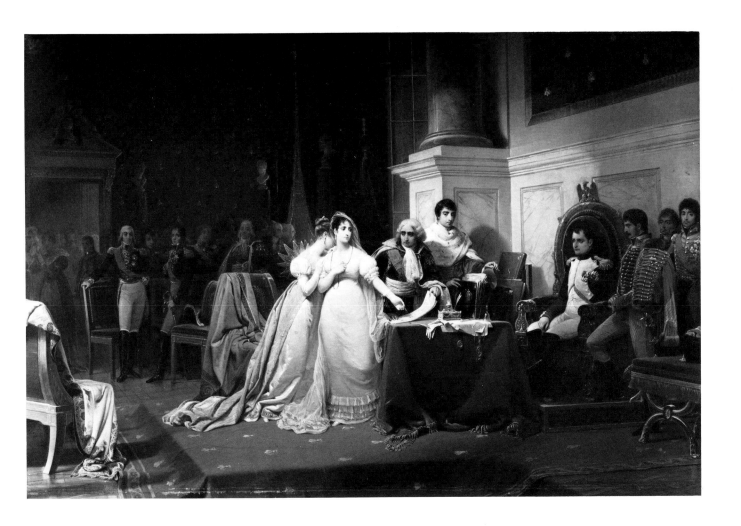

F. H. Schopin *Le Divorce de l'impératrice Joséphine*/The Divorce of the Empress Josephine, 1846.
Oil on canvas 57 × 81 cm.

which might also be seen as a decline, in other branches of history painting. The anecdotal style was gradually to take over in pictures based on seventeenth and eighteenth century history as well. Cardinals Mazarin and Richelieu became the sly and tricky cardinals and leery monks of the cabinet pictures which were so highly prized by the bourgeois public in the second half of the nineteenth century. The groups of men in seventeenth century costume no longer plan campaigns and draw up treaties but play games and make music. The two worlds of history painting existed uneasily side by side at the Salon exhibitions, marking a further divide in an already divided world. Sartre's novel *La Nausée* (1938) contains a perceptive satirical description of the paintings – especially the portraits – which fill the provincial museum of 'Bouville', a bastion of respectable bourgeois society. Such paintings are seen as a necessary status symbol, an affirmation of the right of certain individuals to a place in a respectable society dedicated to upholding 'les devoirs et les droits, la religion, le respect des traditions qui ont fait la France' (The rights and duties, religion and the respect for traditions that have made France).

The mid nineteenth century marks the beginning of the dual standard; of pictures which appealed to the mass of the middle-class public and those which were appreciated only by the intelligentsia. This was a situation which had not existed in the past but which was to become a permanent feature of the art scene in the twentieth century. An analogy can be drawn between painting and literature where the same situation was to arise; the most popular works giving pleasure only to the uninstructed masses and the appreciation of the *avant-garde* being jealously kept as the exclusive province of the intellectual. Like the popular fiction of today, with its emphasis on power, sex and money or

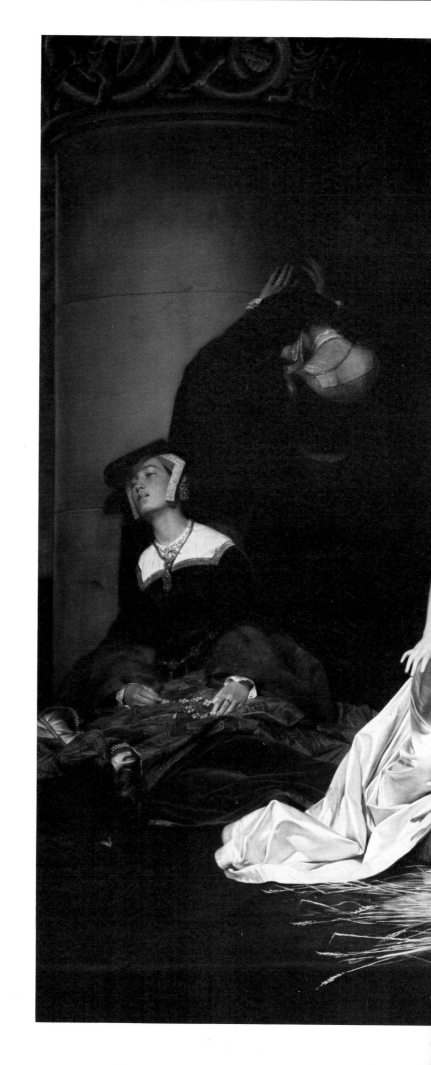

P. Delaroche *L'Exécution de Jane Grey*/The
Execution of Lady Jane Grey, 1834.
Oil on canvas 246.4 × 297 cm.

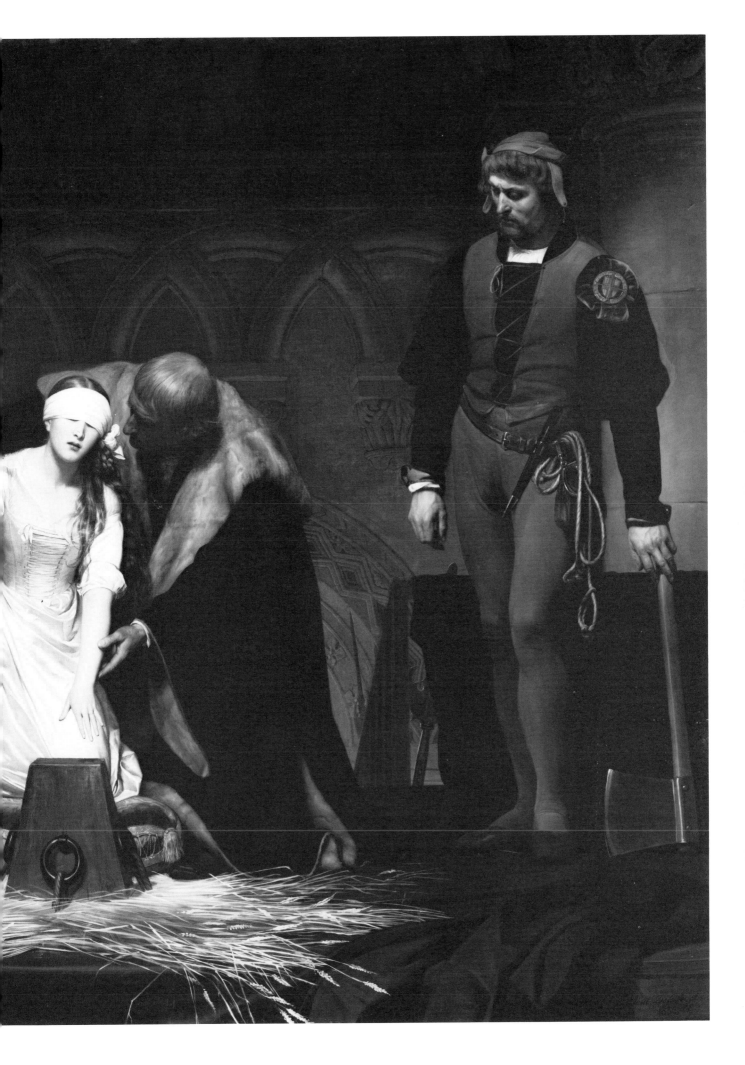

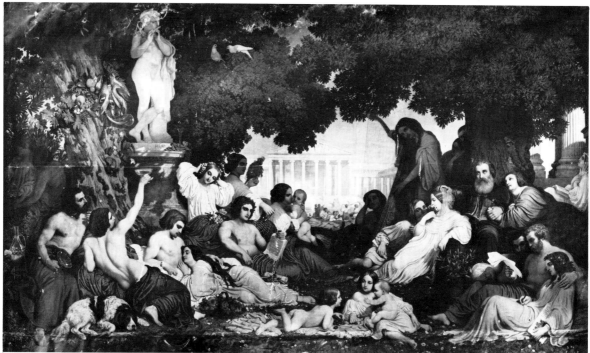

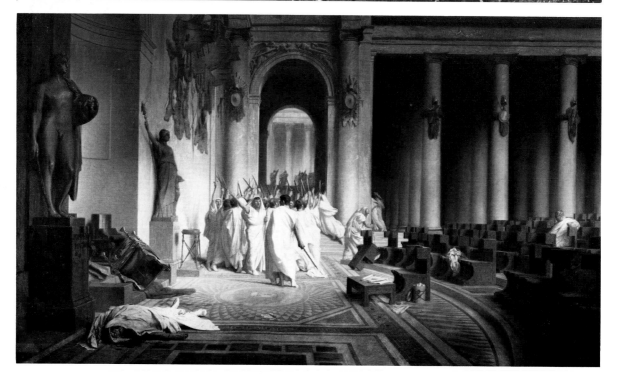

M.-C.-G. Gleyre *Minerve et les graces*/Minerva and the Graces, 1866.
Oil on canvas 226.5 × 139 cm.

Opposite

J.-L. Hamon *La Comédie humaine*/The Human Comedy, Salon 1852.
Oil on canvas 131 × 316 cm.

D. L. Papety *Rêve de bonheur*/A Dream of Happiness.

J.-L. Gérôme *La Mort de César*/The Death of Caesar, 1867.
Oil on canvas 85.5 × 145.2 cm.

sentimental love stories, late nineteenth-century cabinet pictures had a similar sort of mass appeal. Both can be understood and assimilated without initiation into the mysteries of complex intellectual thinking – although nineteenth-century painters chose to disguise their real subject matter beneath a fusty cloak of antique heroics, emotive historicism, nubile Venuses and exotic Oriental stage-sets. This veiled and often hypocritical pandering to public taste made these artists as wealthy and well-known in their own time as they might have been had they been born into the twentieth century as pulp fiction writers.

Painting, in fact, was ahead of literature in this respect since looking at pictures, unlike reading, is not considered an acquired skill. The Education Act of 1870 meant that the literate public was to be greatly enlarged, thereby creating a wider audience for popular novels like, for example, those by Ouida and, later, Elinor Glyn. By contrast, 'popular painting' had been in existence since the middle of the nineteenth

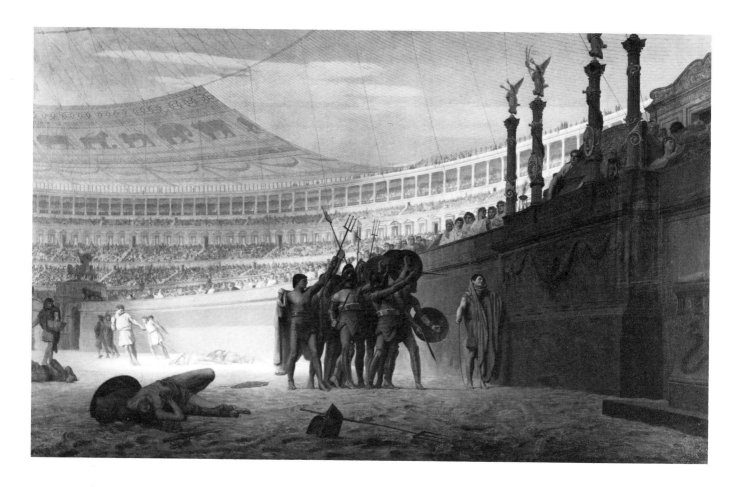

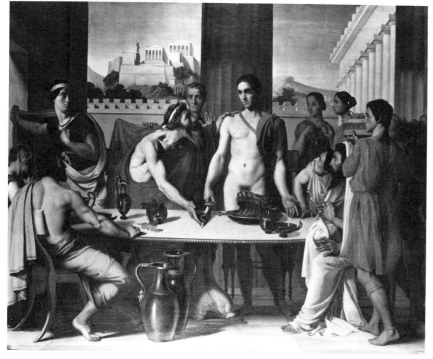

J.-L. Gérôme *Ave Caesar! Nous qui allons à la mort vous saluons*/Hail Caesar! We who are about to die salute you, 1859.
Oil on canvas 93 × 145.4 cm.

H. Flandrin *Thesée reconnu par son père*/Theseus recognized by his Father, 1832.
(Winner of the *Prix de Rome*)

century. Apart from making no demands on the intellect, nineteenth century cabinet pictures also had the great advantage of being in a visual tradition which had been increasingly refined and codified since the Renaissance whereas Realism and then Impressionism made great demands on the visual intelligence of the spectator. Within this context the suspicion with which their work was regarded is easy to understand.

It is less easy to appreciate the dual standard which was applied to the

Opposite
T. Couture *Les Romains de la décadence*/The Decadence of the Romans, 1847.
Oil on canvas 466 × 775 cm.

Page 46
J.-L.-E. Meissonier *Napoléon III à la bataille de Solférino, 24 juin 1859*/Napoleon III at the Battle of Solferino, 24th June, 1859, 1863.
Oil on canvas 44 × 76 cm.

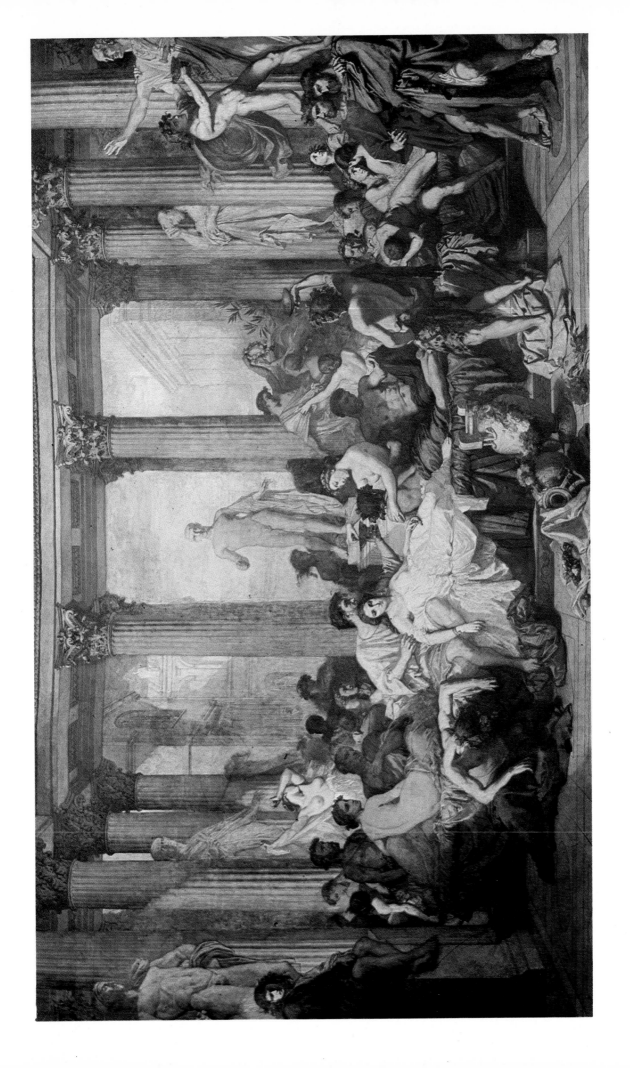

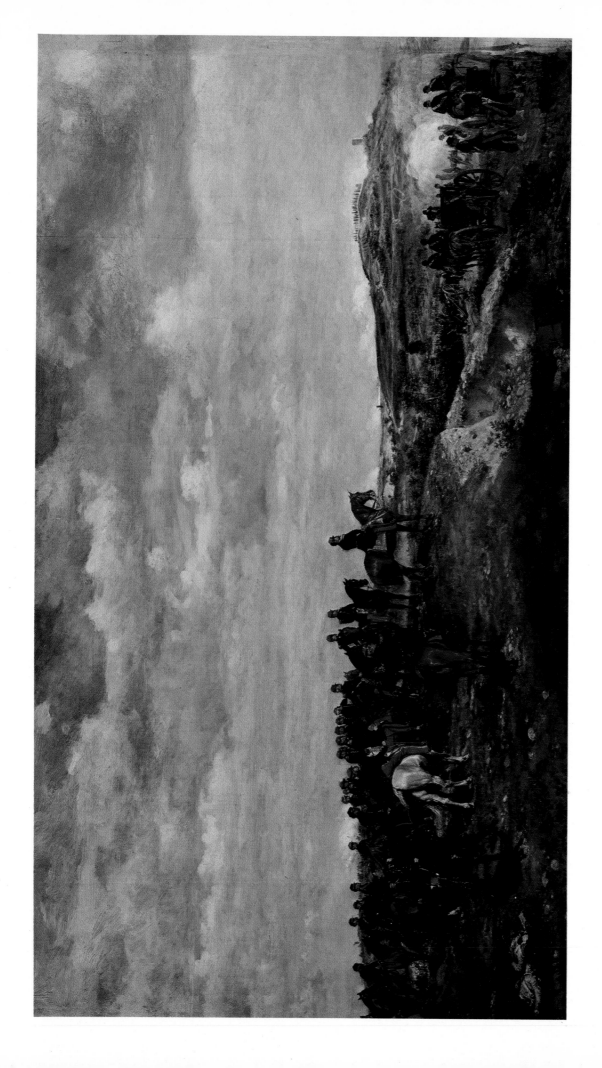

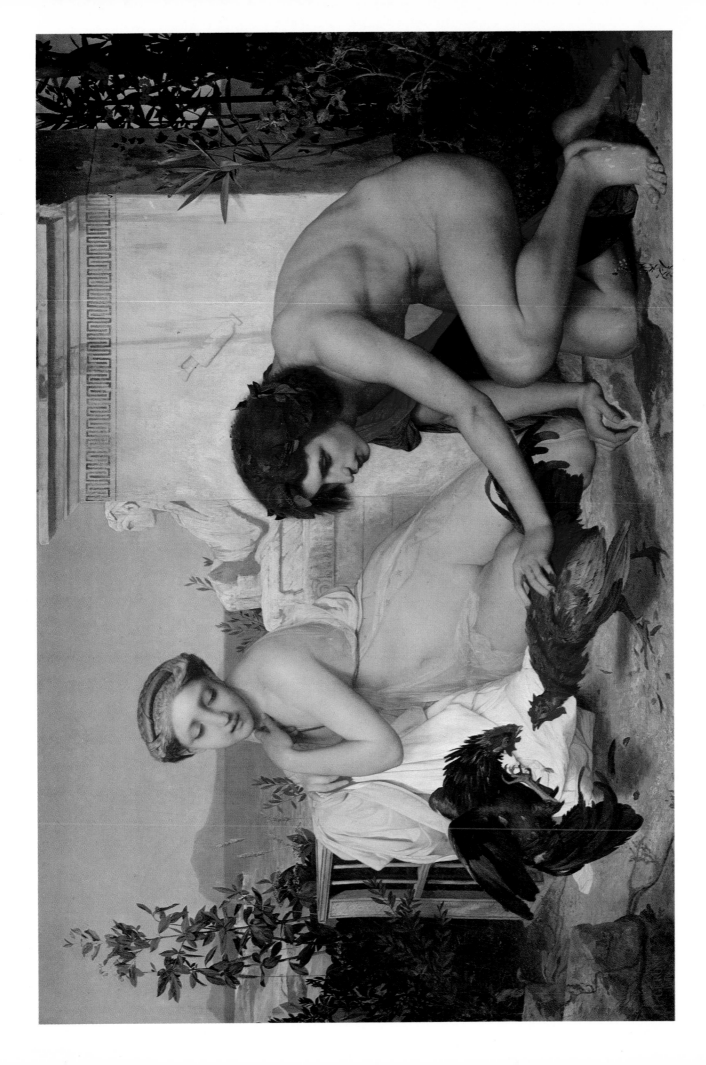

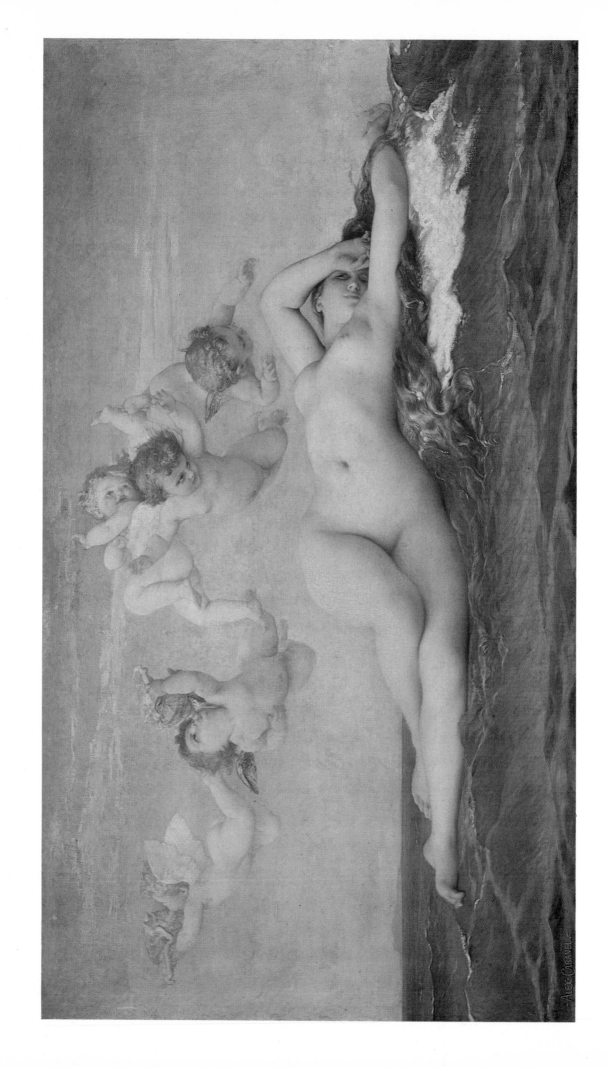

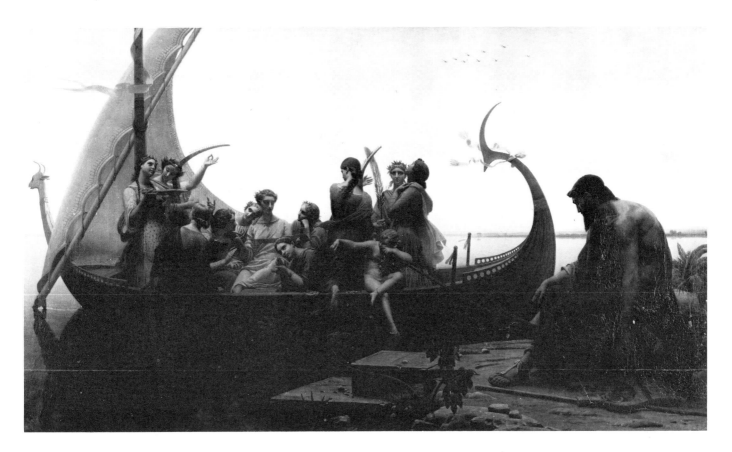

M.-C.-G. Gleyre *Les Illusions perdues* ou *Le Soir*/Lost Illusions *or* The Evening, 1843. Oil on canvas 137 × 240 cm.

Page 47
J. L. Gérôme *Jeunes Grecs faisant battre des coqs (Combat de coqs)*/The Cock Fight, 1846. Oil on canvas 143 × 204 cm.

Opposite
A. Cabanel *La Naissance de Vénus*/The Birth of Venus, 1862. Oil on canvas 130 × 225 cm.

depiction of the nude. Suitably labelled as a Venus or a Susannah, a flagrantly erotic nude could be publicly shown at the Salon and bought by the Emperor himself without causing unduly adverse comment. Without the convenient fiction that a mythological or historical figure was the subject, the picture immediately became an offence to public morality. In Manet's *Déjeuner sur l'herbe* and Courbet's *Baigneuses* the subjects were regarded as crude. It is interesting to compare them with the most popular picture at the Salon of 1863, Cabanel's *La Naissance de Vénus* which was bought by Napoleon III, a picture which now seems to be blatantly titillating in a way which Manet's serious approach to both compositional and technical problems explicitly disdains.

It is now difficult to gauge the extent to which the nineteenth century public was fooled by its own ingenuousness. It is apparent that many intelligent people were, in fact, aware of their baser motives and the explicit eroticism of many mid-nineteenth century Venuses was commented on by contemporary critics. Philip Hamerton wrote at some length about Cabanel's *Vénus* in his discussion of the Salon for the *Fine Arts Quarterly Review* (October 1863): 'She lies in the full light on a soft couch of clear sea-water, that heaves under her with gleams of tender azure and pale emerald, wherein her long hair half mingles, as if it were a little rippling stream of golden water losing itself in the azure deep. The form is wildly voluptuous, the utmost extremities participating in a kind of rhythmical, musical motion. The soft sleepy eyes just opened to the light are beaming with latent passion and there is a half childish, half womanly waywardness in the playful tossing of the white arms.' Like the picture it describes this is a 'wildly voluptuous' piece of descriptive writing, and it argues a greater clear-sightedness in Hamerton than in many of his contemporaries.

Baudelaire's approach to eroticism in art was more coy:

s'il est bien dessiné, comportant un genre de plaisir dans les éléments duquel le sujet n'entre pour rien ... Une figure bien déssinée vous pénètre d'un plaisir tout à fait etranger au sujet. Voluptueuse ou terrible, cette

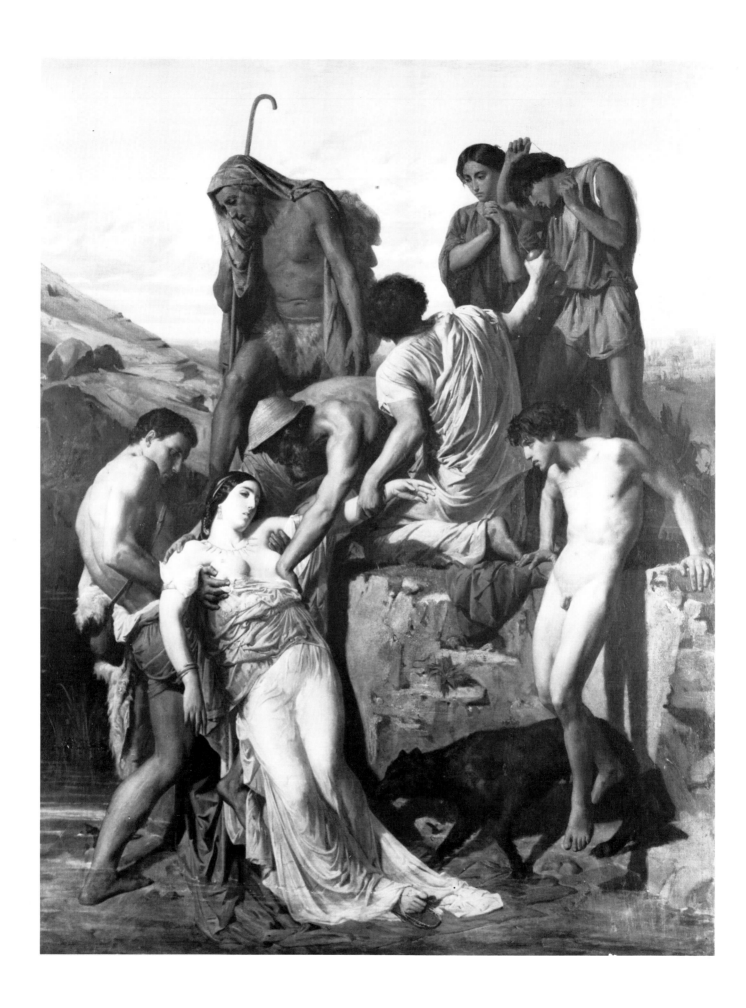

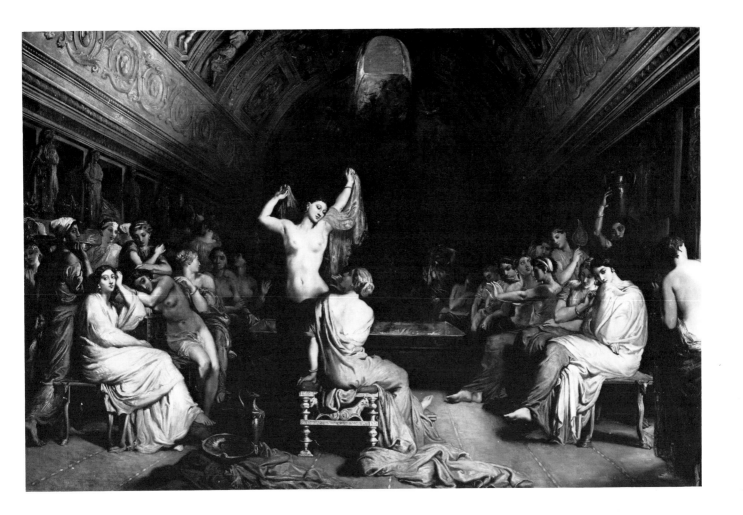

T. Chassériau *Le Tepidarium*/The Tepidarium, 1853.
Oil on canvas 169 × 257 cm.

figure ne doit son charme qu'a l'arabesque qu'elle découpe dans l'espace. (If it is well-drawn there is pleasure to be gained in its very structure which has nothing to do with its subject . . . A well-drawn figure fills you with a pleasure far removed from the subject matter. Whether voluptuous or frightening, the charm of such a figure lies simply in the curve which it cuts in space.)

Some members of the public were not so easily deluded. Edith Wharton, writing about the low intellectual standard of the New York dinner-party conversation of her youth describes the guests discussing the novels of Trollope or the 'discreet allusion made to Mr William Astor's audacious acquisition of a Bouguereau Venus' (from *A Backward Glance*, published in 1933). There is no possibility of misinterpreting her meaning since her choice of words was always meticulously precise. Such a picture was recognised as having a thinly disguised eroticism. Like the Orientalist works, the most avid admirers of these pictures were from the level of society where outward propriety was most highly valued.

Academic history painting sowed the seeds of its decline by the application of an unbending academic standard to both composition and execution. The refusal of the academic establishment to realise the importance of new ideas and hitherto unexplored sources of inspiration – photography, Japanese art, the real appearance of the modern world, the machine ethic (the list could be interminable) – spelled the death sentence for the Academic ideal. Led by Gérôme, the establishment fought a spirited rear-guard action against the recognition of Impressionism as a valid new departure in the development of painting. In so doing they hastened the onset of years of obscurity and derision which were to be the judgement of history on their own work.

W.-A. Bouguereau *Zénobie trouvée sur les bords de l'Araxe*/Zenobia found on the banks of the Araxes, 1850. (Winner of the *Prix de Rome*)
Oil on canvas 148 × 118 cm.

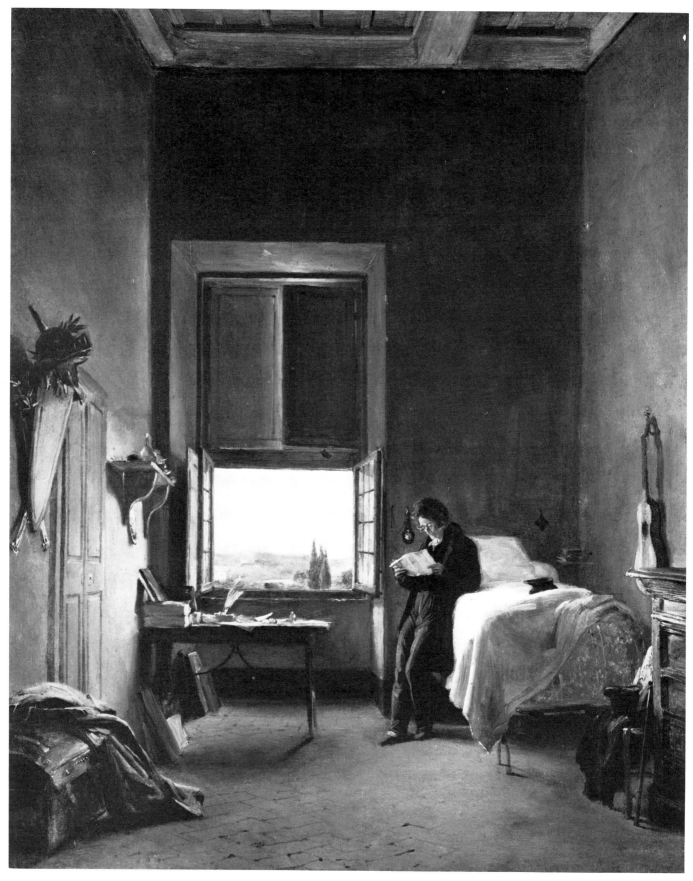

L. Cogniet *La Première lettre de chez lui*/The
First Letter from Home, (Portrait of the artist
in his room at the Villa Medici), 1817.
Oil on canvas 43.3 × 36 cm.

3. The Academic Treatment of the Modern Life Subject

It is surely no exaggeration to say that the issue of the introduction of contemporary Realism into art was central to the development of nineteenth-century style. In the post-1830 period, artists were confronted with an uncomfortable choice of subject matter – either historicism or contemporaneity – a choice made more invidious by the opposition of both the artistic establishment and the public to a movement – Realism – that was clearly of crucial importance to the mainstream of artistic development. Manet and Courbet showed that they were able to treat public and critical disapproval with equanimity and self-assurance. Both of them were prepared to tackle modern life subjects without resorting to the subterfuges of metaphor or symbolism which were the refuge of those lesser masters anxious to retain the favour of the establishment, as represented by the Salon jury.

Gervex unfortunately suffered the fate of rejection by the jury with his picture *Rolla*, submitted in 1878. The subject, taken from a poem by Alfred de Musset, is sufficiently sordid to have frightened the jury anyway, but Gervex – on the advice of Degas – had added to the verisimilitude of the scene by painting, in the righthand lower corner, an explicit still-life of discarded clothes. This touch of crude realism was enough to condemn the work. It was refused on the grounds of immorality and was shown separately in a shop in the chaussée d'Antin, where it attracted a large crowd of fascinated Parisians.

Daumier is quoted as having said, 'Il faut être de son temps', a rallying cry for the Realist movement and Baudelaire wrote at some length on the heroism of modern life, a passionate plea to artists to recognise an aspect of contemporary life in which living men exhibited an *esprit heroïque* every bit as sublime as that of the great figures of myth and history. Baudelaire, however, was never able to bring himself to embrace Realism with whole-hearted enthusiasm, preferring the compromise of the modern allegory, as in Delacroix's *La Liberté guidant le peuple* or Meissonier's *Le Siège de Paris*. True Realism, as envisaged by Courbet, (though Courbet himself was not above employing a complex allegorical scheme for one of his greatest works, *L'Atelier du peintre*) went much further. Courbet found matter worthy of the artist's attention in the most humdrum and unromantic aspects of life such as the everyday events of the *petit bourgeois* and the labourer. Baudelaire found this type of Realism ugly, and he was not alone in feeling distaste for life unvarnished by an ideal vision.

Contemporary clothes were the chief stumbling-block for many people (the very clothes which we now find so picturesque), particularly the subfusc male garments which seemed, at the time, to nullify any heroic gesture. This attitude is summed up in Millais' celebrated remark about the absurdity of painting Charles I in checked trousers. As early as

1864 A. de La Fizelière, writing in the *Union des Arts*, pin-pointed the greatest hazard inherent in treating the trivia of modern life as worthy subject matter for a picture. Discussing the work of the modern life painters, among them Auguste Toulmouche, a pupil of Gleyre and a minor genre painter who married a cousin of Monet, he says:—

> [Ils] s'adonnent à la peinture des mœurs modernes. Le grand intérêt de leur peinture gît dans cette circonstance très heureuse que, s'occupant à reproduire le roman intime de la vie parisienne, ils conservent à leurs personnages le costume et les manières de l'époque où nous vivons au lieu de les revêtir, à l'exemple de tous les petits maîtres de la vie élégante ... des modes du temps passé.

> ([They] devote themselves to the depiction of modern manners. The main interest of their work lies in this happy instance as, occupying themselves with the intimate story of Parisian life, they preserve in their characters the costumes and the ways of the time in which we live instead of reclothing them, in the way of all those 'little masters' of the fashionable life ... in the styles of the past).

No ambitious painter wished to be regarded simply as a depictor of *la vie parisienne*, for the interest of his work to the generations of the future would be merely its value as a record of the mannerisms of his epoque.

For the traditional academic artist, steeped in classical myth and history, with an extensive knowledge of the Bible and a detailed acquaintance with the glorious episodes from the history of France, the advent of Realism presented problems which could be resolved in a number of different ways. Fortunately for them, almost at the moment when nineteenth century artists were faced with the greatest pressure to accept and assimilate the concept of Realism or contemporaneity the French discovered the East. The Orientalists found a world uncontaminated by Social Realism in its more unacceptable forms. Here there was scenery untouched by urban development, costume unaffected by changing fashions and a way of life, hallowed by tradition, dating back almost to the beginning of the history of the modern world. Delacroix indicated the solution to the problem of integrating the classical tradition with the demands of Realism when he wrote from his journey to the East to say that he had found ancient Romans in the streets of Algiers. An artist like Gérôme who was, throughout his life, bitterly opposed to the decline of the academic tradition – reserving his most stinging criticism for the despised Impressionists – found that the combination of Neo-Classical history painting and Orientalism, interspersed with a few excursions into the seventeenth century and the Napoleonic era, provided enough subject matter for his painting. To Gérôme Realism was simply a matter of historical and architectural research.

The myth of the timeless quality of history painting, however, with its elevating affirmation of noble aspirations and eternal verities, is repeatedly confuted in the work of the nineteenth century Neo-Classicists, not least in the work of Gérôme who, with his fellow Pompéistes, reduced Neo-Classicism to genre-painting in fancy dress. Couture, who painted a portrait of himself in his allegory of republicanism, *Les Romains de la décadence*, (with its references to the failure of Louis-Philippe's political régime) thereby inadvertently identified the whole group as Victorians in fancy dress. Thus it is a no more convincing depiction of a Roman orgy than those filmed in Hollywood nearly a century later. This is nowhere more unequivocally shown than in Gustave Boulanger's record of the play-acting at Prince Napoleon's Pompeian palace in the avenue Montaigne. Théophile Gautier and the actors and actresses of the Comédie-Française are just as good as ancient Romans as the models used by Couture or Gérôme. There is, after all, no truly timeless physiognomy since the way in which

H. Gervex *Rolla*, 1878.
Oil on canvas 175 × 220 cm.

G. Courbet *L'Atelier du peintre*/The Painter's Studio, 1855.
Oil on canvas 361 × 598 cm.

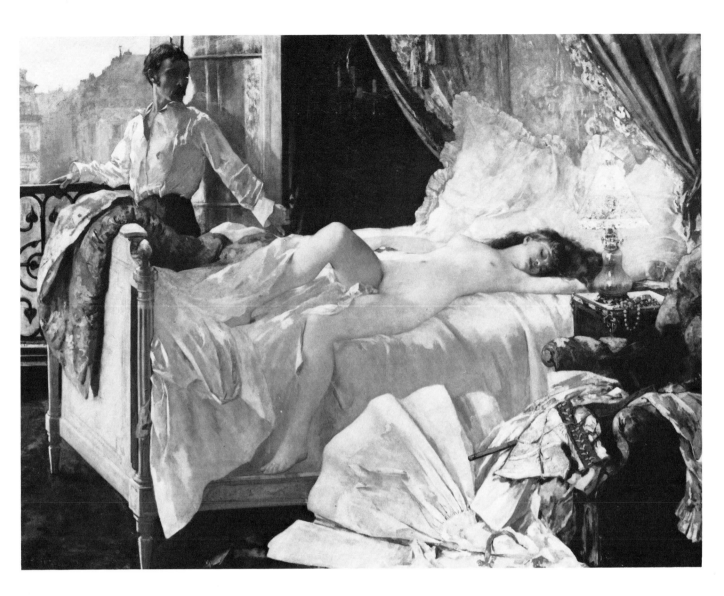

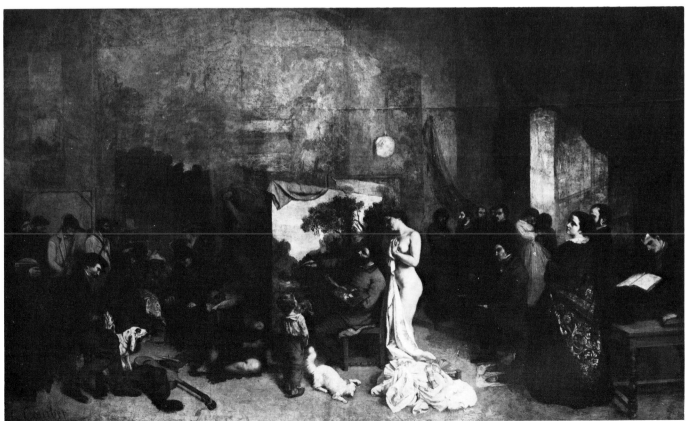

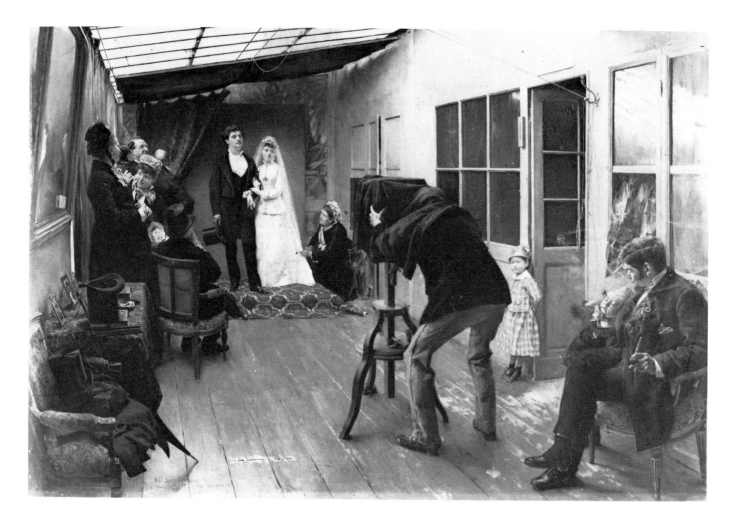

an artist's perception of the world about him is recorded on canvas must be irredeemably imbued with the spirit of his age. The idealisation of the human form recommended by the teachers at the Ecole des Beaux-Arts was merely a tidying-up operation, a smoothing-away of the crudeness of nature effected on unalterably nineteenth-century models. Realism could not be completely avoided but it is nonetheless interesting to see the ways in which academic painters arrived at a compromise between the demands of the Realists and the established preference for history-painting.

A number of solutions were open to the artist who wished to set his subjects outside the limiting time-scale which a fashionable modern setting imposed on a picture. The journey to Rome, which was the goal of every competitor in the Prix de Rome contest and the reward of the winner, had revealed a world of traditional, unchanging peasant activity almost at the gates of the city. By using the peasants in their traditional costumes as models, contemporary events could be set against a background which would not 'date'. Leopold Robert made a speciality of scenes from the peasant life of the Roman Campagna and his discovery of this source for subject matter was to influence the work of a number of his contemporaries, notably J. V. Schnetz. Schnetz's *Vœu à la Madone* exploits the timeless qualities of both the traditional peasant costumes and religious observances, thus removing his picture from the real world of advancing industrialisation.

At almost the same time the provinces of France were being rediscovered by the *literati* and the artists at home, a world at first revealed to them by the Berichon novel, *La Mare au Diable* by George Sand. As in the *Vœu à la Madone* many of these pictures of French peasant and working life are in the style sometimes referred to – with

E. Dagnan-Bouveret *La Noce chez le photographe*/The Wedding Photograph, 1878–9.
Oil on board 85 × 122 cm.

Horace de Callias *Une soirée à l'Hôtel de Verteillac, 35 boulevard des Invalides, Paris*/An Evening at the Hôtel de Verteillac, 35 boulevard des Invalides, Paris, n.d.
Oil on canvas 81.3 × 100.3 cm.

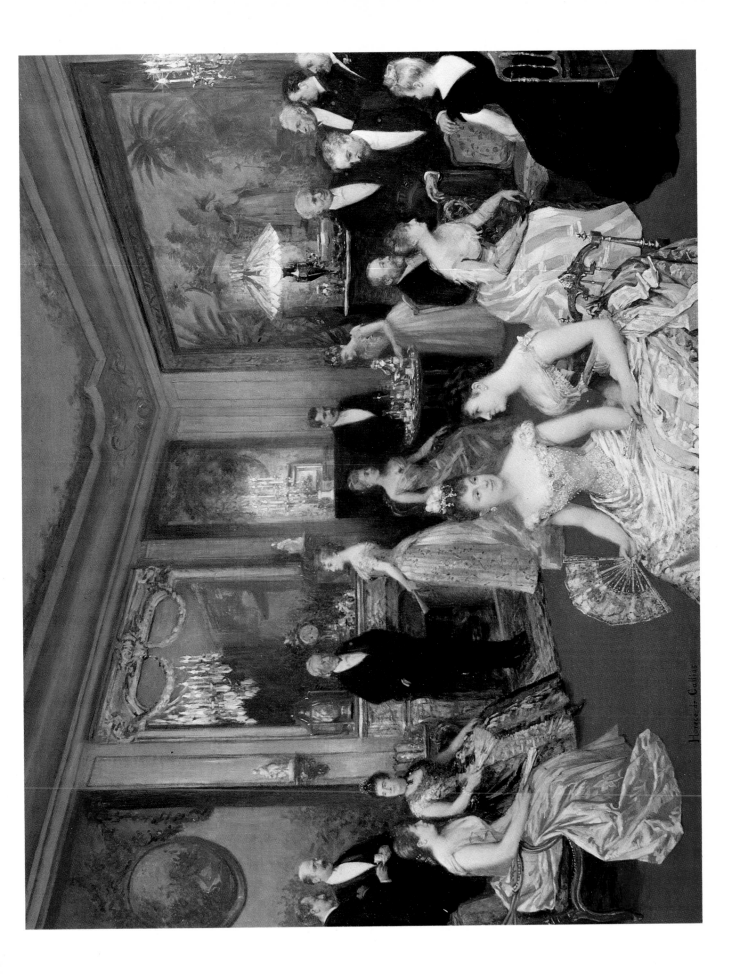

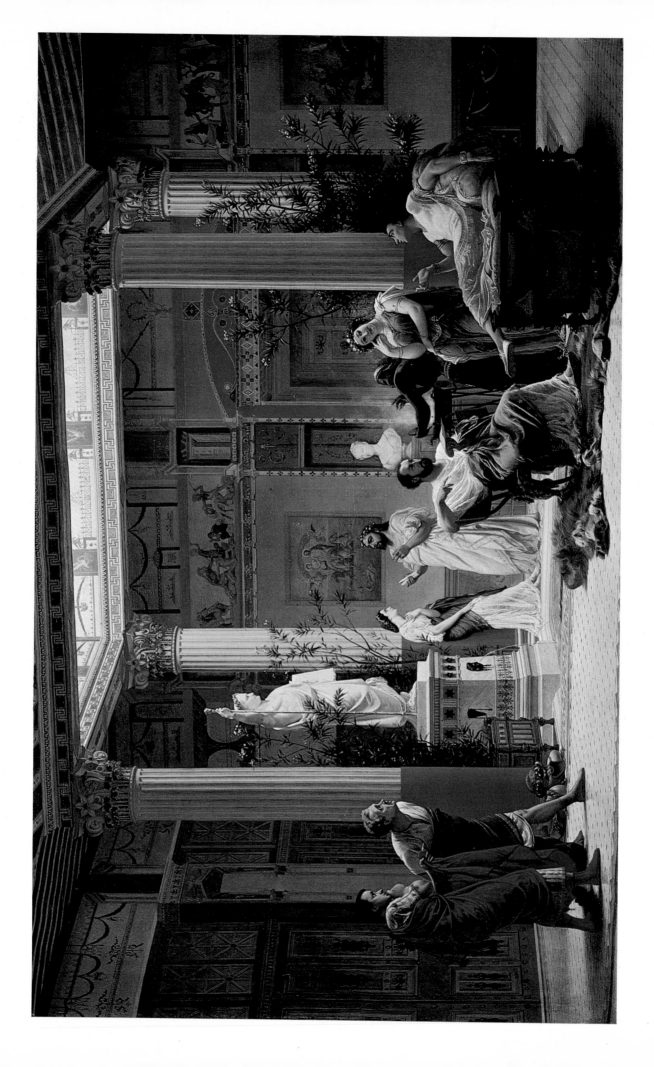

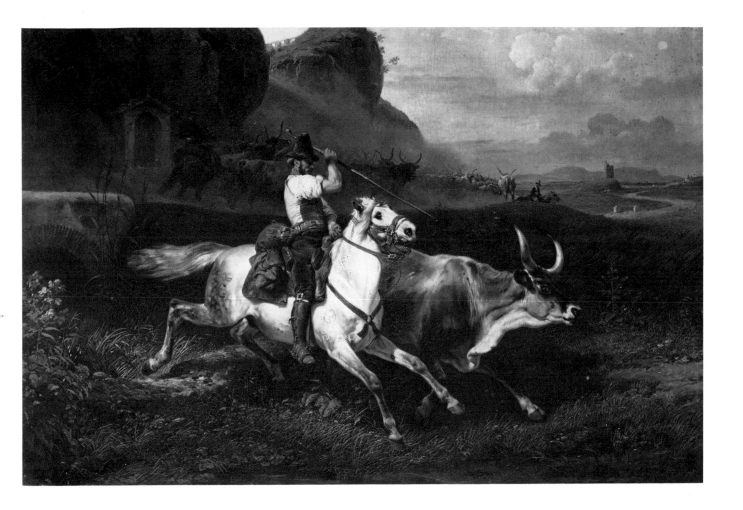

E. J. H. Vernet *Pâtre romain conduisant ses bestiaux*/A Roman Herdsman driving Cattle, 1829.
Oil on canvas 89 × 133 cm.

wonderful explicitness – as 'Church genre'. In these pictures the setting is thus free of the fripperies of modern taste in the same way as the clothes, with their traditional ornamentation, transcend fashion. Armand Gautier, François Bonvin and Alphonse Legros – to name only three – all used this framework for pictures which have an essentially Realist bias. Legros' *L'Ex-Voto*, exhibited at the 1861 Salon was, absurdly, seen as an imitation of Courbet and influenced in particular by *L'Enterrement à Ornans*, a work with which it has not the slightest spiritual connection since it lacks the powerful undertones which imbue Courbet's monumental picture with significance. Bonvin also used as a setting long-established institutions such as the orphanages run by the Sisters of Charity where the costumes, hallowed by age, do almost achieve the widely sought timeless quality. By extension mourning can be seen as traditional costume, at least to the extent that it eschews the extremes of fashionable exaggeration.

This search for the compromise solution should not be seen as a rather ignoble exercise in evasive action. The subtlety with which the oblique approach to Realism was presented can be more readily appreciated when the work by the great academic masters of the nineteenth century is set in its context – beside the more shallow bravura of the Belle Epoque artists who portrayed *la vie parisienne*, artists like Jean Beraud and Raffaëlli who have achieved precisely that reputation which was predicted for Toulmouche in that the primary interest of their pictures lies in the record they provide of the life of the period.

G.-C.-R. Boulanger *La Répétition du 'Joueur de flûte' et de 'La Femme de Diomède' dans l'atrium de la maison pompeienne du Prince Napoléon, avenue Montaigne en 1861*/The Rehearsal of 'The Flute Player' and 'The Wife of Diomedes' in the Atrium of the Pompeian House of prince Napoleon, avenue Montaigne, in 1861, 1861.
Oil on canvas 83 × 30 cm.

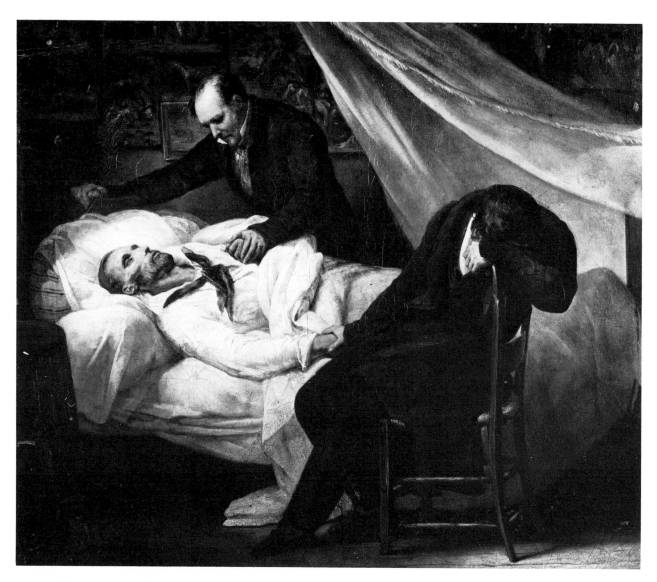

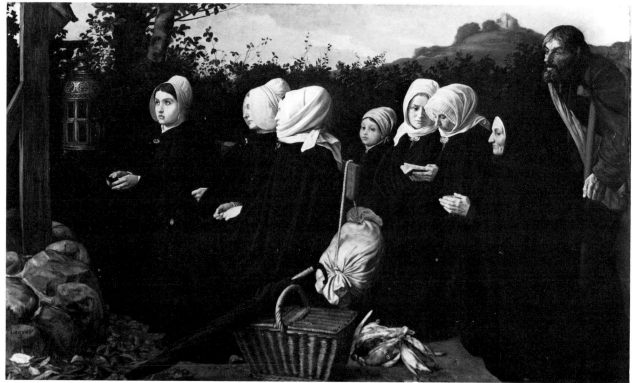

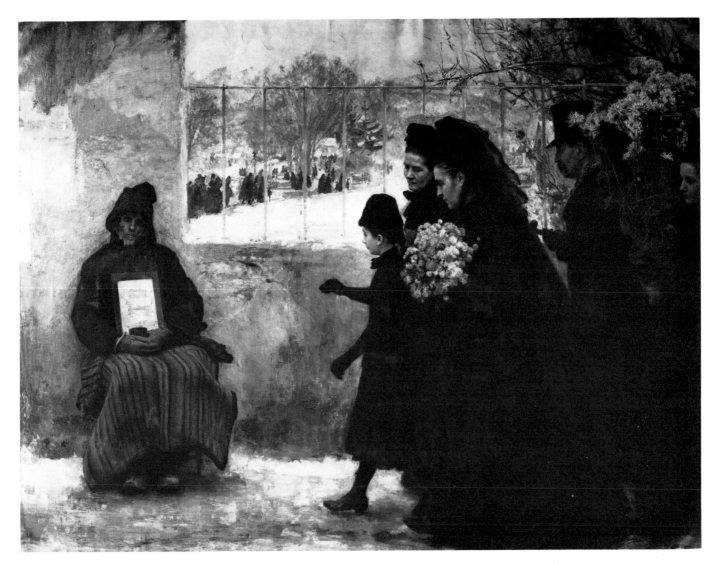

E. Friant *Le Toussaint*/All Saints' Day, 1888.
Oil on canvas 254 × 325 cm.

A. Scheffer *La Mort de Géricault*/The Death of
Géricault, 1824.
Oil on canvas 38 × 46 cm.

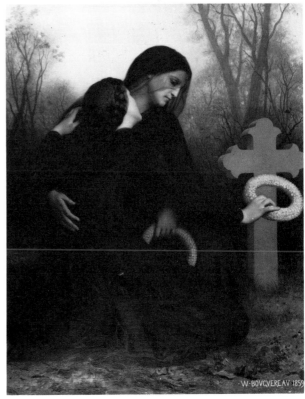

Opposite
A. Legros *Le Pèlerinage*/The Pilgrimage, 1871.
Oil on canvas 137.2 × 226 cm.

W.-A. Bouguereau *Le Jour des Morts*/The Day
of the Dead, 1859.
Oil on canvas 147 × 120 cm.

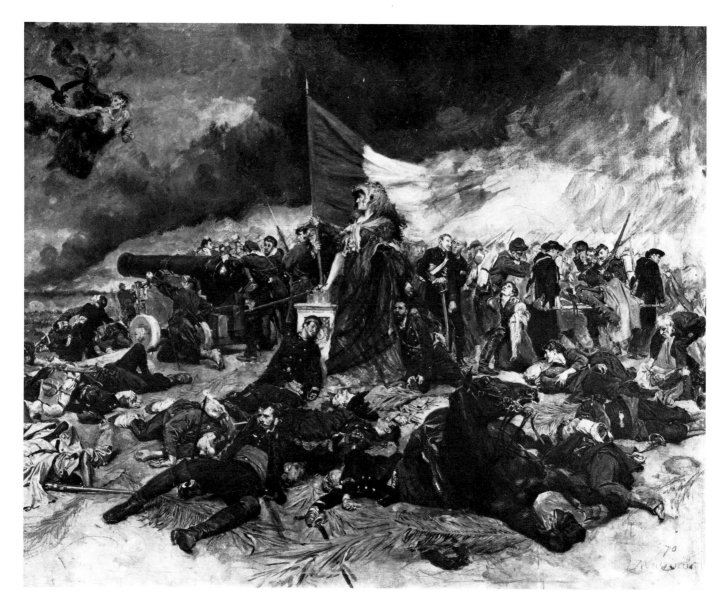

J.-L.-E. Meissonier *Le Siège de Paris*/The Siege
of Paris, 1870.
Oil on canvas 53 × 70 cm.

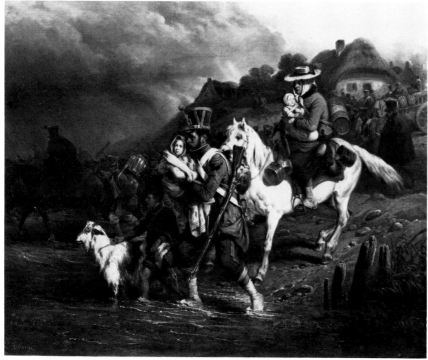

J.-L.-H. Bellangé *Traversant un cours
d'eau*/Crossing the Ford, c. 1837.
Oil on canvas 54 × 73 cm.

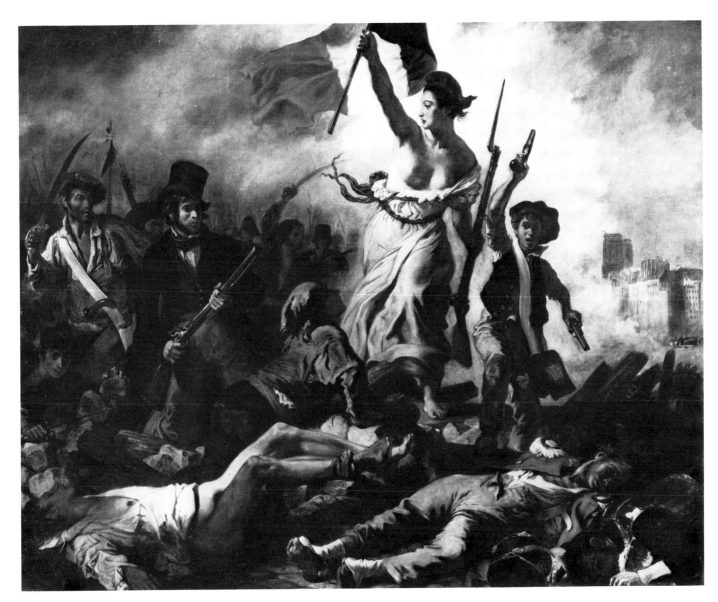

E. Delacroix *La Liberté guidant le peuple*/Liberty guiding the People, 1830.
Oil on canvas 260 × 325 cm.

L. J. B. Perault *Une veuve et son enfant*/Widowed and Fatherless, 1874. Oil on canvas 109.2 × 92.7 cm.

W. A. Bouguereau *La Couronne de Marguerites*/The Daisy Chain, 1874. Oil on canvas 87.6 × 55.8 cm.

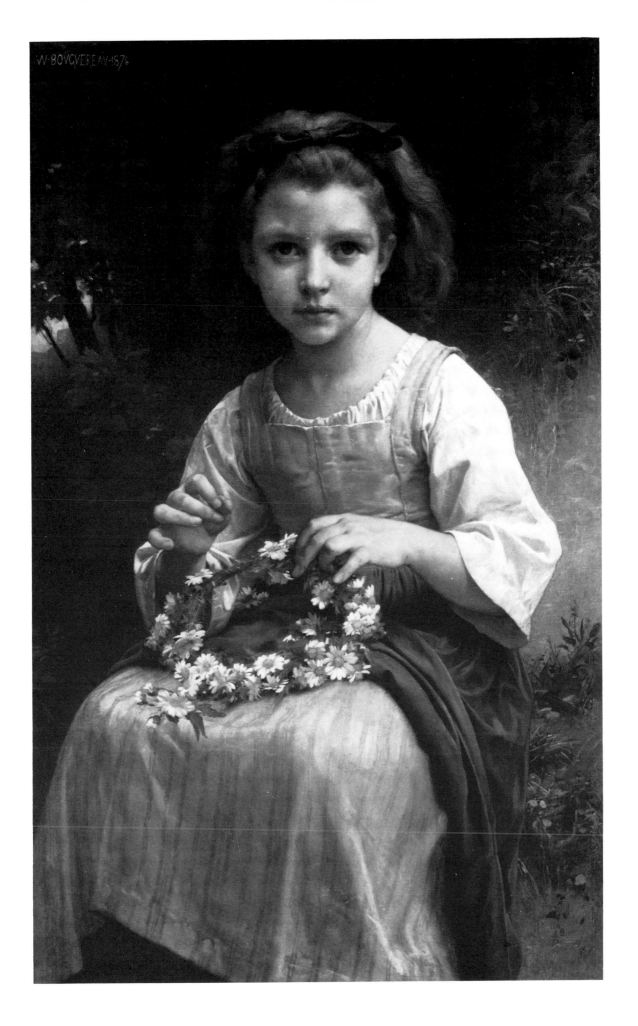

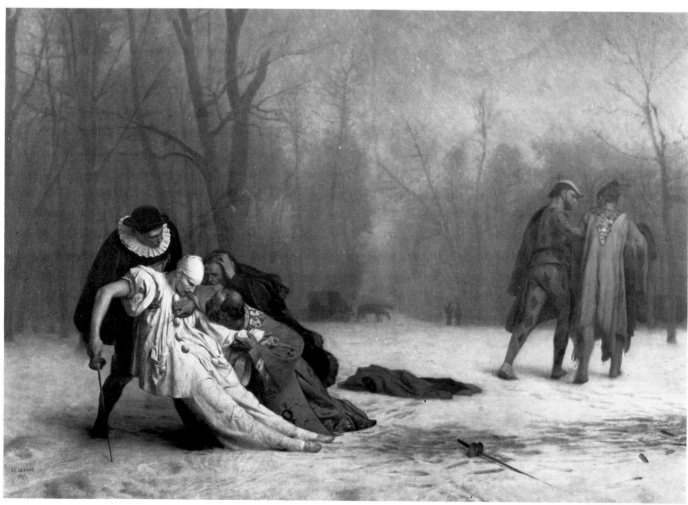

J.-L. Gérôme *Suite d'un bal masqué*/After the
Masked Ball, 1857.
Oil on canvas 50 × 72 cm.

Top: J.-V. Schnetz *Le Voeu à la Madone*/The Vow to
the Madonna, 1831.
Oil on canvas 282 × 490 cm.

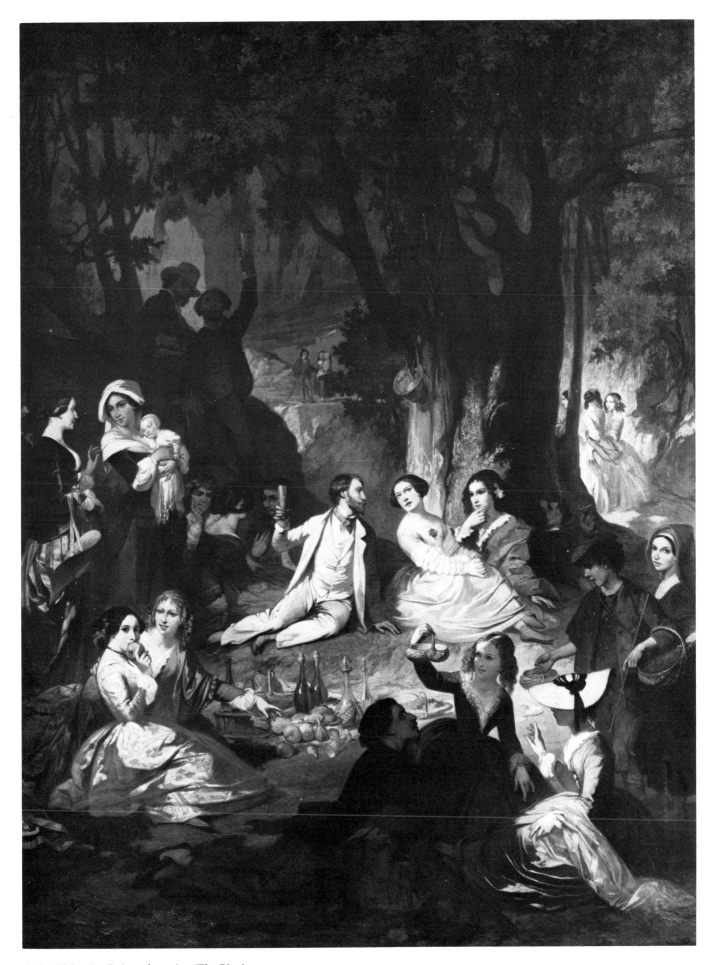

A.-B. Glaize *Le Goûter champêtre*/The Picnic,
1850–1.
Oil on canvas 145 × 114cm.

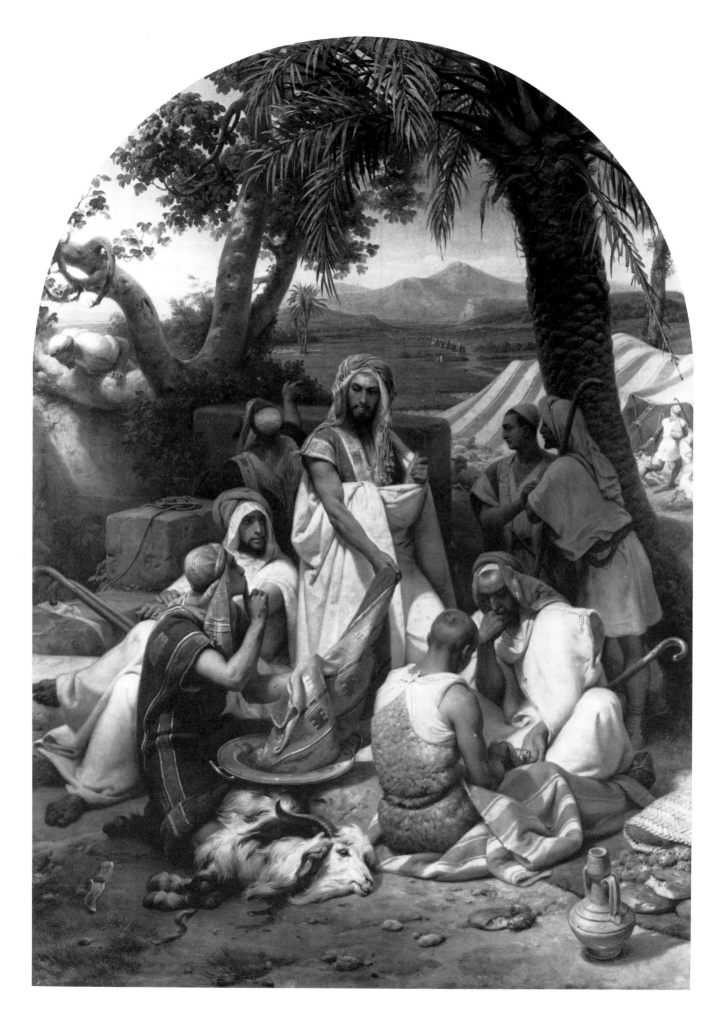

4. The Orientalists

In 1876 the critic Jules Castagnary, writing on the Salon exhibition of that year, said:

> Vous rappelez-vous comment la chose vint? C'est l'insurrection de la Grèce et la mort de Lord Byron qui furent le point de départ. Il y eut alors en France une émotion comme on n'en pas vu depuis, même quand des interêts nationaux semblaient la commander. Tous les regards, tous les coeurs se tournèrent vers le Bosphore. Dans les conversations, il ne fut plus question que de Missolonghi, de Scio, de Stamboul et du Grand Canaris. La jeunesse fut entraînée. Tout le monde se mit à faire de l'Orient d'intention, sans avoir vu, sans le connaître. Delacroix, dans son atelier de la rue de Grenelle – Saint-Germain, peignit l'épisode enflammé du massacre de Scio (1824); Victor Hugo, en se promenant dans la pépinière du Luxembourg, rima les Orientales (1827). Enfin, le canon de Navarin retentit. L'Orient était ouvert à nos paysagistes. Decamps et Marilhat s'y precipitèrent.
>
> (Do you remember how it began? The War of Greek Independence and the death of Lord Byron provoked in France an emotion which had never been seen before, even when the interests of France herself had been involved. All eyes, all hearts turned towards the Bosphorus. In conversation, nothing was talked of except Missolonghi, Chios, Istanbul and Canari [on Corsica]. Young people were swept off their feet. Everyone began to paint the Orient of the imagination, without having seen it or known it. Delacroix in his studio painted the episode of the massacre of Chios (1824); Victor Hugo, pacing the nursery gardens of the Luxembourg, composed his Orientales (1827). Finally came the crash of the canon at Navarino. The Orient was opened to our landscape painters. Decamps and Marilhat hurried there immediately).

In the eighteenth century Orientalism was nearly exclusively the domain of the decorator, although European painters since the time of Gentile Bellini and Carpaccio have been fascinated by the East. Thus the Orientalists of the nineteenth century had a long tradition of *turqueries* and eastern fantasies to draw on when their attention was first fixed on the Greek struggle for independence. French interest in the East had already been stimulated by Napolean's Egyptian campaign, and the episodes painted by Girodet and Baron Gros can be seen as the earliest examples of the nineteenth-century Orientalist pictures. However, the *Bataille d'Aboukir* and *Bonaparte visitant les pestiférés de Jaffa*, both by Gros, and the *La Révolte du Caire* by Girodet, like *Le Bain turc* by Ingres, *Massacre de Scio* and *Mort de Sardanapale* by Delacroix, were all concocted in the studio from costumes and accessories collected by travellers without any of the artists having seen the East themselves. In these pictures the two conflicting paths of nineteenth-century artistic

E. J. H. Vernet *Les Vêtements de Joseph*/Joseph's Coat, 1853. Oil on canvas (arched top) 140 × 104 cm.

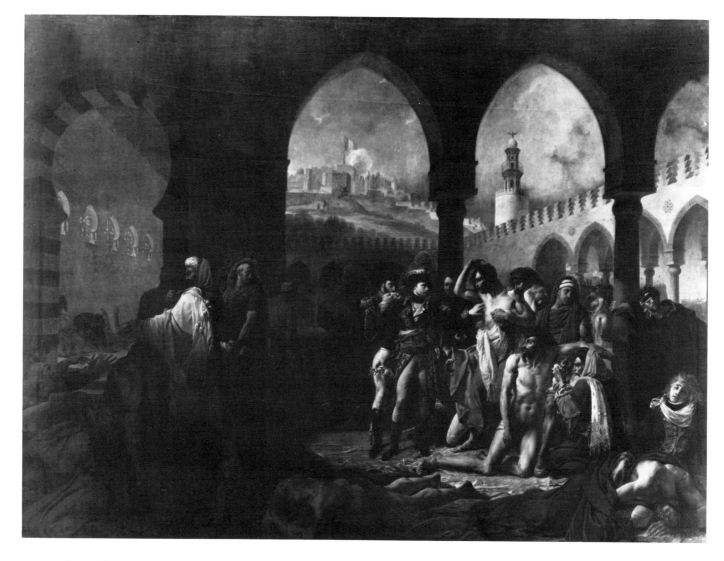

expression still dominate the anecdotal Orientalism which is so apparent in the work of those artists who travelled in Africa and Asia. In *La Révolte du Caire* the Neo-Classical compositional formulae are still carefully observed. The picture is conceived in terms of a shallow bas-relief, like a Roman sarcophagus, but it is combined with a romantic intensity of colour and expression.

The same adherence to accepted canons of taste in composition and pictorial organisation can be seen in the pictures which Delacroix painted before going to Algeria, and in the group portrait of *Ali Ben Hamet* painted by Chassériau in 1845, just before the artist went to Algeria himself. The impact of reality in the case of these eastern travellers was enormous. Echoes of the romanticism discovered in these crucial visits can be found throughout the remainder of their careers, in spite of the fact that Delacroix, at least, was profoundly struck by the many parallels between life in Tangier and classical Rome. He wrote, shortly after arriving in Tangier, that one could see Catos and Brutuses lying in the sun or walking in the streets and that even the air of hauteur that the masters of the world must have had was not lacking in them. These men had only one garment in which they walked, slept, and were buried, yet they seemed as contented as Cicero must have been with his chair of office. Delacroix concluded that antiquity had nothing finer to show.

From the time of Napoleon's Egyptian campaign (resulting in the monumental *Description de l'Egypte*, which appeared in twenty volumes at intervals between 1809 and 1828) until the opening of the Suez Canal

A.-J. Gros *Bonaparte visitant les pestiférés de Jaffa*/Bonaparte visiting the Plague Victims of Jaffa, 1804.
Oil on canvas 532 × 720 cm.

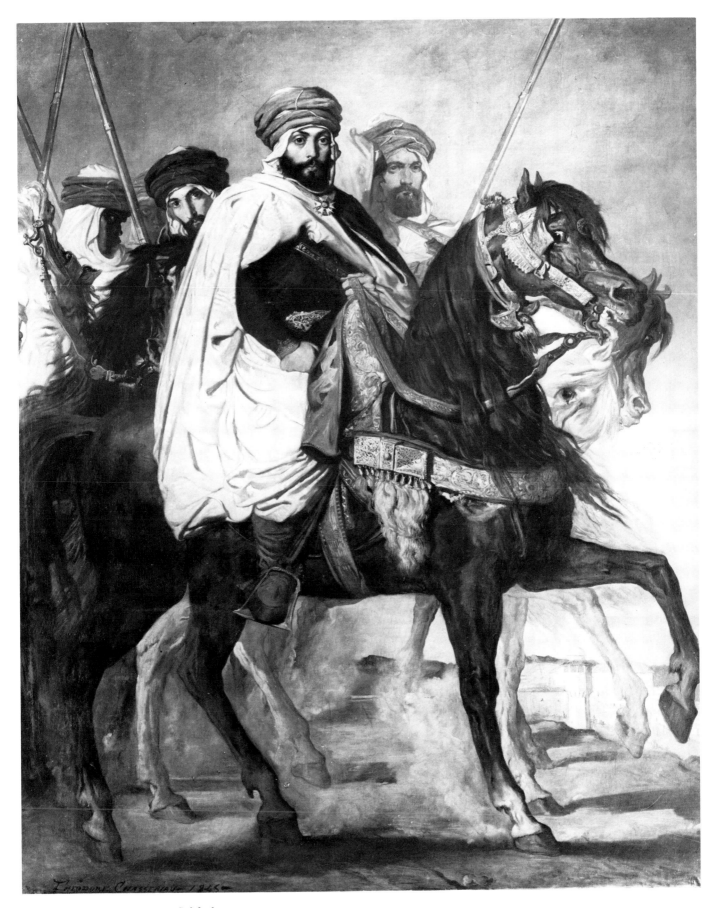

T. Chassériau *Ali Ben-Hamet, Calife de
Constantine*/Ali Ben-Hamet, Caliph of
Constantine, 1845.
Oil on canvas 325 × 260 cm.

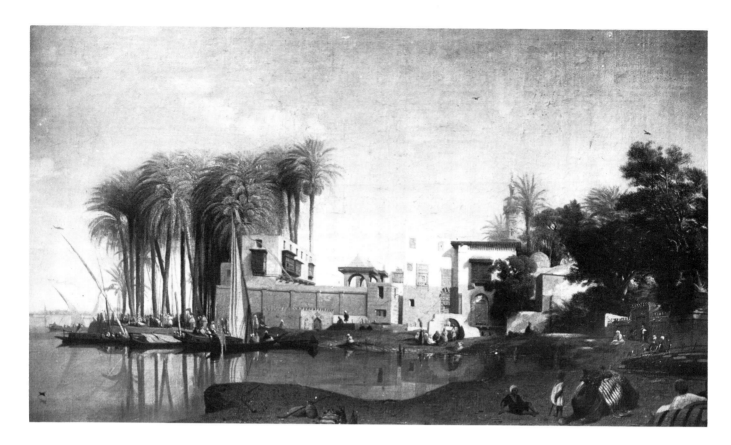

in 1869, the East had the great attraction of topicality for French artists. Following closely on the Greek struggle for independence from Turkish rule, the French engaged in the campaign in Algeria, and from 1830 public interest in scenes with an Algerian background was strong. From this date innumerable artists made what had now become an almost obligatory visit to Algeria and the Salons were swamped with the results of these voyages of discovery. The opening of the Suez canal greatly facilitated travel in the East and Orientalist painting after 1869 is less anecdotal and informative as the public became accustomed to the idea of these hitherto mysterious lands now being easily accessible. Later Orientalist pictures are more imbued with mysticism and metaphysical reflections as the informative traveller was gradually swallowed up by the Symbolist.

Nineteenth-century Orientalism was restricted geographically. Little of China was accessible to European travellers and the opening of Japan to Western traders in 1856 produced a form of *japonisme* in European painting which has no connection with academic Orientalism. For the Salon Orientalist the East began in Spain with its memories of Moorish occupation and also in Greece where lingering traces of Turkish domination remained for many years after independence was won in 1824. The Holy Land became the source of valuable authentic background material for Biblical subjects. Both Horace Vernet and Tissot travelled in the East with the avowed intention of finding useful picture props in the form of figures, costumes and other accessories with which to make biblical subjects more immediate. Orientalism gained such a hold on the contemporary artistic imagination that a number of artists who had never visited the East created their own evocations of these romantic lands from their imagination, to satisfy an apparently insatiable demand for the genre.

There is no mystery about the attraction of the East for the nineteenth century art-loving public. These pictures offered, in a setting of opulent exoticism, a combination of savagery and sensuality. Their exotic overtones, closely parallel to the scenes from classical history, proved

P.-G.-A. Marilhat *Scène sur le Nil*/A Scene on the Nile, n.d.
Oil on canvas 45 × 74 cm.

M.-C.-G. Gleyre *Paysage de Basse-
Egypte*/Landscape in Lower Egypt, n.d.
Oil on paper 37.5 × 30.5 cm.

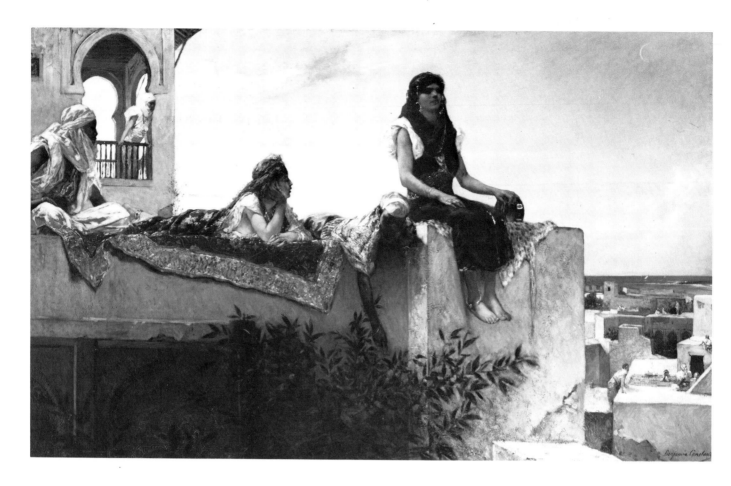

J.-J.-B. Constant *Une terrasse au Maroc, le soir*/A Morocco Terrace, Evening, 1879. Oil on canvas 123.1 × 198.5 cm.

irresistible. The glowing colours of the landscape, the resplendent finery of the figures and the lavishly decorated settings of the interiors offered a temporary escape from the grey, misty, Northern European landscape with its encroaching industrial development.

It is no coincidence that newly rich manufacturers and prosperous hard-working merchants were among the most enthusiastic patrons of the Orientalists since these pictures offered a picture of life as far removed from their round of toil and convention-bound society as it is possible to imagine. The popularity of Eastern subjects with the public lasted until after the turn of the century. Over sixty years of activity culminated in the formation, in 1893, of the Societé des Peintres Orientalistes with Gérôme as honorary president. Over twenty years earlier, in 1872, Jules Castagnary had written: 'Il est visible que l'Orientalisme est mort'. By then the high standards of inspiration which had imbued the early work of Decamps or Marilhat had declined to a point where the movement was, indeed, all but dead. However, some work of considerable force and power continued to be produced, notably by such artists as J.-J.-A. Lecomte du Noüy, Ludwig Deutsch (an Austrian by birth who became a naturalised Frenchman), Edouard Debat-Ponsan and Georges Rochegrosse.

Castagnary pin-points the first phase of nineteenth-century Orientalism at the dates when Decamps and Marilhat first travelled in the East, or rather, when the first fruits of these travels were shown at the Salons. Although the *Massacre à Scio* had astounded the public in 1824, the fact that its authentic eastern appearance was concocted from costumes and accessories borrowed from Delacroix's friend Monsieur Auguste makes it into a history painting first and an Orientalist subject second. The immediacy conveyed by Decamps' pictures, which were painted from material gathered *sur motif*, brought the East to life for the public. Gautier said of Decamps' Orientalist works:

J.-L. Gérôme *Le Défilé*/The Procession, n.d. Oil on canvas 53.3 × 76.2 cm.

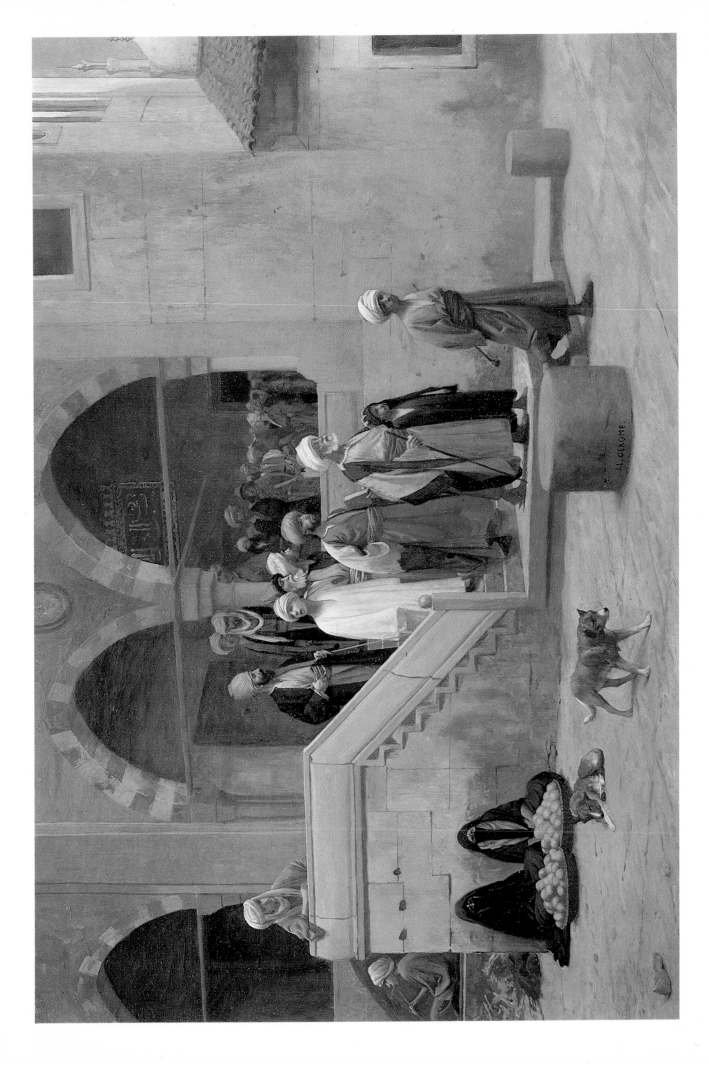

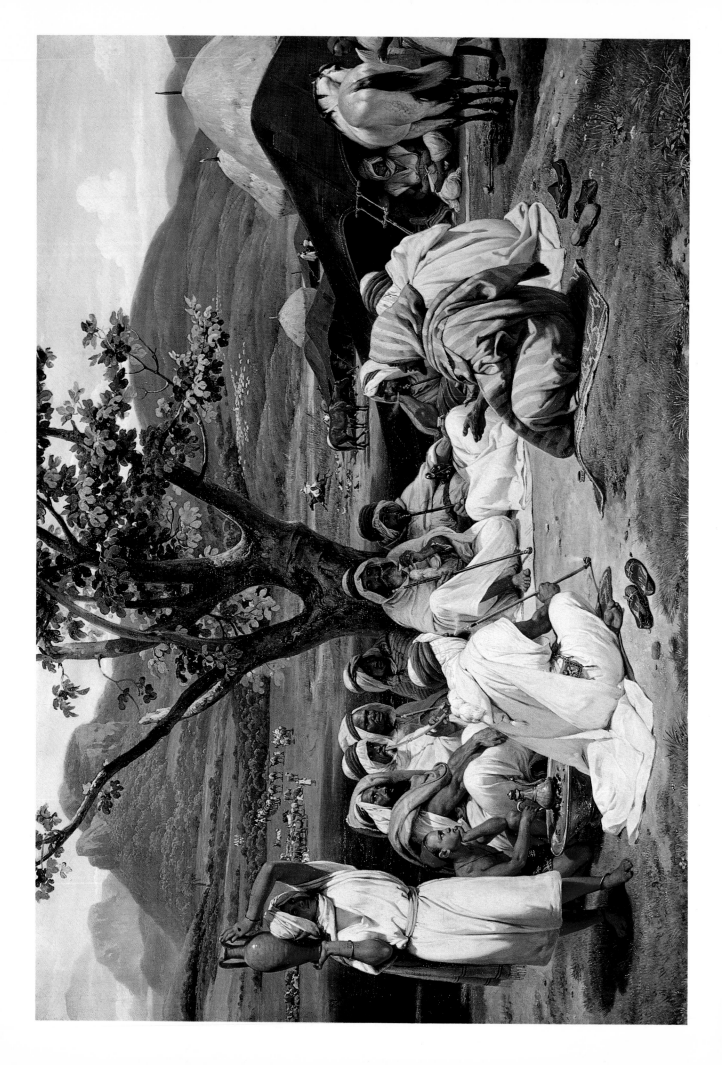

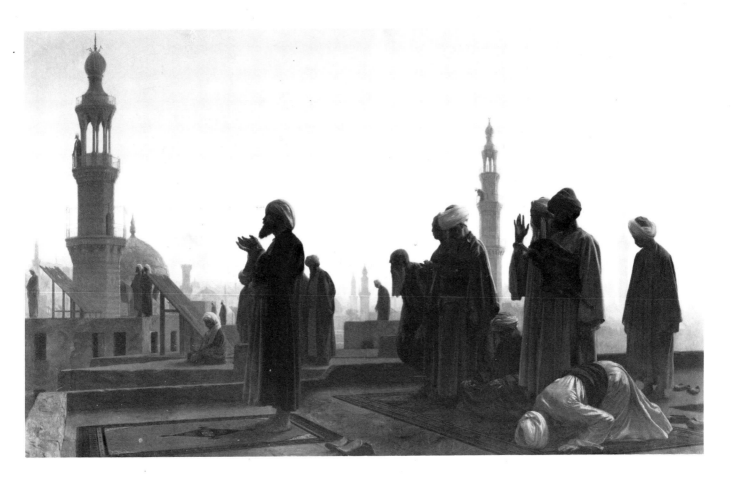

J.-L. Gérôme *Musulmans à la prière à Caire*/Mohammedans at Prayer in Cairo, 1865. Oil on panel 49.9 × 81.2 cm.

Ce n'est pas de couleur, c'est de la lumière. Nous pensions que le soleil donnait dessus; il n'y avait de soleil que sur la toile; le temps était couvert et les nuages ′egouttaient la pluie; c'était un rayon fixé par un procédé inconnu aux autres peintres.

(It is not colour, it is pure light. We thought the sun was shining on it, but the sun was contained in the canvas. Outside it was a cloudy day, drizzling with rain. Decamps had captured a ray of sunshine by some means unknown to other painters).

Gautier thereby implied that the pictures were painted not with colours in the convential manner, but with light.

With the start of the campaign in Algiers a number of official artists were appointed to record the principal episodes of the war, among them the marine painter Théodore Jean Gudin, and, in 1833, the celebrated history-painter Horace Vernet. Vernet became fascinated by the East and travelled to Egypt, Syria and Turkey in 1839, gathering authentic material for Biblical scenes and anticipating the advice of Thoré-Burger who wrote in 1864:

Au lieu d'inventer à froid dans un atelier de Paris la scène de Rachel à la fontaine ou de la Samaritaine causant avec Jésus, allez peintre la loin dans le désert quelque fontaine au milieu d'une oasis avec les filles arabes qui viennent y puisser l'eau.

(Instead of inventing from scratch in a Parisian studio a scene with Rachel at the fountain or the good Samaritan chatting with Jesus, go and paint out there in the desert some fountain in the middle of an oasis with Arab girls coming to draw water).

Meanwhile, in 1831, Prosper Marilhat departed for the East attached as a draughtsman to a scientific expedition led by Baron von Hugel. The cool refinement of his picture, executed in a manner reminiscent of Corot, was a contrast to the heavy impasto and dramatic chiaroscuro of

E. J. H. Vernet *L'Arabe, diseur de contes*/The Arab Tale-teller, 1833. Oil on canvas 100 × 138 cm.

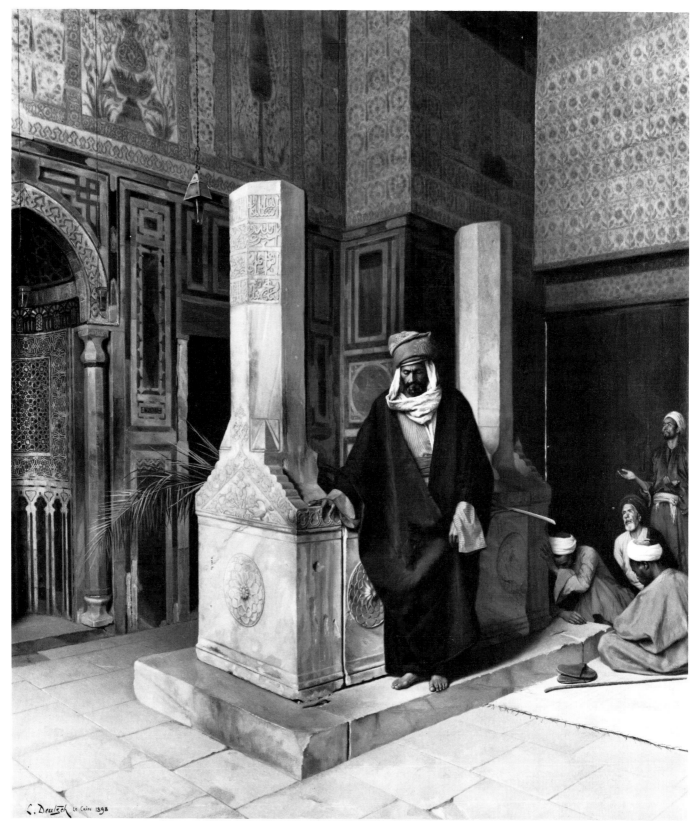

L. Deutsch *La Prière au tombeau*/The Prayer at the Tomb, 1898.
Oil on panel 68.5 × 59.5 cm.

L. Deutsch *Devant un café mauresque*/Outside a Moorish Coffee Shop, 1903.
Oil on panel 58.4 × 19 cm.

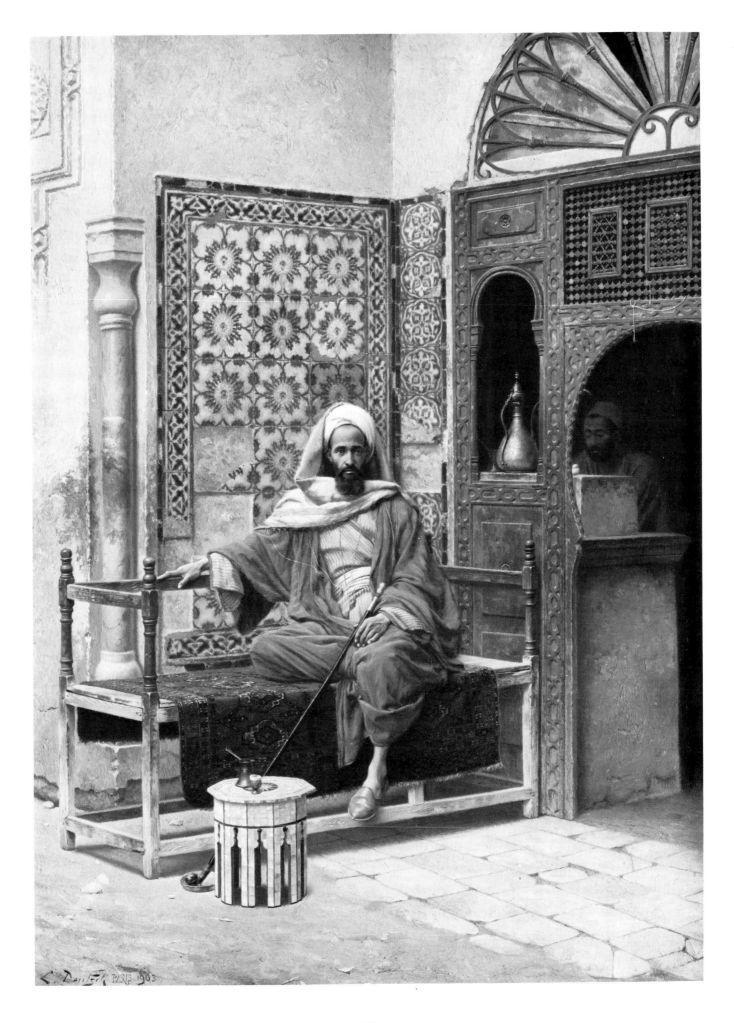

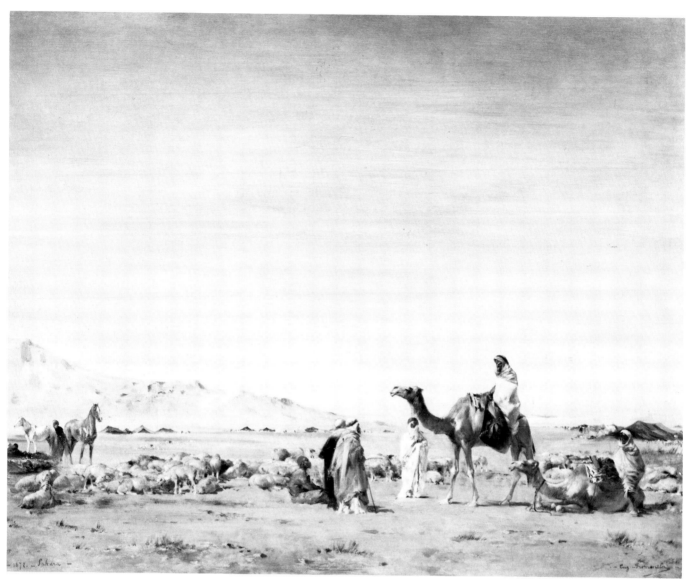

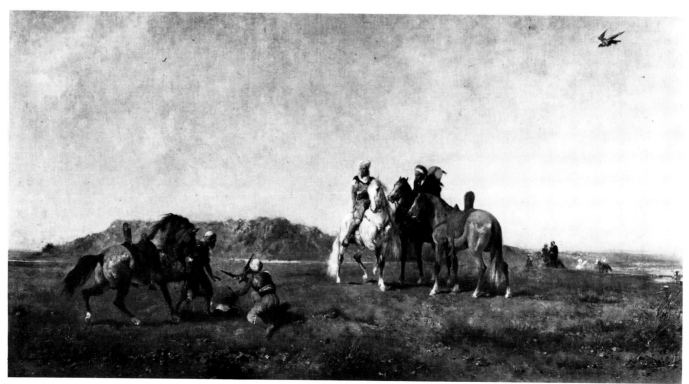

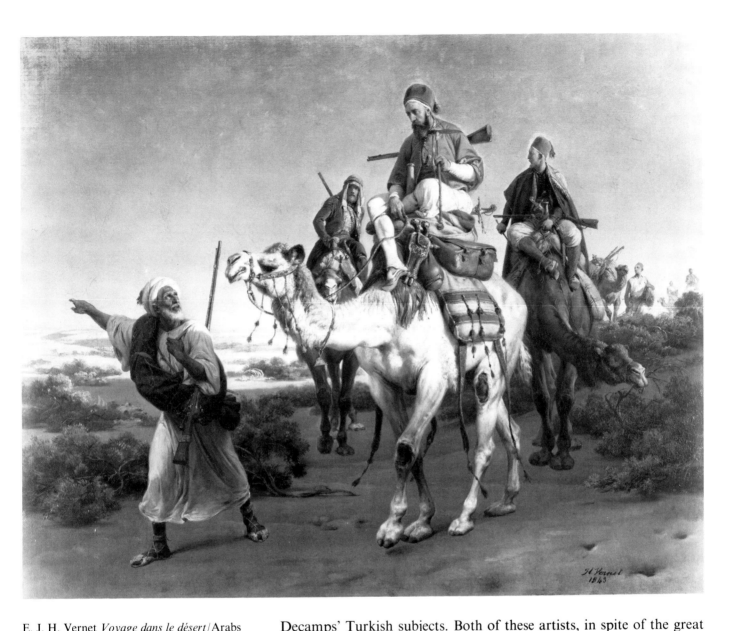

E. J. H. Vernet *Voyage dans le désert*/Arabs
Travelling in the Desert, 1843.
Oil on canvas 46 × 58 cm.

Opposite
E. Fromentin *Un campement dans le
Sahara*/Encampment in the Sahara, 1877.
Oil on board 47 × 57.8 cm.

E. Fromentin *La Chasse au faucon en
Algérie*/Hunting with Falcons in Algeria, 1863.
Oil on canvas 74 × 95 cm.

Decamps' Turkish subjects. Both of these artists, in spite of the great
differences in their vision of the East, were to be enormously admired.
Decamps seemed to depict an '*Orient d'intention*'. Gautier had rec-
ognised this quality in Decamps' work and had written of the *Souvenir
de la Turquie d'Asie* (Salon of 1831) that it had: 'une si grand force
d'illusion que la réalité serait peut-être inférieure' (such is the power of
this vision that reality may perhaps seem inferior). Marilhat, on the
other hand, was admired for the clarity and accuracy of his vision.

In 1832, early in the year, Delacroix visited Morocco in the suite of the
comte de Mornay, who had been designated special ambassador of
Louis-Philippe to the Sultan. For Delacroix this must have been the
realisation of a dream – to see in reality the mysterious Eastern world of
which he had already received hints from readings of Byron and from
the curious exotic plunder which filled Monsieur Auguste's studio. The
record of this epoch-making journey exists in Delacroix's letters and in
his sketch-books, full of impressions of the people and their life, which
crowded in on him from every side. The recruitment, so to speak, of this
major artist to the Orientalist camp gave the movement a validity and
vigour which the most accomplished work of the *petits maîtres* could
never have achieved.

French Orientalism unquestionably benefited very greatly from the
high artistic stature of these first discoverers of the East. However, by the
second half of the nineteenth century every Salon exhibition was sated

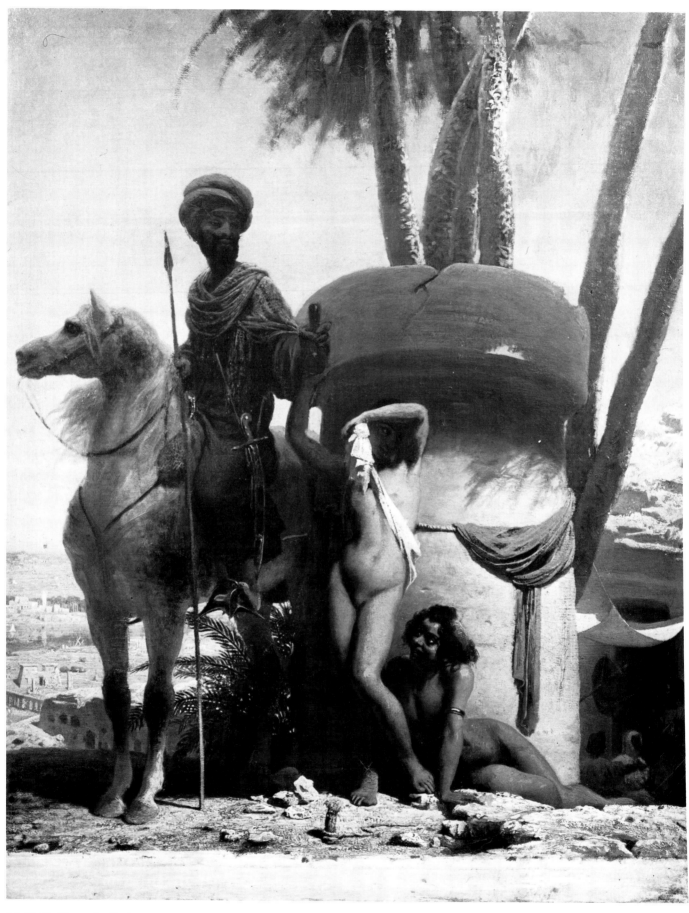

M.-C.-G. Gleyre *La Pudeur
égyptienne*/Egyptian Modesty, 1838–9.
Oil on canvas 77.5 × 63.5 cm.

J.-L. Gérôme *Un marché d'esclaves*/The Slave
Market, n.d.
Oil on canvas 84.3 × 63 cm.

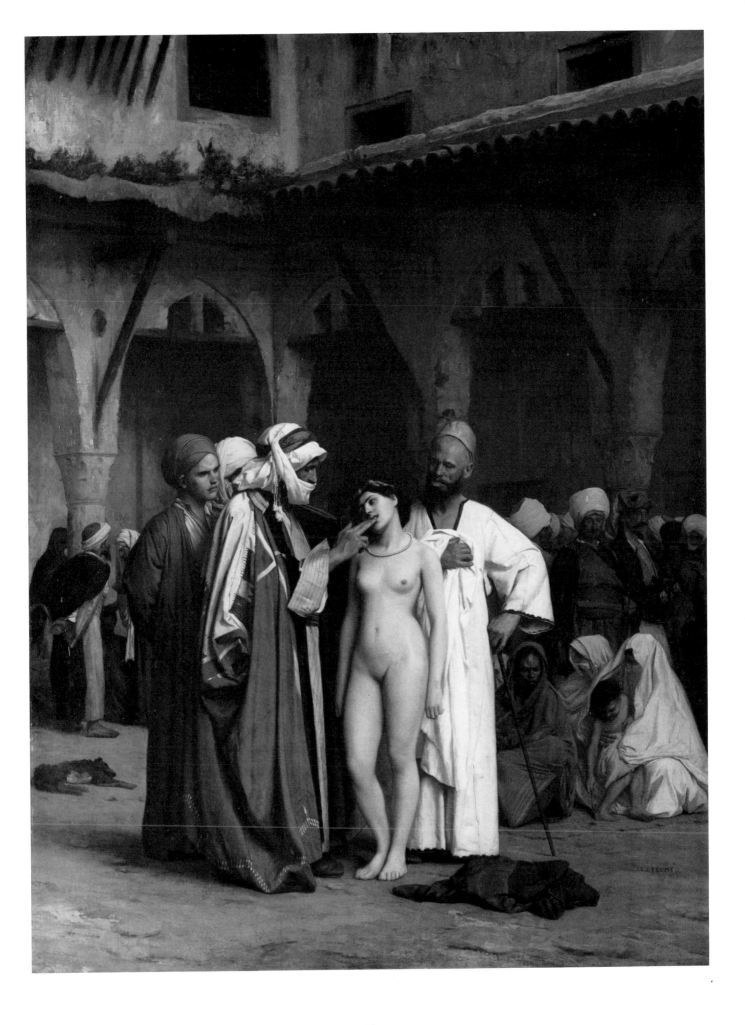

with a glut of Eastern subjects. It was said that the journey to Algiers had superseded the once obligatory artistic pilgrimage to Rome, and contemporary critics saw the movement as a slow but inevitable decline from the heights of achievement which marked the early 1830s and 1840s. Eugène Fromentin and Chassériau carried on the tradition of romantic Orientalism in the manner of Delacroix during the 1840s and 1850s. The next decade saw the development of a highly naturalistic 'photo-realist' style of painting which can be seen at its most accomplished and highly wrought in the work of J. L. Gérôme and his associates and pupils.

Gérôme went to Greece and Turkey in 1854, but his real interest in the East seems to have been stimulated by the eight months which he spent in Egypt in 1856. Many visits were to follow this first one, and a description of one of these was published anonymously by his pupil Paul Lenoir in 1872. The fruits of these trips can be seen in the large body of work with Eastern settings produced by Gérôme during his career, including even Napoleonic subjects with a background of the 1798 campaign in Egypt. Léon Belly, who had already travelled in Egypt in 1850, returned there with Gérôme in 1856. He painted a monumental picture of the departure of a pilgrimage to Mecca which caused a considerable sensation when it was shown at the Salon. In its fanatical attention to realistic detail it serves as an illustration to Robert Burton's memorable description of a similar scene which he himself had seen on his epic journey to Mecca and Medina:— 'The huge and doubtful forms of the sponge-footed camels with silent tread, looking like phantoms in the midnight air, the quarrels among the exhausted pilgrims, the Meccans badgering for lodgers, the fierce desert wind which moaned and

L. Deutsche *Devant le palais*/ In front of the Palace, n.d.
Oil on panel 69.8 × 96.5 cm.

Opposite
R. Ernst *Après la prière*/ After Prayer, n.d.
Oil on panel 90.1 × 71.1 cm.

Page 86
J.-L. Gérôme *Le Prisonnier*/The Prisoner, 1861.
Oil on panel 45 × 78 cm.

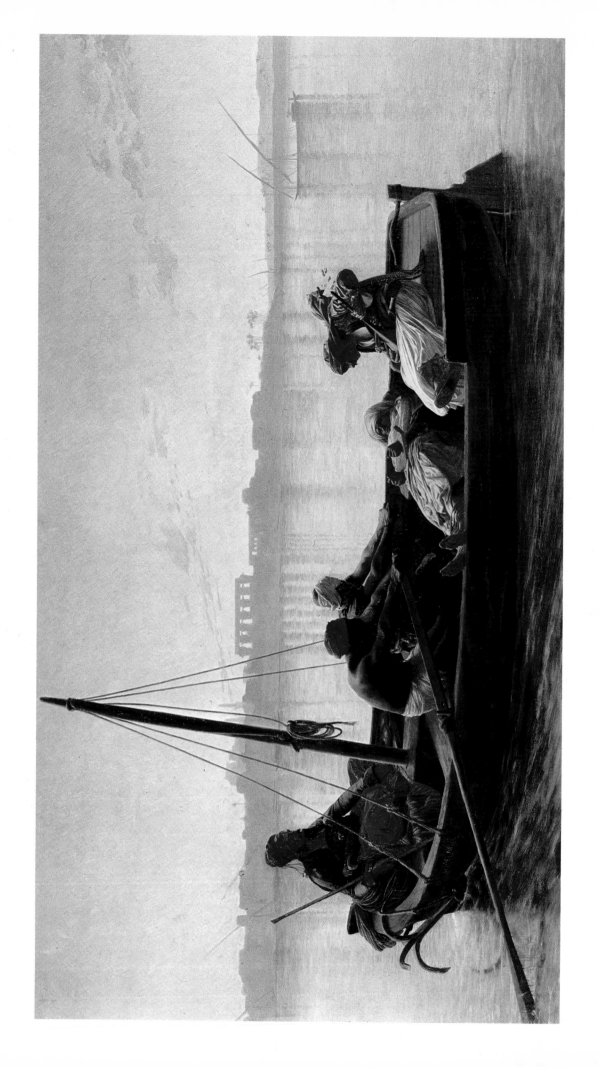

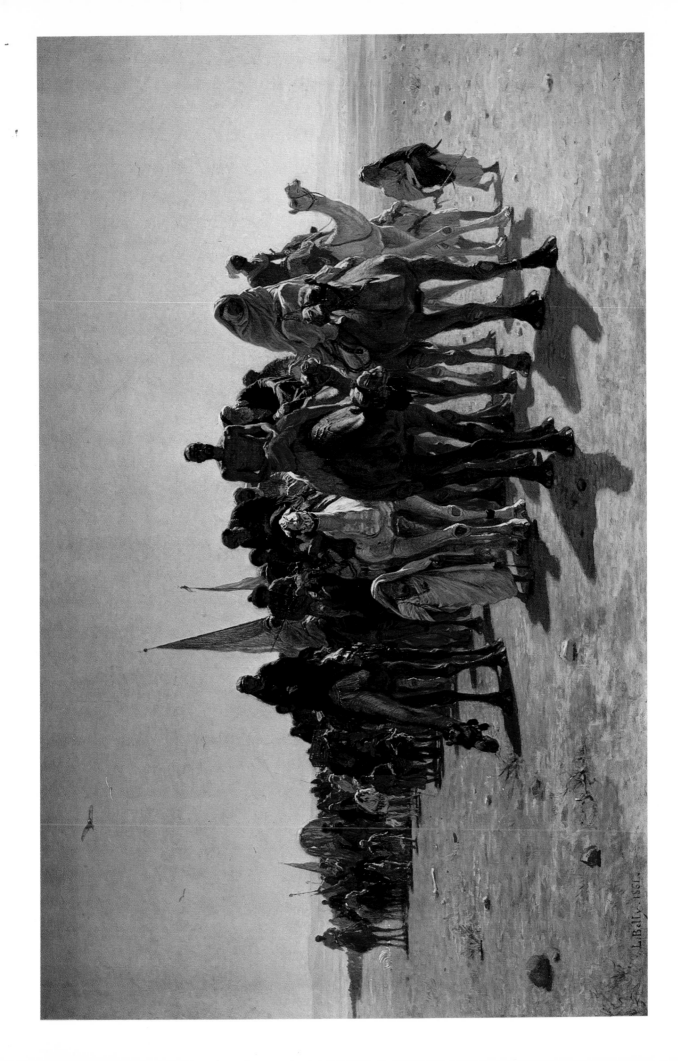

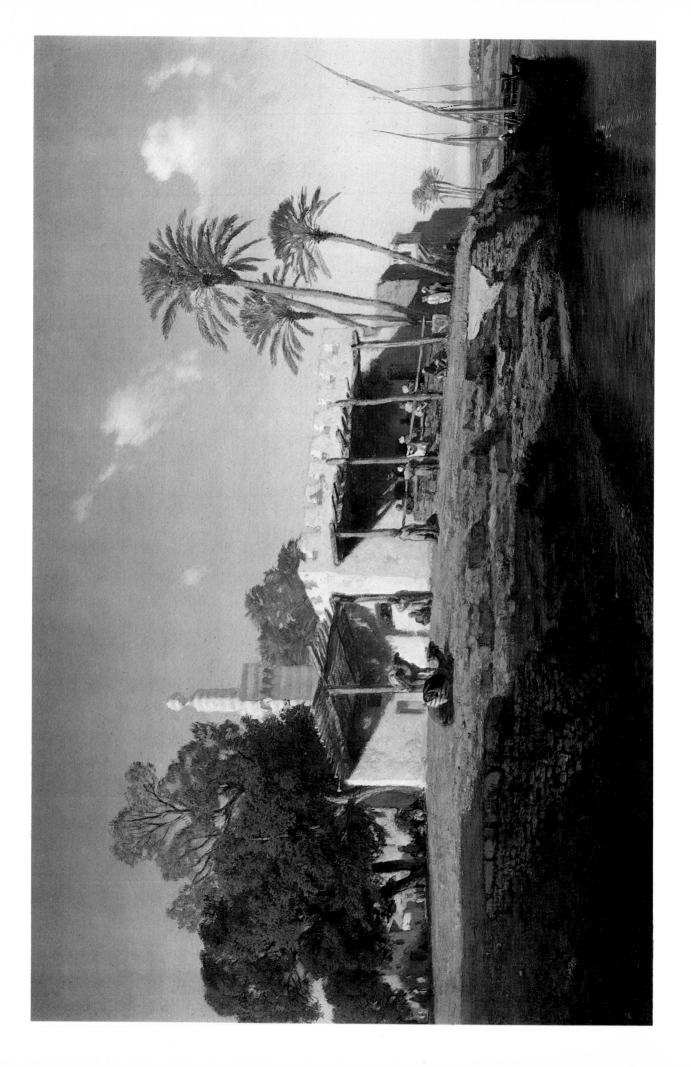

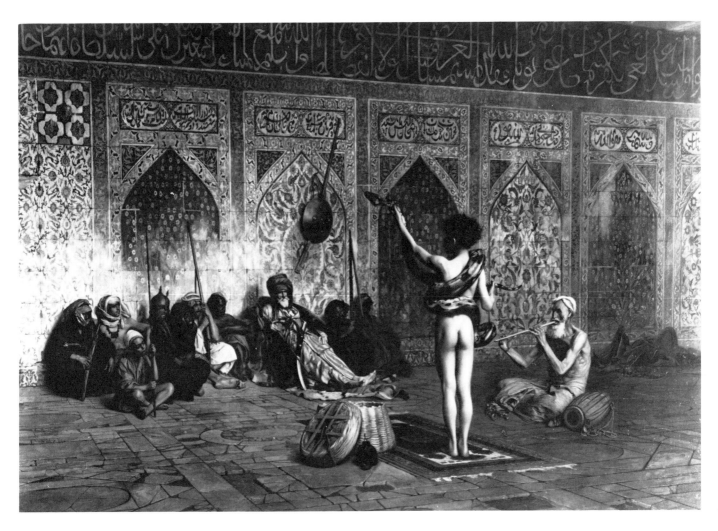

J.-L. Gérôme *Le Charmeur de serpents*/The
Snake Charmer, n.d.
Oil on canvas 83.8 × 122.1 cm.

whirled from the torches sheets of flame and fiery smoke.'

Even if the critics were tired of this realist Orientalism by the end of the
1860s their adverse comments did not significantly diminish the flow of
Orientalist pictures for at least two more decades. The critics of the time
were, of course, in no position to judge the value of such an accurate and
extensive record of a land which was to have every tradition and ancient
custom devastated within a century in the name of progress. The
explosion of interest in the works of these artists which has manifested
itself in recent years is archaeological in origin – just as the original
impetus for the movement came from the archaeological studies of
Napoleon's scientists.

Page 87
L.-A.-A. Belly *Pèlerins allant à la
Mecque*/Pilgrims going to Mecca, 1861.
Oil on canvas 161 × 242 cm.

Opposite
P.-G.-A. Marilhat *Benisoef sur le Nil*/Benisoef
on the Nile, n.d.
Oil on panel 31 × 45 cm.

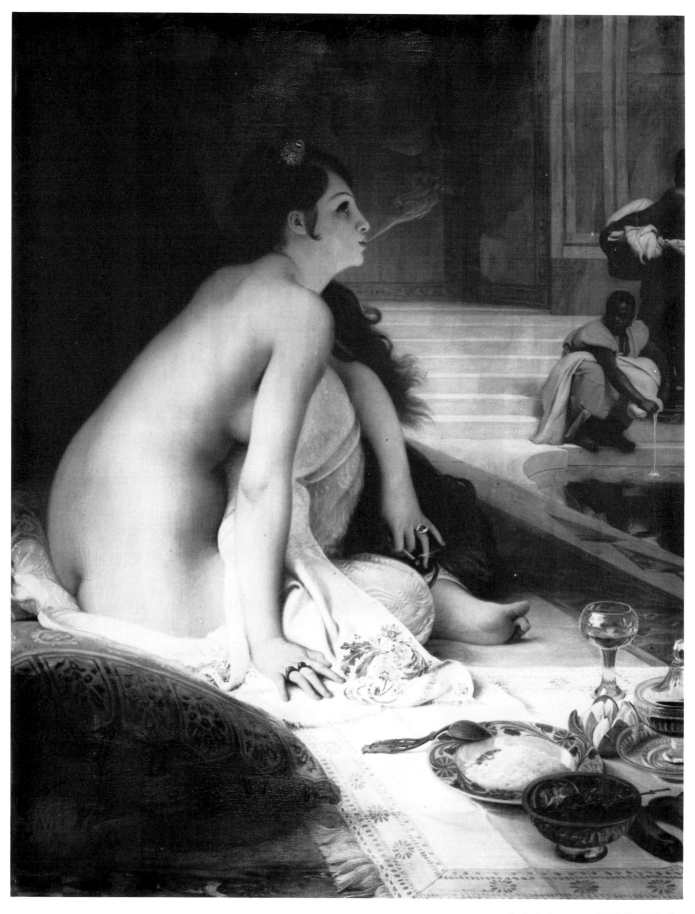

J. J. A. Lecomte de Noüy *L'Esclave blanche*/The White Slave, 1888. Oil on canvas 146 × 118 cm.

Prix de Rome

1793		The Louvre opened to the public as a museum and art gallery containing the old Royal collections.
1798		Beginning of Napoleon's campaign in Egypt. Admission to the Salon determined by a fifteen-member jury.
1801	*Ambassadeurs envoyés par Agamemnon à Achille, pour le prier de combattre.* 1st prize: J. A. D. Ingres 2nd prize: Jules-Antoine Vauthier	French defeated at the battle of Canope and the army withdrawn from Egypt.
1802	*Sabinus et Eponine devant Vespasien.* 1st prize: Alexandre Menjaud 2nd prize: G. D. J. Descamps	Publications: *Génie du Christianisme* by Chateaubriand; *Voyage dans la Basse et Haute Egypte* by Baron Vivant-Denon.
1803	*Enée portant son père Anchise.* 1st prize: Méry-Joseph Blondel 2nd prize: Georges Rouget	The voyage to Rome for the winner of the Prix de Rome suspended in this year. The winner received 1,000 francs in compensation.
1804	*Mort de Phocion.* 1st prize: Joseph-Denis Odevaere 2nd prize: C. A. Chasselat	Napoleon crowned as Emperor of the French. Baron Gros painted *Les Pestiférés de Jaffa.*
1805	*Mort de Démosthènes.* 1st prize: Félix Boisselier 2nd prize: J.-M. Langlois	
1806	*Retour de l'enfant prodigue.* 1st prize: Félix Boisselier 2nd prize: François-Joseph Heim 3rd prize: A.-F. Caminade	
1807	*Thésée vainqueur du Minotaure.* 1st prize: François-Joseph Heim 2nd prize: A.-F. Caminade 3rd prize: Alexandre-Charles Guillemot	
1808	*Cause de la maladie de Antiochus découverte.* 1st prize: Alexandre-Charles Guillemot 2nd prize: F.-L. de Juinne	Baron Gros, *La Bataille d'Aboukir.*

1809	*Priam redemande à Achille le corps de son fils.* 1st prize: Jérôme-Martin Langlois 2nd prize: L.-V.-L. Pallière	First volume of *Le Description de l'Egypte* completed by the *Institut de l'Egypte* set up by Napoleon to study the archaeology of Egypt. A further twenty-one volumes followed, the final one in 1828.
1810	*Colère d'Achille.* 1st prize: Michel-Martin Drolling 2nd Prize: Alexandre-Denis-Joseph Abel	Napoleon's marriage to Marie-Louise of Austria. *La Bataille des Pyramides*, Baron Gros.
1811	*Lycurgue présente aux Lacédémoniens l'héritier du trône.* 1st prize: Alexandre-Denis-Joseph Abel 2nd prize: François-Edouard Picot	Birth of Napoleon's son, the Roi de Rome. Publication of Chateaubriand's *Itinéraire de Paris à Jerusalem*.
1812	*Ulysse et Télémaque massacrent les poursuivants de Pénélope.* 1st prize: L.-V.-Léon Pallière 2nd prize: Henri-Joseph Forestier	Napoleon's Russian campaign followed by the retreat from Moscow.
1813	*Mort de Jacob.* 1st prize: Henri-Joseph Forestier, F.-E. Picot 2nd prize: A.-J.-B. Thomas, J.-B. Vinchon	
1814	*Diagoras porté en triomphe par ses fils.* 1st prize: J.-B. Vinchon 2nd prize: J. Alaux, L.-E. Rioult	Restoration of the Monarchy. Louis XVIII accepted in principle the constitution drawn up by the legislature. Napoleon exiled to the island of Elba.
1815	*Briséis rendu à Achille trouve dans sa tente le corps de Patrocle.* 1st prize: Jean Alaux 2nd prize: Léon Cogniet	The Hundred Days ends with the defeat of Napoleon at the battle of Waterloo. He is exiled to the island of St Helena. J.-L. David who had been named as Napoleon's '*premier peintre*', voluntarily exiled himself to Brussels. In complying with the terms of the Treaty of Vienna works of art seized by Napoleon during his European campaigns were returned to their country of origin. The resulting gaps in the galleries of the Louvre were filled from the old collections of the Luxembourg Palace.
1816	*Œnone refuse de secourir Paris au siège de Troie.* 1st prize: A.-J.-B. Thomas 2nd prize: F.-F. Lancrenon, J.-V. Schnetz	
1817	*Hélène délivrée par Castor et Pollux, ses frères.* 1st prize: Léon Cogniet 2nd prize: F. Dubois	Institution of a *Prix de Rome* for *Paysage Historique*, as a 4-yearly event, subject – *Démocrite et les Abdéritaius*, winners: 1st prize: A. Michallon 2nd prize: A.-F. Boisselier 3rd prize: A.-A. Poupard
1818	*Philémon et Baucis réçoivent Jupiter et Mercure.* 1st prize: Nicolas-Auguste Hesse 2nd prize: P.-A. Coutant	The Galerie du Luxembourg established as a museum for the work of living French artists. The works to be kept only until five or ten years after the death of the artist when they would enter the Louvre or a suitable provincial museum. This rule was irregularly applied, many works remaining in the Luxembourg collection for a long time after the death of the more famous artists. The remaining pictures from the collection were dispersed in 1937.

1819	*Thémistocle se réfugie chez Admète, roi de Molosses.* 1st prize: François Dubois 2nd prize: C.-P. Larivière	The *Radeau de Méduse* by Géricault dominated the Salon of this year.
1820	*Achille demande à Nestor le prix de la sagesse aux jeux Olympiques.* 1st prize: Paul-Amable Coutant 2nd prize: P.-R.-J. Monvoisin 3rd prize: C.-P. Larivière	
1821	*Samson livré aux Philistins par Delila.* 1st prize: J.-D. Court 2nd prize: J.-S.-F. Dubois 3rd prize: J.-B.-S.-A. Périn	Greek uprising against the Ottoman Empire. Death of Napoleon on the island of St Helena, supposedly poisoned by the British. Siege of Missolonghi. *Paysage Historique : Enlèvement de Proserpine par Pluton.* 1st prize: J.-C.-J. Rémond 2nd prize: L.-F. Villeneuve, A. Bourgeois 3rd prize: Alphonse Périn
1822	*Oreste et Pylade.* 1st prize not awarded 2nd prize: Auguste-Hyacinthe Debay, François Buchot 3rd prize: L. W. Norblin	Massacre at Chios (Scio).
1823	*Egisthe, croyant retrouver le corps d'Oreste mort, découvre celui de Clytemnestre.* 1st prize: Auguste-Hyacinthe Debay, François Buchot 2nd prize: Eloy Féron	Publication of Stendhal's *Racine et Shakespeare* aroused interest in the English dramatist.
1824	*Mort de Alcibiade.* 1st prize: Charles Philippe Larivière 2nd prize: Elzidor Naigeon	Succession of Charles X. Death of Byron at Missolonghi. Delacroix exhibited *Les Massacres de Scios*, depicting a savage episode from the war of Greek independence. Death of Géricault. Stendhal's *Salon de 1824* codified the Romantic Movement.
1825	*Antigone donnant la sépulture à Polynice.* 1st prize: S.-L.-W. Norblin 2nd prize: Jean-Louis Bézard	Death of Jacques-Louis David in Brussels. Second part of *Racine et Shakespeare* published. *Paysage Historique: Chasse de Méléagre.* 1st prize: Alphonse Giroux, 2nd prizes: Jacques Brascassat, Jean-Baptiste Gilbert.
1826	*Pythias, Damon et Denis le tyran.* 1st prize: Eloy-Firmin Feron 2nd prize: François-Xavier Dupré	*La Grèce sur les ruines de Missolonghi* by Delacroix.
1827	*Coriolan chez Tullus, roi des Volsques.* 1st prize: François Xavier Dupré 2nd prize: Théophile Vauchelet	Successful Shakespeare season in Paris aroused further interest amongst the Romantic artists. Kemble and Harriet Smithson (later wife of the composer Berlioz) played the leading roles in *Hamlet* and *Romeo and Juliet*. The Anglo-French fleet destroyed the Ottoman fleet at the Bay of Navarino.
1828	*Ulysse et Néoptolème viennent chercher Philoctète dans l'île de Lemnos.* First prize not awarded. 2nd prize: Paul Jourdy.	

1829	*Jacob refusant de livrer Benjamin.* 1st prize: J.-L. Bézard, Théophile Vauchelet 2nd prize: Emile Signol, E. Roger 3rd prize: Henri-Frédéric Schopin	*Paysage Historique: Mort d'Adonis.* 1st prize: J.-B. Gilbert 2nd prize: Hugues Fourau, E.-M.-E. Poidevin
1830	*Méléagre reprenant ses armes à la solicitation de son épouse.* 1st prize: Emile Signol 2nd prize: Henri-Frédéric Schopin	The 'July Revolution' forced the abdication of Charles X. Louis-Philippe of Orleans elected King. Greece declared independent. Beginning of the French campaign in Algeria. Publication of *Une Passion dans le Désert* by Balzac, and first performance of *Hernani* by Victor Hugo.
1831	*Le Xanthe poursuivant Achille.* 1st prize: Henri-Frédéric Schopin 2nd prize: P. A. Blanc	Salons held annually from this date. Marilhat set off with Baron von Hugel on an expedition throughout the East lasting for two years. Delacroix exhibited *La Liberté guidant le peuple.*
1832	*Thésée reconnu par son père.* 1st prize: Jean-Hippolyte Flandrin 2nd prize: A. P. Gibert 3rd prize: H. D. Holfeld	Delacroix travelled in Morocco with comte de Mornay. *Musée Historique* established by Louis Philippe in an almost interminable suite of appartments in the palace at Versailles. The rooms were refitted and hung with pictures celebrating events from the history of France, some taken from the Louvre and other Royal Palaces and continually added to by commissions to contemporary painters, notably Horace Vernet.
1833	*Moïse et le serpent d'airain.* 1st prize: Eugène Roger 2nd prize: Philippe Comairas, L. V. Lavoine	*Paysage Historique: Ulysse et Nausicaa.* 1st prize: R.-E.-G. Prieur 2nd prize: H.-J. Saint-Ange Chasselat, Pierre Girard 3rd prize: E.-F. Buttura
1834	*Homère chantant ses poésies dans les villes de la Grèce.* 1st prize: Paul Jourdy	Delacroix exhibits *Les Femmes d'Alger dans leurs appartements.*
1835	*Tobie rendant la vue à son père.* 1st prize not awarded. 2nd prize: L. F. M. Roulin, C. O. Blanchard 3rd prize: J. B. A. Leloir	Publication by A. de Lamartine of *Souvenirs, impressions, pensées et paysage, pendant un voyage en Orient (1832–33).* 4 vols.
1836	*Frappement du rocher par Moise.* 1st prize: Dominique-Louis-Féréol Papety, Charles-Octave Blanchard 2nd prize: Jean Murat, J. B. Guignet	
1837	*Sacrifice de Noé.* 1st prize: Jean Murat 2nd prize: Thomas Couture, P. N. Brisset, J. B. Guignet	*Paysage Historique: Apollon, gardant les troupeaux chez Admète, invente la tyre.* 1st prize: E.-F. Buttura 2nd prize: F.-H. Lanoue, Jean-Achille Benouville 3rd prize: ? Esbrat Opening of the *Musée Historique* at Versailles.
1838	*Saint Pierre guérissant un boitier aux portes du temple.* 1st prize: Isador Alexandre Auguste Pils 2nd prize: J. A. Duval-Lecamus fils	
1839	*Coupe de Joseph trouvée dans le sac de Benjamin.* 1st prize: A.-A.-E. Hébert 2nd prize: Prosper-Louis Roux	

1840	*Caius Gracchus, cité devant le sénat, partant pour Rome.* 1st prize: Pierre-Nicolas Brisset 2nd prize: A. Lebouy	Exhibition of Ingres' *Odalisque et l'esclave.*
1841	*La robe de Joseph présentée à Jacob.* 1st prize: Auguste Lebouy 2nd prize: C. F. Jalabert, J. A. F. Naudin	Hemicycle of the Triumph of the Arts completed by Paul Delaroche at the Ecole des Beaux-Arts. Chasseriau exhibited the *Toilette d'Esther. Paysage Historique: Adam et Eve chassés du Paradis terrestre.* 1st prize: F.-H. Lanoue 2nd prize: T.-C. Blanchard, A.-C.-P. Cinier.
1842	*Samuel sacrant David.* 1st prize: V. F. E. Biennourry 2nd prize: L.-J. N. Duveau 3rd prize: F.-J. Barrias	
1843	*Œdipe s'exilant de Thèbes.* 1st prize: Eugène Jean Damery 2nd prize: F. L. Benouville 3rd prize: H. A. Crambard	Eugène Fromentin visited Algeria for the first time. Taking of the 'Smalah' of Abd-el-Kader by the duc d'Aumale at the head of two cavalry regiments. Booty of enormous value and 5,000 prisoners were the rewards of this successful surprise attack. The 'Smalah' of Abd-el-Kader comprised his itinerant residence, his court, harem and treasury, and upwards of 20,000 persons including the chiefs of principal tribes with their families.
1844	*Cincinnatus recevant les deputés du sénat.* 1st prize: Félix-Joseph Barrias 2nd prize: Jules-Eugène Lenepveu	
1845	*Jésus dans le prétoire.* 1st prize: François-Léon Benouville 2nd prize: Alexandre Cabanel.	Gustave Flaubert visited Algeria. Salon reviewed by Charles Baudelaire for the first time. Serialization of *Scènes de la Bohème* by Henri Murger in *Le Corsaire.* Horace Vernet completed his enormous picture of the *Prise de Smalah* for Louis-Philippe's *Musée Historique* at Versailles. *Paysage Historique: Ulysse et Nausicaa* 1st prize: Jean-Achille Benouville.
1846	*Maladie d'Alexandre.* 1st prize not awarded 2nd prize: Charles Alexandre Crauk	Théodore Chassériau in Algeria at the invitation of the caliph of Constantine, whose portrait he painted in the previous year. Exhibition at the Bazar Bonne-Nouvelle, with seventy-one paintings including ten by J.-L. David and thirteen by J.-A.-D. Ingres, which attracted a critical essay from Baudelaire, who again also reviewed the *Salon.*
1847	*Mort de Vitellius.* 1st prize: Jules-Eugène Lenepveu 2nd prize: P. J. A. Baudry	Gérôme exhibited the *Jeunes Grecs faisant battre les coqs (Combat des Coqs)* and established the *Néo-Grec* or *Pompéiste* ('Pompeian') style.
1848	*Saint Pierre chez Marie.* 1st prize not awarded 2nd prize: R. C. Boulanger, W.-A. Bouguereau 3rd prize: C. G. Housez.	The February Revolution lead to the establishment of the Second Republic. In December Louis Napoleon, nephew of Napoleon I was elected President. The Salon, thrown open by order of the Government accepted all contributions, and an unprecedented number of over 5000 pictures hung.

1849	*Ulysse reconnu par Euryclée, sa nourrice.* 1st prize: Rudolphe-Clarence Boulanger 2nd prize: C. C. Chazal	Alfred Dehodencq in Andalusia. Flaubert and Maxime du Camp travel in the East. First performance of the dramatization of Murger's *Scenes de la vie de Bohème*. This inspired Puccini's opera of the same name which was first performed in 1896. *Paysage Historique: Mort de Milon de Crotone.* 1st prize: C.-J. Lecombre 2nd prize: M.-A. de Curzon
1850	*Zénobie trouvée sur les bords de l'Araxe.* 1st prize: Paul-Jacques-Aimé Baudry, William-Adolphe Bouguereau 2nd prize: J. B. E. Bin, T. P. N. Maillot 3rd prize: F. N. Chifflard	
1851	*Pericles au lit mort de son fils.* 1st prize: Francois-Nicolas Chifflard 2nd prize: F.-H. Giacomotty, Emile Lévy.	
1852	*Résurrection de la fille de Jaire.* 1st prize not awarded 2nd prize: Félix Fossey	Album of photographs related to their travels in Egypt prepared by Maxime du Camp and Gustave Flaubert. Napoleon III proclaimed Emperor.
1853	*Jésus chassant les vendeurs du temple.* 1st prize not awarded 2nd prize: H. P. Picou, Jules Elie Delaunay	Chassériau's *Tepidarium* at the Salon. Publication of Flaubert's *Voyage pittoresque en Algérie*. *Paysage Historique*: prize not awarded as the entries are judged to be of too low a standard. The competition is suspended until the following year.
1854	*Abraham lavant les pieds aux trois anges.* 1st prize: Félix-Henri Giacomotty, Théodore-Pierre-Nicolas Maillot 2nd prize: Emile Lévy 3rd prize: Charles-Ernest Romagny	*Paysage Historique: Lycidas et Méris (églogue de Virgile).* 1st prize: J.-F.-A.-F. Bernard 2nd prize: T.-N. Chauvel 3rd prize: J. F. Chaigneau By Imperial decree the Salon of 1854 was postponed to coincide with the opening of the Exposition Universelle in May of the following year.
1855	*César dans la barque.* 1st prize not awarded 2nd prize: J.-F.-C. Clere, P.-L.-J. de Coninck	Exposition Universelle. Works by the Pre-Raphaelite painters exhibited in the British section aroused great interest in France. Courbet's *Salon du Realisme* set up in protest at the rejection of his *Un enterrement à Ornans* and *Le Studio*, by the jury of the Exposition Salon. In spite of a long adulatory article by Champfleury in *L'Artiste* little interest was shown by the public.
1856	*Retour de jeune Tobie.* 1st prize: Félix-Auguste Clément, Jules-Elie Delaunay 2nd prize: E. B. Michel	Gérôme's visit to Cairo with a group of friends including Léon Belly and Narcisse Berchère. Publication of Flaubert's *Constantinople* and Fromentin's *Un eté dans le Sahara*.
1857	*Résurrection de Lazare.* 1st prize: Charles-François Sellier 2nd prize: L. H. Leroux, J. F. L. Bonnat Mention: Benjamin Ulmann	*Paysage Historique: Jésus et la Samaritaine.* 1st prize: Jules Didier 2nd prize: C.-O. de Penne.

W.-A. Bouguereau *La Naissance de Vénus*/The Birth of Venus, 1863.
Oil on canvas 300 × 217 cm.

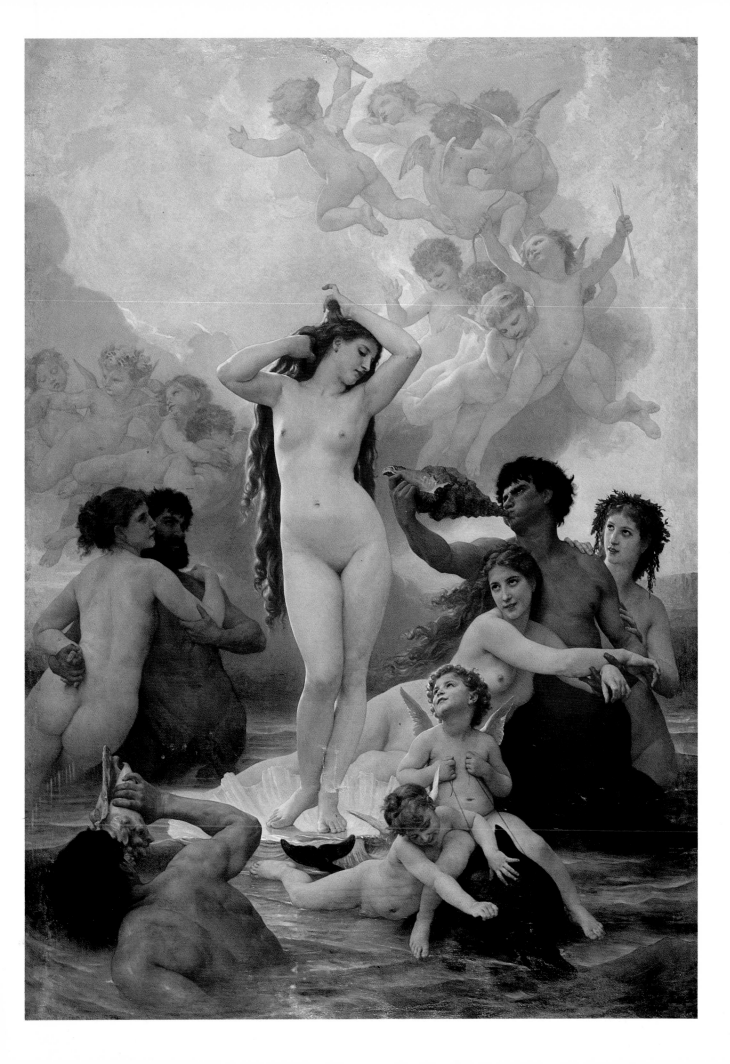

1858 *Adam et Eve trouvant le corps d'Abel.*
 1st prize: Jean-Jacques Henner
 2nd prize: B. Ulmann
 Mention: Jules-Joseph Lefebvre

Publication of *Un an dans le Sahel* by Eugène Fromentin.

1859 *Coriolan chez Tullus, roi des Volsques.*
 1st prize: Benjamin Ulmann
 2nd prize: J.-J. Lefebvre
 Mention: F. T. Lix

Publication of Baudelaire's *Salon du 1859.*

1860 *Sophocle accusé par ses fils.*
 1st prize: Ernest-Barthélemy Michel
 2nd prize: F. J. S. Layraud
 Mention: X. A. Monchablon

1861 *Mort de Priam.*
 1st prize: Jules-Joseph Lefebvre
 2nd prize: A. A. Leloir, M. F. F. Girard
 Mention: Tony Robert-Fleury

Paysage Historique: (the last time this competition was held). *La Marche de Silène.*
 1st prize: Paul-Albert Girard
 2nd prize: G. A. Guillaumet
 Mention: A. H. Bonnefoy.

1862 *Veturie au pieds de Coriolan.*
 1st prize not awarded
 2nd prize: A. Loudet, X. A. Monchablon
 Mention: A. G. H. Regnault

Ingres exhibited *Le Bain turc.*
Publication of *Salammbô* by Gustave Flaubert.

1863 *Joseph se fait reconnaître par ses frères.*
 1st prize: Fortuné-Joseph-Sérafin Layraud
 Accessit: X. A. Monchablon
 2nd prize: L. P. U. Bourgeois, Pierre Dupuis
 Mention: D. U. N. Maillart

Salon des Refusés set up by Imperial decree to provide an alternative exhibiting venue to those artists whose work was refused by the Salon jury. Death of Delacroix. Reform of the Academy of the Beaux-Arts. The organisation of the Prix de Rome competition was removed from their jurisdiction.

1864 *Homère dans l'île de Scyros.*
 1st prize: Diogène-Ulysse-Napoléon Maillart
 Accessit: Alexandre-Louis Leloir
 2nd prize: E. Thirion

1865 *Orphée aux enfers.*
 1st prize: Jules-Louis Machard
 Accessit: M. F. Firmin Girard
 2nd prize: M. L. F. Jacquesson de la Chevreuse

Napoleon III travelled in Algeria.

1866 *Thétis apporte à Achille les armes forgées par Vulcain.*
 1st prize: Alexandre-Georges-Henri Regnault, Pierre-Paul-Léon Glaize
 2nd prize: J. Blanc
 3rd prize: E. T. Blanchard

1867 *Meurtre de Laius par Oedipe.*
 1st prize: Paul-Joseph Blanc
 Accessit: Léon Pierre Urbain
 2nd prize: E. T. Blanchard

Exposition Universelle in Paris. Courbet again set up his own exhibition in opposition to the official Salon choice of over 600 works which were shown at the Exposition.
Execution of Emperor Maximilian in Mexico. Manet's picture of this subject refused by the Salon jury for political reasons.

J. J. A. Lecomte de Noüy *Rhamsés dans son harem*/Rameses in his Harem (side panel), *1886.*
Oil on canvas 129.5 × 77.4 cm.

1868 *Mort d'Astyanax.*
 1st prize: Edouard-Théophile Blanchard
 Accessit: Ernest Stanislas Blanc-Garin

1869 *Le soldat de Marathon.* Inauguration of the Suez Canal in the presence of the
 1st prize: Luc-Olivier Messon Imperial family. Gérôme, Berchère and Fromentin
 Accessit: Pierre-Oscar Mathieu formed part of the official delegation invited by the
 2nd prize: E. Vimont Khedive Ismail.
 3rd prize: J.-N. Sylvestre Publication of Gerard de Nerval's *Voyage en Orient*.

1870 *Mort de Messaline.* Outbreak of the Franco-Prussian War in mid-July. The
 1st prize: Jacques-François-Fernand Lematte French defeat at Sedan in September brought about the
 Accessit: Alfred Constantin Charles downfall of the Empire and a Government of National
 2nd prize: L. H. Marqueste Defence was set up in Paris. Third Republic
 proclaimed.

1871 *Adieux d'Œdipe aux cadavres de la femme et ses* In March Napoleon III joined the Empress Eugénie in
 fils. exile in Kent, England. Paris besieged by the Prussian
 1st prize: Edouard Toudouze Army. *Aïda* the opera by Guiseppe Verdi performed in
 Accessit: Edouard Vimont Cairo. Paris Commune established in opposition to the
 2nd prize: J.-A.-J. Lecomte de Noüy national Government at Versailles, overthrown after a
 few months. Thiers proclaimed president of the Third
 Republic.

1872 *Une scène du déluge.*
 1st prize: Joseph-Marie-Augustin-Gabriel
 Ferrier.
 Accessit: Eugène Isidore Médard
 2nd prize: L. F. Comerre

1873 *La Captivité des Juifs à Babylone.*
 1st prize: Aimé-Nicolas Morot
 Accessit: Edouard-Bernard Debat-Ponsan
 2nd prize: J. A. Rixens

1874 *Mort de Timophane.* First group exhibition of the Impressionists, received
 1st prize: Paul Albert Besnard with derision by critics and public alike.
 Accessit: Léon-François Comerre
 Mention: E. J. Dantan

1875 *L'Annonciation aux Bergers.*
 1st prize: Léon-François Comerre
 Accessit: Julien Bastien-Lepage
 2nd prize: Camille Félix Bellanger

1876 *Priam demandant à Achille le corps d'Hector.*
 1st prize: Joseph Wencker
 Accessit: Jean-Adolphe-Pascal Dagnan-
 Bouveret

1877 *Papirius insulté par un Gaulois après la prise de* Death of Courbet on 31st December.
 Rome.
 1st prize: Théobald Chartran
 Accessit: Pierre Fritel
 2nd prize: G. C. E. Courtois

1878 *Auguste visitant le tombeau d'Alexandre à*
 Alexandrie.
 1st prize: François Schommer
 Accessit: Henri Lucien Doucet
 2nd prize: J. E. Buland

1879 *Mort de Démosthène.*
1st prize: Alfred-Henri Bramtot
Accessit: Jean-Eugène Buland
2nd prize: E. Pichot

1880 *Reconnaissance d'Ulysse et de Télémaque dans la cabane d'Eumée.*
1st prize: Henri-Lucien Doucet
Accessit: Georges Truffot
2nd prize: F.-N. Royer-Lionel

Foundation of the *Société nationale des artistes français* who assumed the responsibility of administering the Salon exhibitions.

1881 *La Colère d'Achille apaissé par Minèrve.*
1st prize: Paul Edouard Fournier, Henri-Camille Danger.

Biographies

AMAURY-DUVAL, Amaury-Eugène-Emmanuel Pineu-Duval
b. 1808 Paris, d. 1885 Paris

Amaury-Duval was a pupil of Ingres and wrote an account of Ingres' *atelier* which was published in 1872. He exhibited at the Salon from 1830, winning a second-class medal in the following year. Contemporary critics compared his work with that of Cabanel and Paul Baudry. They also noted Amaury-Duval's debt to his master Ingres – a debt which the artist himself was the first to acknowledge. Amaury-Duval recorded Ingres' verdict on his work in a vivid passage:

> Il me parla de ce qu'il avait vu de moi, en me félicitant de mes tendances honnêtes. 'Vous serez peut-être pas' me dit-il, 'un peintre'... (et alors, faisant le geste d'un homme qui soulève des poids, le poing fermé)... 'un peintre à la Michel-Ange... Mais...' (et changeant d'expression, avec des mouvements arrondis et gracieux) vous avez de l'élégance, de la modestie dans le talent... Vous serez un peintre aimable.
>
> (He spoke to me of what he had seen of me, congratulating me on my honesty. 'You will, not perhaps, be', he said to me, 'a painter', (and then, copying the movements of a man lifting weights, his fists clenched), 'a painter in the same sense as Michelangelo... But...' (with a change of expression, and sweeping, graceful gestures) 'you have elegance, a modest talent... You will be a charming painter.')

AUGUSTE, Jules-Robert ('Monsieur Auguste')
b. 1789(?) Paris, d. 1850 Paris

Auguste was the son of a rich jeweller and was a connoisseur of eighteenth century French art, admiring the rococo style when it was still generally abominated. In 1810 he won the Prix de Rome for sculpture, but he was persuaded to concentrate on painting by his *protégé* Théodore Géricault. Auguste undertook a long voyage to the Orient, Greece and Albania, returning to Paris in 1820. He was an intimate friend of Delacroix and was known chiefly through this connection, but his style of painting is closer to Decamps or Diaz in the preoccupation with a brilliant and glittering surface texture. In the course of his travels he made a large collection of Oriental costumes and accessories and these were lent freely to those friends, notably Delacroix, who became fascinated with Orientalism. Auguste is now usually remembered as an Orientalist himself.

BARRIAS, Félix-Joseph
b. 1822 Paris, d. 1907 Paris

Son of a miniaturist and porcelain painter, Barrias studied at the Ecole des Beaux-Arts in Paris and in the studio of Léon Cogniet. He won the Grand Prix de Rome in 1844, having already exhibited at the Salon in 1840 and 1841. During the next sixty-five years he showed history paintings regularly at the Salon, with subjects taken from classical, medieval and contemporary myths and historical episodes. He was a prolific mural painter, working in London and St. Petersburg as well as

in Paris. He became a *chevalier* of the Légion d'honneur and died at an advanced age in his native Paris.

His younger brother, Louis-Ernest, became a successful sculptor, also winning the Grand Prix de Rome and becoming an *officier* of the Légion d'honneur.

BAUDRY, Paul-Jacques-Aimé
b. 1828 Bourbon-Vendée (La Roche-sur-Yon), d. 1886 Paris

Before going to Paris to study with Drolling in 1844, Baudry had been a pupil of an artist called Sartoris in La Roche-sur-Yon. In 1847 he came second in the Prix de Rome competition, finally winning the first prize in 1850 which he shared with Bouguereau. His stay in Rome was decisive in

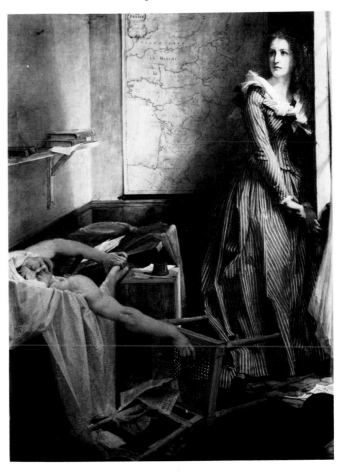

E. Levy *Mort d'Orphée*/The Death of Orpheus, 1866.
Oil on canvas 189 × 118 cm.

P. Baudry *Charlotte Corday*, 1861.
Oil on canvas 203 × 154 cm.

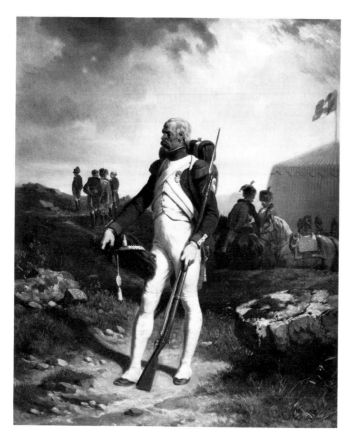

J.-L.-H. Bellangé *La Tente impériale*/The Imperial Tent, c. 1859. Oil on panel 46 × 38 cm.

the formation of his style, and his great debt to Titian, above all, and the Venetian painters of the Renaissance can be traced in his work throughout his career.

Baudelaire dismissed his talents, writing of his *Toilette de Vénus*, exhibited at the Salon in 1859: 'Il est à craindre que M. Baudry ne reste qu'un homme distingué' (I cannot help fearing that M. Baudry remains no more than a 'distinguished' artist). Two years later Maxime du Camp reinforced this lukewarm verdict when discussing Baudry's *Charlotte Corday* (Salon of 1861): 'A voir les tableaux de M. Baudry on comprend bien vite qu'il n'a sur l'art que des idées d'un ordre assez médiocre.' (Seeing the paintings by M. Baudry one quickly realises that he has nothing but mediocre ideas on the subject of art).

On his return from Rome he won an immediate reputation as a portrait painter. He exhibited for the first time at the Salon – and won a first class medal – in 1857, the year in which he also received his first commission for mural decoration. His most important commission, and the work for which he is now best remembered, was for the decoration of the Paris Opéra which he started in 1866, the work being finally completed in 1874. In 1861 he was awarded the cross of the Légion d'honneur, becoming an *officier* in 1869 and a *commandeur* in 1875. He died aged fifty-eight, while still planning the *Joan of Arc* series commissioned for the decoration of the Panthéon. A retrospective exhibition of his work was held at the Ecole des Beaux-Arts in the same year.

BELLANGÉ, Joseph-Louis-Hippolyte
b. 17 January 1800 Paris, d. 10 April 1866 Paris

Bellangé entered the studio of Gros at an early age in 1816, where he was a contemporary and friend of Charlet, the lithographic artist, who inspired him to study printmaking. He produced a series of lithographs of figures in military costume, but he exhibited at the Salon (from 1822) as a battle painter and was one of the first to be called upon to work for the Musée Militaire at Versailles. His work in this genre was immediately successful and he executed fourteen works for the museum at Versailles. Bellangé collaborated with Adrien Dauzats (q.v.) who helped with the architecture in the military subjects, notably *Un jour de revue dans la cour du Carrousel*, painted in 1862, which is now in the Louvre. Bellangé became a director of the Rouen Museum in 1836, a post which he occupied until 1852. He was made a *chevalier* of the Légion d'honneur in 1834, and an *officier* in 1861.

BELLY, Léon-Adolphe-Auguste
b. 10 March 1827 St. Omer (Pas de Calais), d. 1877 Paris

Belly spent a short time in Picot's studio before going to work with the landscape painter, Constant Troyon who, with Decamps and Marilhat, was his chief formative influence. He spent some time at Barbizon in 1849. In 1850 he accompanied the map-maker de Saulcy and the writer, Edouard Delessert, on their voyage in the Orient, visiting the Lebanon, Palestine and Egypt. In 1853 Edouard Delessert published *Voyages aux villes maudit: Sodom, Gomorrhe, Seboim, Adama, Zoar*, the results of the voyage, and Belly exhibited views of Beirut, Cairo and Nablus in Syria at the Salon.

Belly revisited Egypt twice, in 1855–6 and 1857–8, and in 1861 painted his monumental *Pèlerins allant à la Mecque* which was exhibited in the Salon of that year – winning a first class medal for the artist. It was acquired by the State for the Musée du Luxembourg. After his marriage in 1862 Belly travelled only in France but continued to send pictures of Oriental subjects to the Salon alongside views of Normandy and other parts of the country. In 1867 he made his only attempt at a large-scale history painting, choosing as a subject *Ulysse et les Sirènes*. The picture was again bought by the State and was sent to St. Omer, Belly's native town. He was awarded the Légion d'honneur in 1862.

BERCHÈRE, Narcisse
b. 1819 Etampes, d. 1891 Asnières

Berchère was an Orientalist painter and a pupil of Rémond. He spent only a short period at the Ecole des Beaux-Arts while attempting, without success, to win the Prix de Rome for the *Paysage Historique* in 1841. Berchère came under the influence of the Barbizon painters in his early career, but after spending two years (in 1849 and 1850) in Egypt, Syria, Asia Minor, Turkey and Greece, he at last found his true métier as a painter of the Orient. In 1856 he accompanied Gérôme to Egypt and in 1860 he was chosen by Ferdinand de Lesseps as official painter to the Suez Canal project.

He wrote an account of his experiences, which appeared in 1863, entitled *Le Désert de Suez, cinq mois dans l'Isthme*. In 1869, with Gérôme, Fromentin, Tournemine, Guillaume and Charles Blanc, editor of the Gazette des Beaux-Arts, he was present at the opening of the completed canal by the Empress Eugènie. He remained faithful to his vision of Africa throughout his career and was consistently successful in his chosen field, winning medals and honours at the Salons and becoming a *chevalier* of the Légion d'honneur.

BONNAT, Léon-Joseph-Florentin
b. 1833 Bayonne, d. 1922 Monchy-Saint-Eloi, Oise

Léon Bonnat spent part of his youth in Spain and studied in Madrid with Madrazo before moving to Paris and becoming a pupil first of Léon Cogniet and then of Delacroix. He exhibited at the Salon from 1857, and became one of the most successful portrait painters of the period. Bonnat was a history painter who was strongly influenced by the paintings of the Spanish school, notably those of Ribera and Velasquez. He also greatly admired the Bolognese artists of the seventeenth century.

One of the pillars of the establishment in the nineteenth century, Bonnat was loaded with honours throughout his career. He assembled a rich collection of works of art, including drawings by Leonardo da Vinci, Michaelangelo and Raphael. This important collection was left to Bayonne, the town of his birth, where it is housed in the Musée Bonnat.

BOUGUEREAU, William-Adolphe
b. 1825 La Rochelle, d. 1905 La Rochelle

Son of a wine-seller, Bouguereau studied from the age of sixteen at the Ecole des Beaux-Arts in Bordeaux before arriving in Paris and entering the *atelier* of the history painter François-Edouard Picot in 1846. In 1848 he achieved the second prize in the Prix de Rome competition and in 1850 he shared the first prize with Paul Baudry. He spent the next four years in Rome and on his return to Paris exhibited the *Triomphe de Martyr* at the Salon where it had a great success, being bought by the State for the Musée du Luxembourg.

After this achievement, Bouguereau's career followed a triumphant course, his work being avidly collected in America – where there was hardly a single collection of any importance without the obligatory Bouguereau. He was loaded with honours throughout his working life and continued to exhibit at the Salon until the year of his death. His pictures fetched high prices from the moment of his first success.

Even when his reputation with the French critics was beginning to ebb, Philippe de Chennevières felt compelled to remind the public of his meticulous professionalism. In 1890 he wrote:

Des hommes comme M. Bouguereau, il en faut! On ne peut pas les aimer,

mais ce serait injuste de méconnaître à leur émerveillante impeccabilité de doigts le maintien presque absolu des traditions de la peinture française. (Men like Bouguereau are a necessity! One cannot like them, but it would be unjust to fail to recognise their marvellous dexterity, to which we owe the preservation, almost in their entirety, of the traditions of French painting.)

Bouguereau was completely dedicated to his art following, year in and year out, a strict routine of work. After a brief illness in 1904 he returned to La Rochelle and died there in his eightieth year.

BOULANGER, Gustave-Clarence-Rodolphe
b. 1824 Paris, d. 1888 Paris

Pupil of Paul Delaroche, Boulanger was awarded the Grand Prix de Rome in 1849. His Salon début had taken place in the previous year when he exhibited *Indiens jouant avec de panthères* and *Un café maure*. His work encompassed both history painting of a mainly Neo-Classical genre and Orientalist subjects. In 1882 he became a member of the Académie des Beaux-Arts. In his picture, *Répétition du joueur de flûte chez le Prince Napoléon*, the interior of Prince Napoléon's Pompeian palace in the avenue Montaigne is shown. This had wall paintings by Gérôme and was a Neo-Classical ideal recreated in bricks and mortar in the centre of Paris. The picture demonstrates unequivocally the way in which the Neo-Classicism of this date depended upon translating modern French life into a carefully recreated classical setting.

Thoré-Burger said:

> . . . C'est une fête réelie, et cette contrefaçon de l'antiquité a pu être etudiée d'après nature et sur des personnages vivantes, deguisés en anciens. On y reconnaît, en effet, M. Théophile Gautier et des acteurs et actrices de la Comédie-Française, tous proprement accommodés à l'unisson de ce palais romain, dans le costume de leurs rôles et étudiant des attitudes et des gestes archéologiques. Que ce déguisement antique va bien aux têtes modernes! C'est aussi amusant à voir que les 'grecqueries' de M. Gérôme, et de même force à peu près comme peinture.

(This is an actual entertainment, and this imitation of the antique past has been taken from nature and from living models, disguised as people from antiquity. Indeed, one can recognise M. Théophile Gautier and the actors and actresses of the Comédie Française, all appropriately dressed up in keeping with this Roman palace, in the costumes of their roles, and studying the postures and gestures of the past. How well these fancy dresses of the past become a modern face! It is just as amusing to see as the 'grecqueries' by Gérôme and in the same way is almost like painting.)

Salon de 1861

CABANEL, Alexandre
b. 1823 Montpellier, d. 1889 Paris

In 1840 Cabanel entered the Ecole des Beaux-Arts in Paris as a pupil of François-Edouard Picot. He exhibited at the Salon for the first time in 1844, and won the Grand Prix de Rome in the following year. A painter of portraits and historical and mythological pictures in the academic manner, Cabanel's notorious *Naissance de Vénus*, shown at the Salon in 1863, was bought by Napoleon III for his own personal collection. Cabanel received a number of State commissions and many official honours, including the Légion d'honneur. He was made a professor at the Ecole des Beaux-Arts in 1863. Amongst his pupils were the artists Bastien-Lepage (who is notable for having achieved a compromise style, uneasily uniting academicism and Impressionism), Cormon, Debat-Ponsan, Friant, E. T. Blanchard (like his master a winner, in 1868, of the Grand Prix de Rome), Gervex and L. Royer.

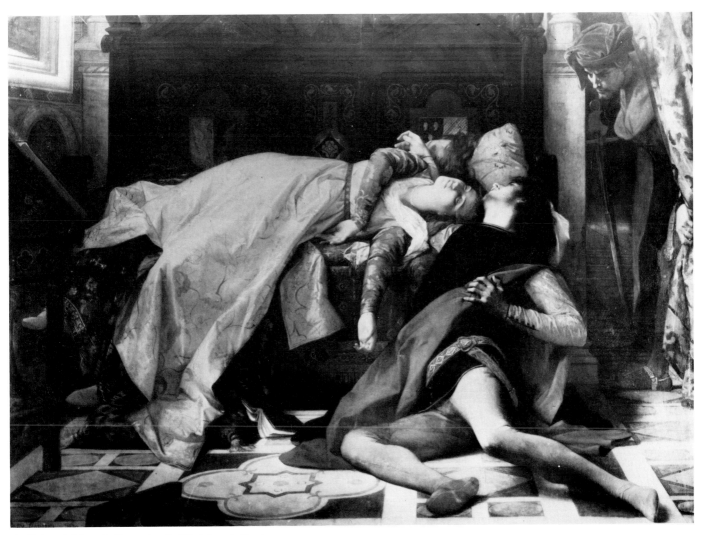

A. Cabanel *Mort de Françoise de Rimini et de Paolo Malatesta*/The Death of Francesca da Rimini and Paolo Malatesta, 1870.
Oil on canvas 184 × 255 cm.

T. Chassériau *Caïd visitant un douar*/The Caïd visiting a Duar,
1849.
Oil on canvas 142 × 200 cm.

Octave Mirbeau wrote: 'Une main habituée à la prestidigitation des
formes, à l'escamotement des lignes caractéristiques, une âme de Prix de
Rome avec un œil de photographé. Tel a été M. Cabanel.' (A hand used
to the conjuring up of forms, to the whisking away of distinctive lines,
the soul of a Rome prizewinner with the eye of a photographer. Such is
M. Cabanel.) Cabanel was a determined opponent of the Impressionists,
joining Gérôme in deploring particularly the work of Manet. He
continued to exhibit at the Salon right up until the year of his death.

CHASSERIAU, Théodore
b. 1819 San Domingo, d. 1856 Paris
Chassériau showed his talent for painting at a very early age and,
through the intervention of Amaury-Duval, was admitted to the studio
of Ingres in 1833, when he was only fourteen years old. He exhibited for
the first time in 1836. *Chaste Suzanne*, exhibited in 1839 and now in the
Louvre, shows how early Chassériau formed his mature style. He
retained his Ingres-like interest in line and form, but became fascinated
by Delacroix's use of colour to express emotion. Chassériau made a visit
to North Africa in 1846 and his subsequent work drew largely on this
experience, like that of Delacroix who visited Algeria himself in 1832.
Chassériau's Oriental paintings were inevitably compared with those of
Delacroix.

In 1853 Chassériau returned to the classical inspiration of his
formative years and produced the large *Tepidarium*, which was bought
by the State for the Musée du Luxembourg and is now in the Louvre. In
1855, at the Exposition Universelle, his last major work, *La Défense des
Gaulles*, was shown alongside successful pictures of the two previous
decades. Badly received by the critics, it shares with Gleyre's *Les
Romains passant sous le joug* of 1858 a curious serried composition and a
brilliant colouring which was found disconcerting in artists who were
regarded as Neo-Classicists. Chassériau died at the early age of thirty-six
and Gautier wrote enthusiastically about his unfinished *Intérieur du*

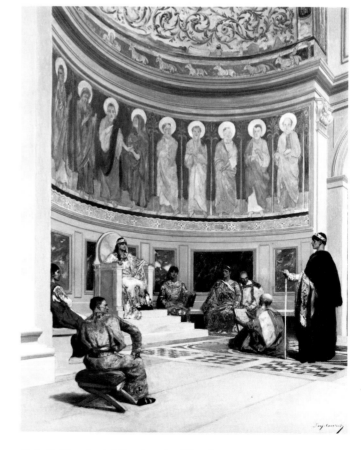

J.-J.-B. Constant *L'Impératrice Theodora recevant un
ambassadeur*/The Empress Theodora receiving an Ambassador,
n.d.
Oil on canvas 99 × 79 cm.

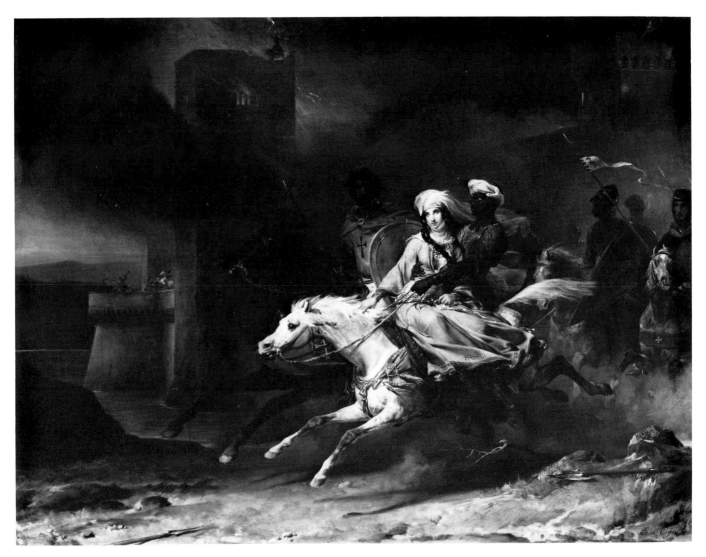

L. Cogniet *Rebecca et Sir Brian de Bois Guilbert*/Rebecca and Sir
Brian de Bois Guilbert, 1828. (Scene from *Ivanhoe* by Sir Walter
Scott)
Oil on canvas 90 × 117 cm.

Harem. Paul Mantz said of Chassériau a few days after his death 'Hélas,
le semeur est parti avant la moisson...' (Alas, the sower left before the
harvest...).

COGNIET, Léon
b. 1794 Paris, d. 1880 Paris
A pupil of Guérin, Léon Cogniet won the Grand Prix de Rome in 1817.
He was a history painter of the same type as his near contemporary, Paul
Delaroche, and the master of Léon Bonnat, the portrait painter. His
reputation was made with the exhibition, in 1824, of *Marius sur les mines
de Carthage*, now in Toulouse. He was awarded the Légion d'honneur in
1846, the year in which he exhibited his most famous picture, *Le Tintoret
peignant sa fille morte*. In 1849 Cogniet became a member of the
Institute. He executed the ceiling decorations of two of the rooms in the
Louvre with incidents from Napoleon's Egyptian campaign and painted
several pictures for the museum at Versailles.

CONSTANT, Jean-Joseph-Benjamin (called Benjamin-Constant)
b. 1845 Paris, d. 1902 Paris
Constant's youth was spent partly in Toulouse and he started his studies
at the Ecole des Beaux-Arts there before making his way to Paris where
he entered the Ecole des Beaux-Arts in 1866. In 1867 he went to study in
the *atelier* of Alexandre Cabanel, and he made his début at the Salon in
1869. He fought in the war of 1870 and did not return to his studies at the
Ecole des Beaux-Arts at the conclusion of hostilities but travelled in
Spain where he met Fortuny in Granada. A trip to Morocco undertaken
soon afterwards had a decisive effect on his work and his paintings in the

1870s were mainly Oriental in inspiration.
Towards 1880 he turned more towards portraiture and decorative
painting. Among his most illustrious sitters were members of the British
Royal family. Both Queen Victoria and Queen Alexandra were painted
by him, as well as M. Alfred Chauchard, proprietor of the Grand
Magazin du Louvre and an enthusiastic patron of the arts.

CORMON, Fernand-Anne-Piestre
b. 1854 Paris, d. 1924 Paris
Cormon commenced his artistic studies in Brussels with the celebrated
history painter Portaëls before arriving in Paris where he entered the
studio of Alexandre Cabanel. He also studied with Eugène Fromentin,
the Orientalist, and his first Salon exhibit, the *Mort de Mahomet* (1863)
reflects the influence of his master. Other Orientalist pictures followed,
before his famous evocations of prehistory, the work by which he is now
best known. He was made a professor at the Ecole des Beaux-Arts,
where he numbered Toulouse-Lautrec amongst his pupils, as well as a
member of the Institute. He was commissioned to decorate the Petit
Palais as well as the Musée d'Histoire Naturelle in Paris.

COUTURE, Thomas
b. 1815 Senlis, d. 1879 Villers-le-Bel
Couture was the son of a shoemaker who moved to Paris from Senlis in
1826. He became a pupil of Baron Gros in 1830. Between 1834 and 1839
he made six attempts to win the Grand Prix de Rome, his only success
being the achievement of the second place in 1837. In 1838 he spent a
period of time in the *atelier* of Delaroche. In 1840 he made his début at

the Salon and had a phenomenal success there with the exhibition, in 1847, of his celebrated picture, *Romains de la décadence*.

Although he received a number of state commissions for large-scale history paintings and decorative work, few of the pictures progressed beyond the sketch stage. His main activity, apart from the painting of portraits, genre scenes and landscapes, was teaching – first in Paris and later in Senlis, where he moved after his marriage in 1860, and in Villers-le-Bel, where he reverted to a peasant existence, growing fruit and gardening. His most celebrated students were Manet and Puvis de Chavannes. After the triumph of *Romains de la décadence*, he exhibited only infrequently at the Salon and his reputation as a painter declined after 1860.

DAGNAN-BOUVERET, Pascal-Adolphe-Jean
b. 1852 Paris, d. 1929 Quincey (Haut-Saône)
A pupil of Gérôme, Dagnan-Bouveret won the second place in the Prix de Rome competition in 1876. After his début at the Salon in the same year with two pictures of mythological subjects, he began to concentrate on events from modern life executed with a certain wit, notably his *Noces chez le photographe*, now in the Museum at Lyons. He became a friend of Bastien-Lepage and his subject matter shows the influence of this relationship, including as it does, a number of religious genre pictures with a Breton character. He became a celebrated portrait painter, much favoured by the French aristocracy, and was accorded the honours due to a successful artist of his period.

DAUZATS, Adrien
b. 1804 Bordeaux, d. 1868 Paris
In 1828 Dauzats, who was a landscape painter by training, became one of the artists to work with Baron Taylor on the *Voyages pittoresques et romantiques dans l'ancienne France*, managing, through this commission, to make sketches in all the regions of France. Subsequently he travelled in Spain, Portugal, Egypt and Asia Minor. A very prolific painter, Dauzats worked with scrupulous attention to accuracy of drawing and with a palette of rich and intense colour. He exhibited regularly at the Salon from 1831 until a year before his death.

DEBAT-PONSAN, Edouard-Bernard
b. 1847 Toulouse, d. 1913 Paris
A pupil of Cabanel, Debat-Ponsan was awarded the second prize in the Prix de Rome competition in 1875. He was a successful academic history painter and portraitist who became president of the Société des Artistes Français. His famous picture *Le Massage*, now in the Museum of Toulouse, employs the traditional Orientalist device of contrasting a white and a dark-skinned model, an idea used so effectively by many eighteenth-century painters for similar bathing subjects.

DECAMPS, Alexandre-Gabriel
b. 1803 Paris, d. 1860 Fontainebleau
Decamps studied first with the father of a childhood friend, the history painter Etienne Bouchot, before entering the *atelier* of Abel de Pujol. Decamps soon began to sell his work and became a keen voyager, travelling all over central France, in Switzerland and, in 1827, departing for two years on an official mission to Greece and Turkey with the marine painter Louis Garnerey to collect documentary information on the battle of Navarino. The material which he brought back from this trip provided him with the inspiration for his much admired Orientalist pictures, and he had his first major success with this genre of painting in the Salon of 1831 with *Cadji-Bey, chef de police de Smyrne, faisant sa ronde*, or *La Patrouille Turque*. He also made a name for himself as a painter of *singeries*, his best known work of this type being *Les Singes experts*.

Travels in Italy in the late 1830s produced yet more successful and popular landscape subjects, but Decamps wished to be known as more than a landscape and genre painter, and his *La Défaite des cimbres*, shown at the Salon in 1834, represents his attempt to become a monumental history painter. The remarkable series of large-scale drawings illustrating the story of Samson, which were shown at the Salon in 1845 were enthusiastically received by public and critics. Baudelaire wrote of them:

> M. Decamps a donc fait une magnifique illustration et de grandioses vignettes à ce poème étrange de Samson – et cette série de dessins où l'on pourrait peut-être blâmer quelques murs et quelques objets trop bien faits, et le mélange minutieux et rusé de la peinture et du crayon – est, à cause même des intentions nouvelles qui y brillent, une des plus belles surprises que nous ait faites cet artiste prodigieux qui, sans doute, nous en prépare d'autres.

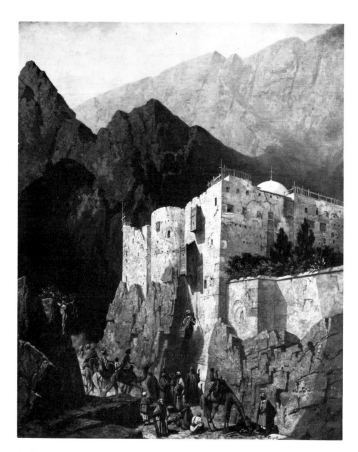

A. Dauzats *Le Couvent de Ste Catherine au Mont Sinai*/St Catherine's Convent on Mount Sinai, 1845. Oil on canvas 130 × 104 cm.

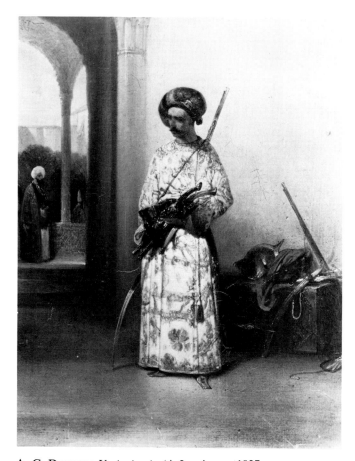

A.-G. Decamps *Un janissaire*/A Jannissary, 1827. Oil on canvas 24 × 19 cm.

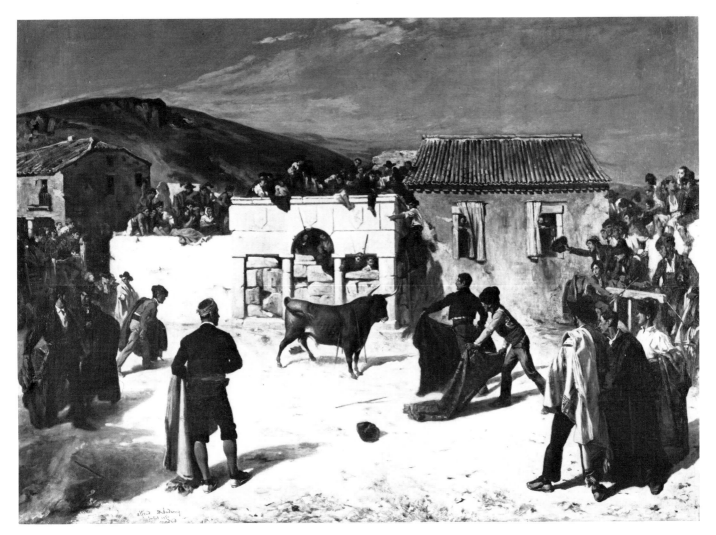

A. Dehodencq *Course de taureaux en Espagne*/Bull-fighting in
Spain, 1850.
Oil on canvas 146 × 206 cm.

(M. Decamps has made a magnificent illustration, a set of grandiose
vignettes, to the strange poetic story of Samson – and although one might
perhaps find fault with the too perfect treatment of the walls or some of
the objects, and with the meticulous and artful mixture of paint and pencil
– this series of drawings is, on account of the new aims which shine forth,
one of the finest surprises produced by this prodigious artist, who is, no
doubt, even now preparing some more for us.)

In spite of his unquestioned success, Decamps gave up painting for
about two years, only resuming his career after the favourable reception
of his work at the Exposition Universelle of 1855.

DEHODENCQ, Edme-Alexis-Alfred
b. 1822 Paris, d. 1882
A pupil of Léon Cogniet, Dehodencq travelled extensively in Spain and
in Algeria. His Salon début took place in 1844 with a religious work,
Sainte Cécile, but he is best remembered for his pictures of Spain and the
East in which he evokes the pitiless heat in the simplified planes and
heavily shaded declivities of Moorish and Oriental architecture. His son,
Edmond, was born in Spain in 1860 and also became an artist. He
studied under his father and became a painter of still-life and genre
subjects.

DELAROCHE, Hippolyte (called Paul)
b. 1797 Paris, d. 1856 Paris
At his father's insistence Delaroche began his studies under the
landscape painter Watelet and was persuaded to enter for the com-
petition for the Prix de Rome in *Paysage Historique* in 1817. The prize
was won by Michallon and Delaroche was not placed among the
runners-up, so he gave up the study of landscape and moved to the
studio of Baron Gros, the famous Neo-Classical history painter.

Delaroche exhibited at the Salon for the first time in 1822. In subsequent
years he enjoyed increasing success as the most celebrated history
painter of the period. In 1837 he was commissioned to execute the
decoration for the Hemicycle in the Ecole des Beaux-Arts, an immense
composition twenty-seven metres long, which shows the most celebrated
painters, sculptors and architects of history.

At the time of the large retrospective exhibition of his work which
took place a year after his death in 1857, Gautier said of him that he was
not a born painter and that all his great achievement as a history painter
was brought about by the exercise of intelligence and will power. This
verdict was to be echoed later by Thoré-Burger in his critique of the
Exposition Universelle in 1867. He wrote: 'Paul Delaroche était un
homme très intelligent, point artiste du tout. Engagé dans la peinture, il
a travaillé avec son esprit.' (Paul Delaroche was a very intelligent man,
but not an artist at all. Having embarked on a career in painting, he
worked with his mind.)

L. Clement de Ris, in his report on the Musées de Province, written in
1859, speaks of the canvases by Delaroche in the Musée des Beaux-Arts
at Nantes, in the following manner:

J'ai examiné ces toiles avec toute l'attention que mérite le nom de leur
auteur. Tout ce que l'étude intelligente et réfléchie peut donner, tout ce
que le travail et la persévérance peuvent produire s'y trouve. Rien de ce
qui ne s'enseigne pas n'y est. Partout on sent la réflexion et la volonté,
nulle part la vocation. Il semble que Delaroche ait peint par devoir.
(I have examined these canvases with all the attention which the
reputation of their artist deserves. Everything which intelligent, thought-
ful study can achieve, everything which work and perseverance can
contribute, is there. But there is nothing that could not be taught.
Everywhere one senses the reflection and the purpose, nowhere the
vocation. It seems to me that Delaroche regarded painting as a duty.)

P. Delaroche *La Barque de cérémonie du Cardinal Richelieu sur le Rhône*/The State Barge of Cardinal Richelieu on the Rhône, 1829. Oil on canvas 55 × 98 cm.

Notwithstanding the verdict of history, Delaroche was one of the most successful artists of his day. He disdained the hurly-burly of the Salon as he had no need of its support, but his great reputation did not survive after his death. The question asked by Gautier in 1857 as to what standing Paul Delaroche would have in relation to posterity has been answered by an almost total neglect of his work lasting for more than a century.

DELAUNAY, Jules-Elie
b. 1828 Nantes, d. 1891 Paris
Delaunay commenced his studies at the Ecole des Beaux-Arts in 1848, and in 1853 he achieved second place in the Prix de Rome competition, winning the Grand Prix three years later in 1856. A pupil of Hippolyte Flandrin, he became a successful history painter and executed a number of commissions for mural decorations in Nantes and in Paris. These included his most interesting and ambitious work in this medium, the *Attila et Sainte Geneviève* in the Panthéon. He remained true to the classical tradition stemming from Ingres, which was imparted to him by Flandrin, showing freedom of execution only in his sketches and small informal portraits.

DETAILLE, Jean-Baptiste-Edouard
b. 1848 Paris, d. 1912 Paris
Detaille showed a precocious talent for painting and at the age of seventeen he entered the *atelier* of Meissonier, making his début at the Salon two years later with a picture of his master's studio. He travelled in Spain and Algeria in 1868 and 1869, returning to Paris as the Franco-Prussian war broke out. He stayed in Paris throughout the war, enlisting as a *mobile*. He studied in the meantime, with his friend Alphonse de Neuville. The incidents of the war were to provide the subject matter for much of his subseqent work. Detaille became one of the best-known military painters of the period, and his extensive collection of military accoutrements and accessories which he had assembled in his studio – to ensure the accuracy of the details of his pictures – was left to the Musée de l'Armée, Paris.

DEUTSCH, Ludwig
b. 1855 Vienna, d. 1935
An Austrian by birth, Ludwig Deutsch became a naturalised Frenchman and made his career in Paris, exhibiting at the Salons and with the

J.-E. Delaunay *Mort de Nessus*/The Death of Nessus, 1870. Oil on canvas 95 × 125 cm.

Société des Artistes Français. After studying at the Wiener Akademie he entered the studio of J. P. Laurens in Paris. He travelled in Egypt and became a popular Orientalist painter, continuing in the minutely naturalistic style used by Gérôme and his circle from the mid 1850s.

FLANDRIN, Hippolyte-Jean
b. 1809 Lyons, d. 1864 Rome
Flandrin came from a family of artists. He was the son of J.-B.-J. Flandrin, who encouraged his sons to take up painting, and brother of Paul-Jean and Auguste. Hippolyte Flandrin studied in Lyons at the Ecole des Beaux-Arts until 1829 when he went to Paris on foot with his younger brother Paul-Jean. There he lived in conditions of abject poverty, studying with Ingres and preparing work for the Prix de Rome competition. In 1822 he won the Grand Prix de Rome, and he travelled to Italy in the following year. In 1834 he was joined in Italy by Paul-Jean, winner of the Prix de Rome for historic landscape, and in 1835 Ingres was made director of the Academy at the Villa Medici.

E. Fromentin *Le Pays de la soif*/The Land of Thirst, n.d.
Oil on canvas 103 × 143 cm.

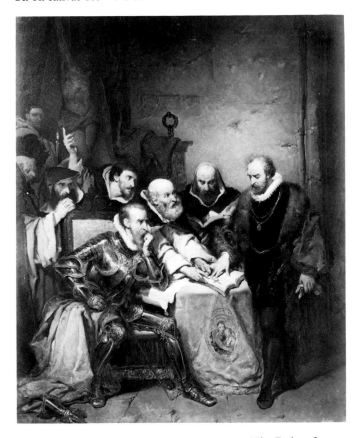

L. Gallait *Le Duc d'Albe faisant prêter serment*/The Duke of
Alba administering an Oath, 1855.
Oil on canvas 101 × 82 cm.

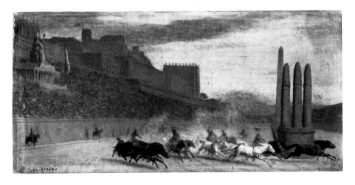

J.-L. Gérôme *La Course de chars*/The Chariot Race, c. 1876.
Oil on canvas 16.1 × 32.3 cm.

Hippolyte Flandrin did not return to Paris until 1839. While in Rome he made contact with Overbeck and the Nazarenes and turned his attention from history painting to religious subjects. On his return he received a number of commissions for decorative painting including the decoration of Saint Séverin (1840–1), Saint-Germain-des-Près (1842–6), Saint-Paul at Nîmes (1847–9) and Saint-Vincent-de-Paul (1849–53), returning to Saint-Germain-des-Près in 1856–61. He was greatly in demand as a portrait painter and is alleged to have turned down two hundred portrait commissions. His early poverty had affected his health, and in 1863 he went to Rome with his family to live, but he contracted smallpox only six months after his arrival there and died in 1864.

FRIANT, Emile
b. 1863 Dienze, d. 1932 Paris
Friant studied at the Ecole des Beaux-Arts in the *atelier* of Cabanel. He first exhibited in 1882 at the Salon, and in 1883 he achieved second place in the Prix de Rome competition. His best known picture, *Le Toussaint*, was bought from the Salon exhibition in 1889 by the State and hung in the Musée du Luxembourg. Vuillard is alleged to have admired the beautifully painted still-life of the bouquet of flowers carried by one of the mourners in *Le Toussaint*, discerning the real painterly talent beneath the sentimentality and banality of the subject matter.

FROMENTIN, Eugène
b. 1820 La Rochelle, d. 1876 Paris
Fromentin was the son of a doctor and was destined for the legal profession. When he made a belated decision in 1843 to become a painter his father, who was a gifted amateur painter and had studied with Bertin, sent his son to study with the landscape painter Rémond (himself a pupil of Bertin). Fromentin, however, was not happy with the classical tradition of landscape painting and he soon moved to the *atelier* of Louis Cabat, a romantic landscapist whose work was strongly influenced by Decamps. In 1844 Fromentin saw the Orientalist works of Prosper Marilhat exhibited at the Salon and immediately became fascinated by the East.

In 1846 he managed to pay a visit to North Africa with a fellow painter and he later returned twice more, in 1848 and in 1852–3. His debut at the Salon took place in 1847. He was already exhibiting the Orientalist subjects which were to be his speciality throughout his career and which, of necessity, pandered to the taste of his public. He published two travel books dealing with his explorations in Africa and a widely respected study of the painters of the Dutch school called *Les Maîtres d'autrefois*. He was the lone champion of Courbet on the Salon jury.

In 1855, when he returned from extensive travels in Algeria, Fromentin shared Gustave Moreau's studio. He became an intimate friend of his fellow painter, meeting him almost daily and discussing with him, during the remaining twenty years of his life, problems and solutions in artistic achievement. Fromentin died accidentally at the comparatively early age of fifty-six.

GALLAIT, Louis
b. 1810 Tournay, d. 1887 Brussels
A Belgian history painter of considerable reputation in his own time, Gallait studied for a period in Paris under Delaroche. He exhibited widely in many European capitals. His popularity was ensured by his position – similar to that of Delaroche in the previous generation – in the *juste milieu* between Classicism and Romanticism.

GEROME, Jean-Léon
b. 1824 Vesoul, d. 1904 Paris
The son of a silversmith, Gérôme studied drawing at his *lycée* before going to Paris and entering the studio of Paul Delaroche in 1839. He became one of Delaroche's most successful pupils and a friend of his master who accompanied him on a visit to Rome in 1844. After spending a year in Rome he returned to Paris and studied for a brief period with Gleyre, who had taken over Delaroche's studio, in order to be eligible to enter the Prix de Rome contest. He had no success in the competition, but in 1847 his picture *Jeunes Grecs faisant battre les coqs (Combat de coqs)* attracted the attention of Théophile Gautier at the Salon, and he wrote a long article in *La Presse* praising the picture. Gérôme became famous overnight.

Gérôme's success with *Combat de Coqs* encouraged him to paint another picture in the same manner. It also attracted a number of Gérôme's fellow students in Gleyre's *atelier* to emulate his stylistic tricks, and these pictures again attracted favourable notice from Gautier, who called the group *Les Néo-grecques* or *Pompéistes* ('Pompeians') in recognition of their sources of inspiration, from Greek vase

painting on the one hand to Roman wall paintings on the other.

From the time of his first success at the Salon, Gérôme was offered a number of lucrative commissions, including the murals for the Musée des Arts et Métiers, Paris and for the Chapel of St. Jérôme in St. Séverin in 1851; decorations for the Exposition Universelle in 1855 and the wall panels for Prince Napoleon's Pompeian palace in the avenue Montaigne in 1858. He was also offered 20,000 francs to paint a large allegorical work, *Siècle d'Auguste et la naissance du Christ*, marking the coincidental founding of both the Pax Romana and Christianity. This was exhibited in 1855.

In 1856 Gérôme went to Egypt with four friends for eight months, the first of several trips, which was to result in a whole new genre of painting for the artist, and from this date minutely detailed Orientalist pictures are mixed with the large Neo-Classical history paintings, the Napoleonic subjects and the seventeenth-century costume pictures. In 1863 Gérôme became a professor at the Ecole des Beaux-Arts and taught a long succession of students over the next thirty-nine years, only abandoning his *atelier* two years before his death.

In 1878 he took up sculpture which he practised with some success, though he continued to paint in order to subsidise his more ambitious and expensive sculptural experiments. His later years are marked by his notorious campaign against the Impressionists and against Manet in particular. His pronouncements on their work are now much quoted as evidence of nineteenth-century academic philistinism. Gérôme was awarded many honours as befits one of the most successful and popular artists of his time, but he outlived his popularity and even before his death his reputation was in decline. His work has only recently begun to attract critical reassessment but the photographic realism of his style still repels many people as it did the critics of the period.

GERVEX, Henri
b. 1852 Paris, d. 1929
A pupil of Cabanel and Fromentin, Gervex became an admirer of Impressionism and was instrumental in getting the work of Claude Monet shown at the Salon. He made some experiments with this style himself and found that it did not suit his mode of expression and returned to the academicism of his training and inclination. He executed a number of official commissions including a ceiling in the Hôtel de Ville and decorative panels in the foyer of the Opéra Comique in Paris. His subject picture *Rolla*, based on a story by Alfred de Musset, was refused by the Salon jury in 1878 on moral grounds, but his *Dr. Peau à l'hôpital de St. Louis* is a serious piece of social realism which inspired a spate of hospital subjects in emulation.

GIRARD, Victor-Julien
b. 1840 Paris, d. 1871 Paris
Pupil of his father, the history painter, Orientalist and caricaturist, Eugène Giraud, and the history painter, Picot, Girard exhibited at the Salon from 1863.

GIRARDET, Eugène-Alexis
b. 1853 Paris, d. 1907 Paris
Son of Paul Girardet, the Swiss history painter and engraver, Girardet attended the Ecole des Beaux-Arts in Paris and studied in Gérôme's studio. He specialised in Eastern subjects, as well as becoming known as an engraver. His brother, Paul Armand, also became a painter and engraver, studying in the *atelier* of Cabanel.

GIRARDET, Karl
b. 1813 Locle, d. 1871 Paris
Son of the Swiss artist Charles-Samuel Girardet, who moved with his family to Paris in 1822. He was a pupil of Léon Cogniet and executed a number of historical paintings in the manner of Delaroche. He first exhibited at the Salon in 1836 where his small genre scenes were a success, and he was attracted to the attention of Louis-Philippe who sent him with his brother Edouard on a trip to Italy and Egypt to gather material for one of the paintings for the historical museums at Versailles. Later Girardet was sent to Spain to record the marriage of the Duc de Montpensier. After the revolution in 1848 Girardet settled in Brienz. He is chiefly known as a forerunner of the Realist school who produced genre and landscape paintings and was also an Orientalist.

GLAIZE, Auguste-Barthélémy
b. 1807 Montpellier, d. 1893 Paris
Pupil of Achille and Eugène Devéria, Glaize exhibited at the Salon from 1836. His *Ecueils de la vie*, exhibited at the Salon in 1864, recalls Gleyre's

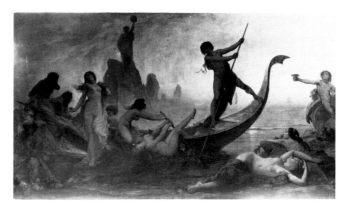

A.-B. Glaize *Les Ecueils de la vie*/The Trials of Life, 1864. Oil on canvas 126 × 252 cm.

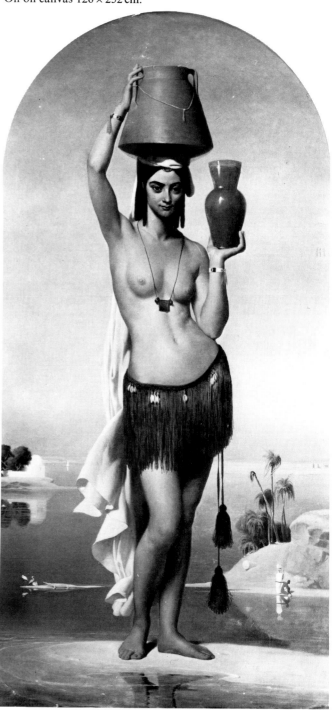

M.-C.-G. Gleyre *La Nubienne*/The Nubian Woman, 1838. Oil on canvas 220 × 109 cm.

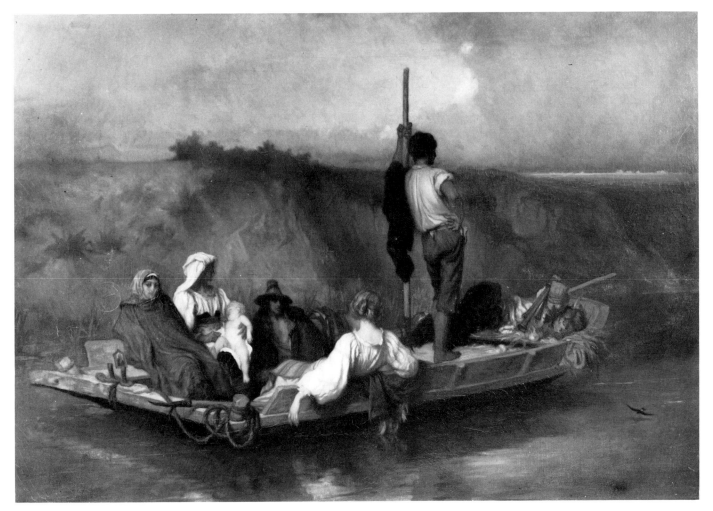

A. A. E. Hébert *La Mal'aria*/Malaria, 1850.
Oil on canvas 135 × 193 cm.

Illusions perdues of twenty years earlier being, like its predecessor, an allegory of life. His son Pierre, born in 1842, also became an artist and studied with his father and with Gérôme. He was awarded the *accessit* to the first prize in the Prix de Rome competition in 1866. Pierre's son, born in 1880, also became an artist. He was killed at the beginning of the First World War in September 1914.

GLEYRE, Marc-Gabriel-Charles
b. Chevilly (Canton de Vaud) 1808, d. Paris 1874.
Orphaned at the age of eight, Gleyre and his two brothers went to live with an uncle in Lyons. He showed a precocious aptitude for art so his guardian encouraged him to become a fabric designer, a *métier* entirely suited to an inhabitant of the silk-weaving centre of France. The encouragement of his teachers, however, made him resolve to concentrate on painting and in about 1825 he made his way to Paris, where he entered the studio of the history painter Louis Hersent. His studies completed, he made a voyage to Italy and arrived in Rome at the beginning of 1829, where he remained for four years. Here he made the acquaintance of many of the students at the French Academy in the Villa Medici, as well as that of Horace Vernet, then the Director of the Academy.

At the request of a rich American – who had asked Vernet to recommend to him a young artist to accompany him on a voyage to the East – Gleyre left Rome in 1834. His task was to make sketches at each important stopping-place of the country and also to draw the costumes of the inhabitants. The relationship between the patron and the artist deteriorated rapidly and at the end of 1835 they parted company. Gleyre remained in the Sudan where he lived in great poverty, ill and nearly blind for the most part of the next two years.

Having recovered his sight, he returned to his family at Lyons and thence, at last, to Paris at the beginning of 1838. These travels were to feed his inspiration for the rest of his career. Although he spent many years in a state close to abject poverty, he eventually knew success with

the showing of his allegory on the human condition, called *Le Soir* or *Les Illusions perdues*, which was exhibited at the Salon in 1843. In this year, influenced no doubt by Gleyre's Salon success, Paul Delaroche asked him to take over his studio, a studio which by virtue of his distinguished predecessors was one of the most celebrated in Paris, having been under the direction first of David and then of Baron Gros.

Gleyre occupies a position of far greater importance to the evolution of style in the nineteenth century than his reputation as a painter would suggest. This is because of the influence he exerted on the students who passed through his *atelier* in the twenty-one years of its existence. A misogynist and a recluse, he was none-the-less loved by his students, and the liberal teaching, which was a feature of his method, instilled the valuable academic discipline into his pupils without stifling their own characteristic artistic talents.

After his first success Gleyre received a number of valuable commissions both in Paris and from his native Canton of Vaud in Switzerland, but from 1849 he more and more eschewed public life. He did not exhibit at the Salon and he refused the Légion d'honneur. After rejection, on account of his age, as a volunteer in the Franco-Prussian war, Gleyre retired to Switzerland. Soon afterwards his always precarious health broke down again, and with some respite in 1872, he spent his remaining years as an invalid, dying three days after his sixty-second birthday in Paris.

GUILLAUMET, Gustave Achille
b. Puteaux 1840, d. Paris 1887
A pupil of Picot and Barrias, Guillaumet achieved the second prize in the Prix de Rome competition in 1861. He made his début at the Salon in the same year, and exhibited thereafter until 1880. His *Le Désert*, shown in 1868, was a success and led to his being called 'le premier de nos peintres Orientalistes'. He was greatly admired for his sincerity. His family presented *Le Désert* to the Louvre after his death, and his work was gathered together and shown at a retrospective exhibition in 1888.

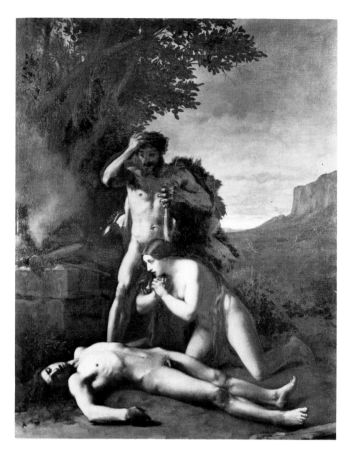

J.-J. Henner *Adam et Eve trouvant le corps d'Abel*/Adam and Eve Finding the Body of Abel, 1858. (Winner of the *Prix de Rome*).

HAMON, Jean-Louis
b. Côtes du Nord (St.-Loup-de-Plouha) 1821, d. St.-Raphaël (Var) 1874.
Hamon was the son of a customs officer, and was destined for the priesthood. However, he displayed an unmistakable artistic talent, and with the help of an award of 500 francs he was able to make his way to Paris. On the advice of Ingres he entered the Ecole des Beaux-Arts in 1842. He studied in the *atelier* of Charles Gleyre where he came into contact with Jean-Léon Gérôme.

His début in the Salon took place in 1847, the year in which Gérôme achieved his great success with the *Combat des coqs*. In the following year the two artists, with Henri-Pierre Picon, were hailed as the *Néo-grecques* or *Pompéistes* by Théophile Gautier. Hamon's most famous picture in this style, *Ma Soeur n'est pas là*, was exhibited in 1853, and became widely known through engraved copies. From 1848 until 1853 Hamon was employed as a designer at the porcelain manufactory at Sèvres. He was made a *chevalier* of the Légion d'honneur in 1855.

HEBERT, Antoine-Auguste-Ernest
b. 1817 Grenoble, d. 1908 Grenoble
Born into a family of bourgeois respectability, Hébert was sent to Paris to study law after completing his education at the *lycée* in Grenoble. Even while he was attending the course of legal studies he attached himself to the studio of the sculptor David d'Angers and also worked with Paul Delaroche. A success with his first Salon picture in 1839 determined his future course and he entered the Ecole des Beaux-Arts in the same year, winning the Grand Prix de Rome. In 1850 the enormous success of *La Mal'aria* established his reputation, and honours followed in quick succession – *chevalier* of the Légion d'honneur in 1853, member of the Institute in 1874 and professor at the Ecole des Beaux-Arts in 1882. He was twice director of the Academy in Rome, in 1867–1873 and 1885–1891. His native town of Grenoble retains a number of his pictures but *La Mal'aria* was bought from the Salon by the State and is now in the Musée Condé at Chantilly.

HENNER, Jean-Jacques
b. 1829 Bernviller (Alsace), d. 1905 Paris
Henner's early artistic studies were undertaken in Strasbourg under Gabriel Guérin, the curator of the Strasbourg Museum and professor at the Strasbourg Ecole de Dessin. In 1847, through the intervention of the local consul-general, he was able to make his way to Paris and enrol in the Ecole des Beaux-Arts where he studied under Drolling and Picot. In 1855 he was forced to return to Alsace to look after his mother who had become gravely ill, and during the two years he spent there he painted a number of portraits.

Returning to Paris in 1858 he won the Grand Prix de Rome. He made his début at the Salon in 1863 and his career as a painter was crowned with success from this date. He was heaped with honours, eventually becoming a *grand officier* of the Légion d'honneur in 1903. He left part of the contents of his studio to the city of Paris, and the four hundred paintings in this bequest now make up the collection of the Musée Henner.

HOUSEZ, Charles-Gustave
b. 1822 Condé, d. 1880 Valenciennes
Housez was a genre and history painter who studied at the Académie in Versailles before starting at the Ecole des Beaux-Arts in Paris in 1838. He entered for the Prix de Rome in 1848, achieving the third prize, and again in the following year when he was unplaced. He made his Salon début in 1845 and continued to exhibit there until his death with genre subjects, historical pictures and portraits. He was made a professor at his first school, the Académie des Beaux-Arts in Valenciennes.

JANMOT, Anne-François-Louis, (called Jean-Louis)
b. 1814 Lyon, d. 1892 Lyon
Janmot studied at the Ecole des Beaux-Arts in Lyon before arriving in Paris in 1832, where he entered the studio of Ingres. In 1834 he studied briefly with André Jacques Victor Orsel, a history painter who specialised in Neo-Classical and biblical subjects, before joining his previous master and the two Flandrin brothers in Rome. On his return he specialised in religious subjects, attaining a certain reputation in his native town. His Salon exhibit, *Fleur des champs*, attracted the attention

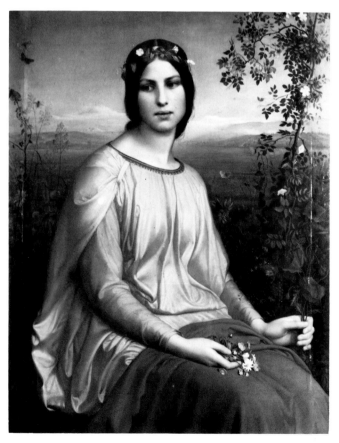

J.-L. Janmot *Les Fleurs des champs*/The Flowers of the Field, 1845.
Oil on canvas 100.3 × 83 cm.

E. J. H. Vernet *Chasse au lion*/The Lion Hunt, 1836.
Oil on canvas 57 × 82 cm.

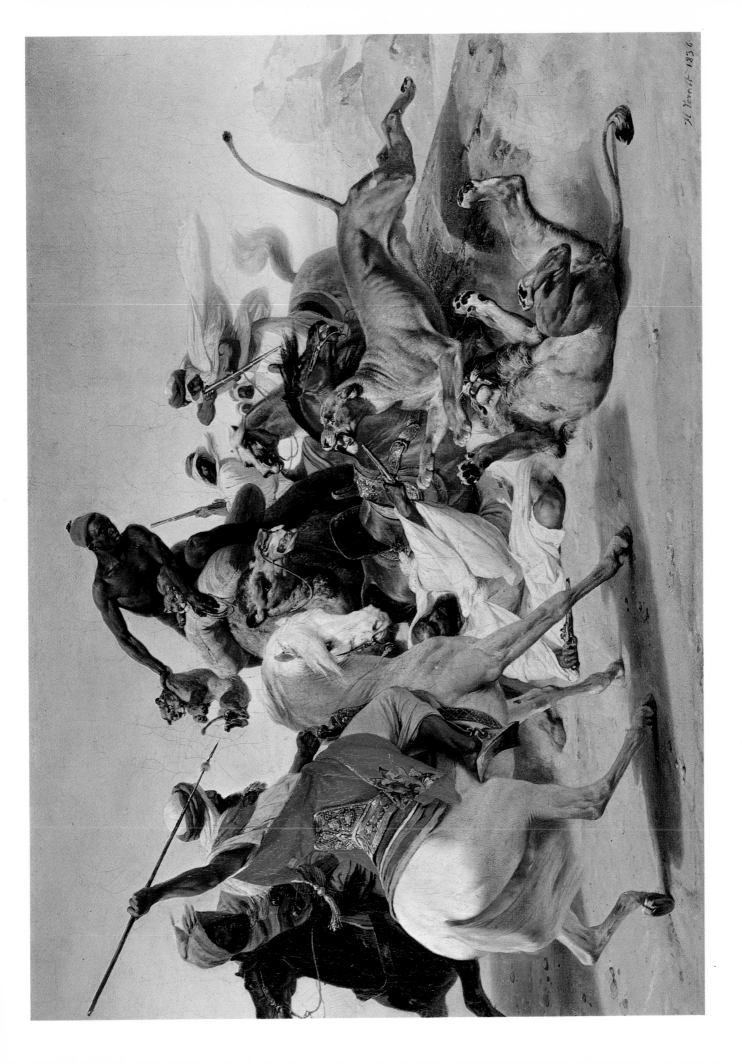

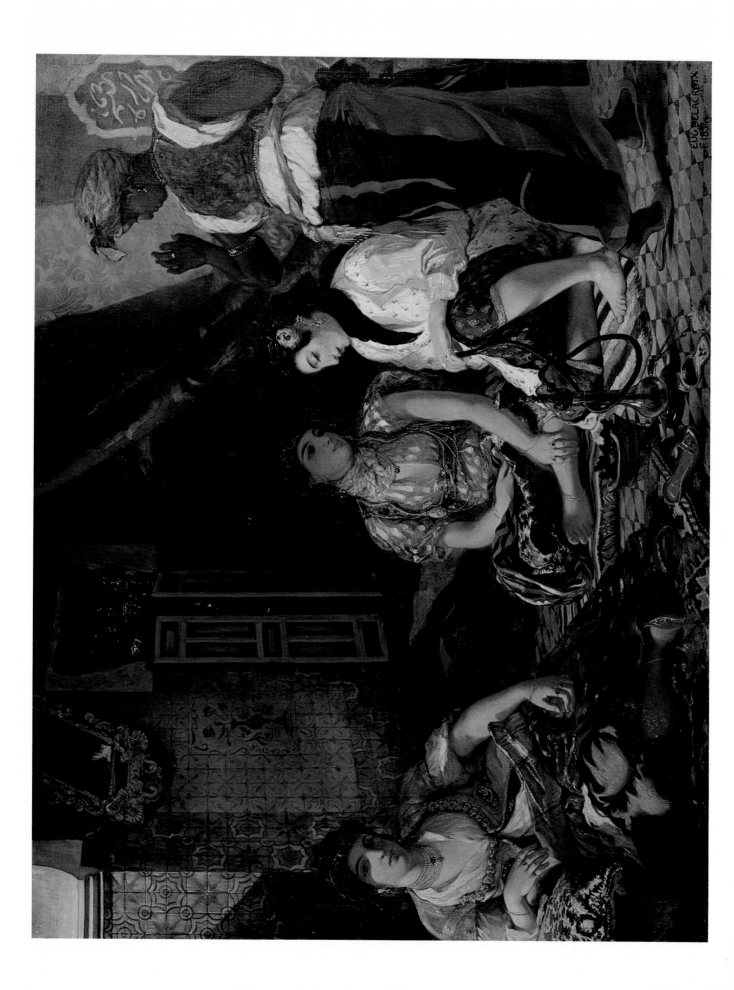

C. Landelle *Une femme arménienne*/An Armenian Woman, 1866.
Oil on canvas 131 × 82 cm.

of Baudelaire in 1845, who understood the romantic and poetic implications of the subject:–

> Cette simple figure, sérieuse et mélancolique, et dont le dessin fin et la couleur un peu crue rappellent les anciens maîtres allemands, ce gracieux Albert Dürer, nous avait donné une excessive curiosité de trouver le reste. (This simple figure, serious and melancholy, which, with its refined drawing and slightly crude colouring recalls the German masters of the past, this charming Dürer has given us an excessive curiosity about the other works by this artist.)

His most ambitious subject, the *Poème de l'Ame*, treated in a series of eighteen canvases and completed in 1854, had a mixed reception at the Exposition Universelle in 1855. It did not find favour with the public in spite of an enthusiastic notice by Delacroix and the two explanatory articles on the series by Théophile Gautier which had appeared in the previous year in the *Moniteur Universelle*. In the later years of his life Janmot was prevented, by family difficulties, from painting. The work of this period is almost all in the form of drawings. His *Opinion d'un artiste sur l'Art*, a collection of articles and letters published in 1887, provides a valuable source of information on the period as Janmot had a wide aquaintance amongst artists and writers in the forefront of the *avant-garde* of his day.

E. Delacroix *Femmes d'Alger dans leur appartement*/Algerian Women in their Quarters, 1834.
Oil on canvas 180 × 229 cm.

LANDELLE, Charles
b. 1821 Laval, d. 1908 Chennevières-sur-Marne
Landelle, a pupil of Paul Delaroche and Ary Scheffer, entered the Ecole des Beaux-Arts in 1839, completing his artistic education by travelling in North Africa. He made his début at the Salon in 1841, where he enjoyed immediate and rapidly increasing success. He made a speciality of smoothly sentimental religious pictures, history-paintings, genre scenes and subjects of Oriental interest. In this last manner his *Femme Fellah* enjoyed an enormous success. It was bought by Napoleon III from the Salon in 1866 and Landelle had to make a large number of replicas and versions of it to satisfy his admirers.

LAURENS, Jean-Paul
b. 1838 Fourquevoux (Haute-Garonne), d. 1921 Paris
Laurens showed an exceptional talent for painting from a very early age, but the extremely modest circumstances of his background made it difficult for him to realise his determined ambition to become an artist. Eventually he managed to make his way to Toulouse where he studied at the Ecole des Beaux-Arts, and finally to Paris, where, with the help of a bursary from the département of the Haute-Garonne, he became a pupil first of Léon Cogniet and then of Alexandre Bida.

Laurens made his début at the Salon in 1863, and his reputation was secured in 1872 when he won a first class medal. He was one of the last artists to make a success with the critics of an almost out-dated concept of history-painting in the grand manner. He was commissioned to provide some of the mural decorations for the new Hôtel de Ville in Paris, rebuilt after the Franco-Prussian War and the Siege of Paris in 1870–71, and he also contributed a *Mort de Sainte Geneviève* to the Panthéon decorations. He was awarded many medals and honours. Laurens replaced Meissonier as a member of the Institute and became director of the Academy of Toulouse.

LECOMTE DU NOÜY, Jean Jules Antoine
b. Paris 1842, d. Paris 1923
Lecomte du Noüy joined Gleyre's studio in 1861, in the last years of its existence. In 1864 Gleyre was forced to give up his teaching for health reasons, to the great regret of his pupils. On leaving the *atelier* Lecomte du Noüy studied for a while with Signol and then with Jean-Léon Gérôme (whose favourite pupil he became) in his recently acquired *atelier* at the Ecole des Beaux-Arts. He made his début at the Salon in 1863 and won second place in the Prix de Rome competition in 1872. In the same year he was awarded a second class medal at the Salon and his famous *Les Porteurs de mauvaises nouvelles* was acquired by the State for the Musée du Luxembourg.

On the strength of this long-awaited success Lecomte du Noüy was able to travel in Egypt, Turkey and Rumania. He took extensive notes on his travels and his archaeological drawings were used in his later paintings. His precision of execution, much admired during his lifetime, indicates the debt he owed to his master Gérôme. He was an accomplished portrait painter, and successfully executed commissions to paint the King and Queen of Rumania led to decorative work in Rumanian churches being offered to him.

LEGROS, Alphonse
b. 1837 Dijon, d. 1911 London
Legros was made an apprentice to a scene-painter, Cambon, before becoming a pupil at the school run by Lecoq de Boisbaudran, master of both Fantin-Latour and L'Hermitte, whose regime of drawing was famous for its severity. He made his début at the Salon in 1857 and in 1859 his *Angélus* attracted the attention of Baudelaire. Thereafter he exhibited regularly, but with only limited success, in spite of the advocacy of Hippolyte Flandrin who had hoped to persuade the jury to award him a medal for his *Ex-Voto* (1861). After further disappointments Legros decided, in 1863, to accept the invitation of his friend Whistler to go to England. Here he was immediately successful and was offered a valuable post in 1876 at University College as Professor of Fine Art at the Slade School.

His work is dominated by the religious genre of his early Salon paintings, but he was also an accomplished etcher. Legros taught etching at the South Kensington Schools when he first came to England, and was also an occasional sculptor and medallist. He became a British subject in 1880 and his work is to be found in many British galleries.

LEHMANN, Karl-Ernest-Rodolphe-Heinrich-Salem
b. 1814 Kiel, d. 1882 Paris
Born in Holstein, the son of the portrait painter Leo Lehmann, Karl

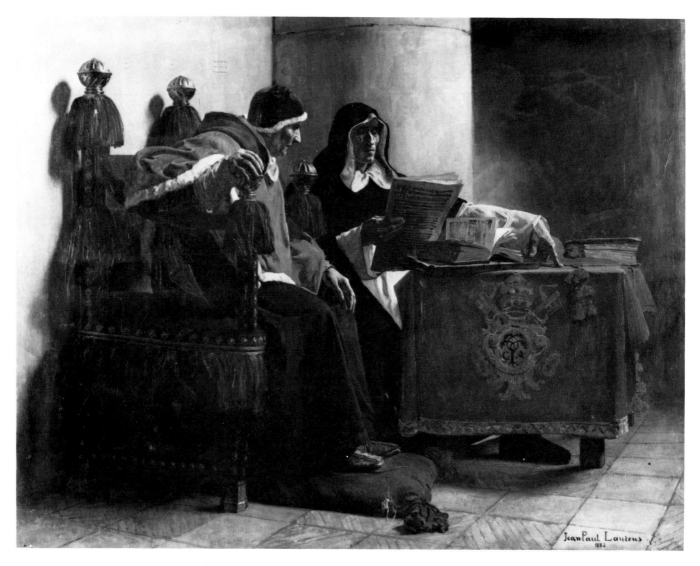

J. P. Laurens *Le Pape et l'inquisiteur*/The Pope and the
Inquisitor, 1882.
Oil on canvas 113 × 134 cm.

studied with his father before arriving in Paris in 1831 where he entered
the *atelier* of Ingres. He was regarded as one of Ingres' best pupils, a
distinction he shared with Hippolyte Flandrin (q.v.). In 1858 it was
written of him that he was:–

> Un des élèves de M. Ingres qui sont arrivés le plus promptement aux
> commandes officielles. Avec la réputation d'un peintre préoccupe du
> grand style, c'est simplement un homme assez adroit, mais d'un adresse
> vulgaire, qui s'est fait une manière avec celle des Allemands modernes
> melangée à celle de M. Ingres. Cet amalgame produit, à mon sens, un
> odieux résultat, mais qui plaît aux architectes, qui prennent cette cuisine
> pittoresque pour du grand style.
> (... Among those of Ingres' pupils who most promptly attracted official
> commissions. He had the reputation of being a painter in the grand style
> but he was simply a man with sufficient facility and a vulgar instinct who
> evolved for himself a manner in which the style of the modern German
> painters was mixed with that of M. Ingres. In my view this mixture
> produced an unattractive result, but it was one which commended itself to
> architects, who took this picturesque recipe for the grand style.)
> Note on Lehmann in the *Dictionnaire de poche des artistes contemporains*,
> Pelloquet, 1858.

Lehmann was naturalised as a Frenchman and took the name Charles
when he came to Paris. He made his début at the Salon in 1835, winning
a second-class medal in the same year. He was regarded as one of the
most rigidly academic artists of the period, a reputation of which he was
proud, and he founded a prize designed to encourage the maintenance of
the academic tradition.

LENEPVEU, Jules-Eugène
b. 1819 Angers, d. 1898 Paris
A pupil of Picot, Lenepveu was awarded the second prize in the Prix de
Rome contest in 1844. In 1847 he achieved the first prize, having entered
the competition at least six times between 1841 and 1847. He became a
prolific mural painter and a successful portraitist. In 1872 he was made
director of the Académie de France in Rome.

LEVY, Emile
b. 1826 Paris, d. 1890 Passy
A pupil of Abel de Pujol and Picot, Lévy won the Grand Prix de Rome
8n 1854. He had already made his début at the Salon in 1848. He was
awarded the Légion d'honneur in 1867. In 1885 he began the decoration
of the Mairie of the 16ième arrondissement, completed in the year of his
death.

LEVY, Henri Leopold
b. 1840 Nancy, d. 1904 Paris
Pupil of Picot, Fromentin and Cabanel he entered the Ecole des Beaux-
Arts in 1856, and made his début at the Salon in 1865. In 1872 his Salon
exhibit, the large composition of the *Hérodiade*, was awarded the Légion
d'honneur. He participated in the decoration of the Panthéon, as well as
various other elaborate schemes including the new Hôtel de Ville.

LUMINAIS, Evariste Vital
b. 1822 Nantes, d. 1896 Paris
A pupil of Léon Cogniet and the landscape painter Constant Troyon,

Luminais made his début at the Salon in 1843. He concentrated mainly on genre and history-painting. His career at the Salon was marked by a succession of medals and he was awarded the Légion d'honneur in 1869.

MARILHAT, Prosper-Georges-Antoine
b. 1811 Vertaizon (Puy-de-Dôme), d. 1847 Thiers

Marilhat was a landscape painter who found his most potent inspiration in the East. He made his début at the Salon in 1831. In the same year he departed for Greece, Egypt and Asia Minor, employed as a draughtsman attached to a scientific expedition led by Baron von Hugel which lasted until 1833. In spite of a tour of the provinces of France, undertaken in the company of Corot in 1836, Marilhat continued to draw on his Eastern experiences throughout his career. He exhibited at the Salon until 1844 and died at an early age in 1847.

MEISSONIER, Jean-Louis-Ernest
b. 1815 Lyons, d. 1891 Paris

Meissonier came to Paris from Lyons as a child but returned to his native town to study classics and mathematics. He then went to Grenoble to complete his education before being apprenticed to a pharmacist. He eventually managed to persuade his father to allow him to study as a painter, first with Antoine-Julien Potier and then with Léon Cogniet. He was influenced by the Dutch genre painters of the

J. E. Lenepveu *La Mort de Vitellius*/The Death of Vitellius, 1847. (Winner of the *Prix de Rome*).

P.-G.-A. Marilhat *L'Erechtheion d'Athènes*/The Erechtheum at Athens, 1841.
Oil on canvas 74 × 93 cm.

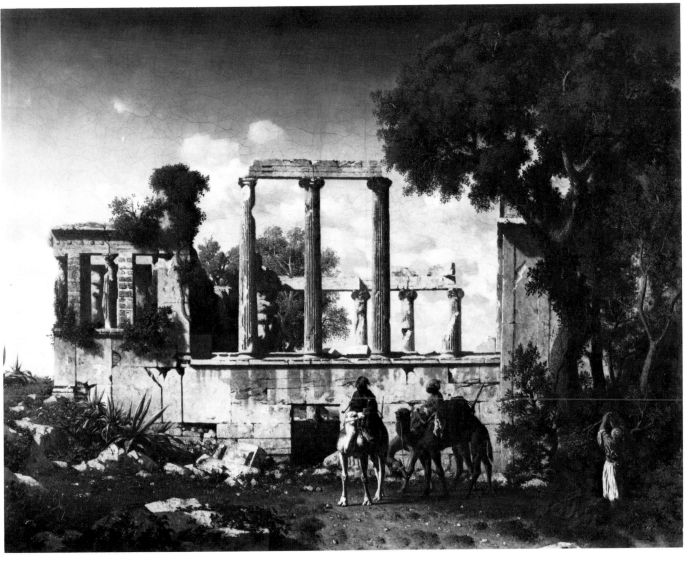

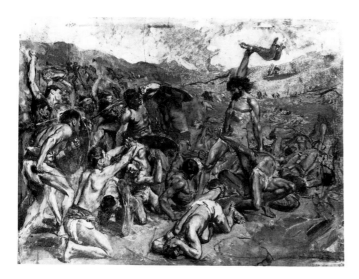

J.-L.-E. Meissonier *Samson abattant les Philistines*/Samson overthrowing the Philistines, c. 1845.

seventeenth century as well as being interested in the practice of *plein air* painting in the manner of the Barbizon school.

Meissonier made his début at the Salon in 1834 before going to Rome to continue his studies. When he returned his father established him in a studio in Paris where he remained until he moved to Poissy in 1845. His first marked success came in 1855 when Napoleon III purchased *The Brawl* from the Salon and presented it to Prince Albert. Early in his career Meissonier conceived the idea of painting a cycle of five paintings based on incidents in the life of Napoleon I. He returned continuously to the project throughout his life, but only two works were ever completed – the relatively large-scale *1807*, representing the battlefield at Friedland (now in the Metropolitan Museum), and *1814*, showing the retreat from Moscow through the Russian winter (now in the Louvre).

His method of working involved making innumerable sketches which, coupled with the meticulously detailed finish of each picture, inhibited the production of large-scale works. Even the size of the Friedland picture, which is not large by most Salon painters' standards, involved him in nearly fifteen years labour. He is best remembered for the small, intimate pictures in the Dutch style of which the Louvre and the Wallace Collection in London have many examples. Meissonier was immensely successful throughout his career and won countless honours. He was the first artist to receive the *grand croix* of the Légion d'honneur in 1878.

MULLER, Charles-Louis
b. 1815 Paris, d. 1892 Paris
Muller entered the Ecole des Beaux-Arts in 1831 and studied with Baron Gros and Léon Cogniet. He made his début at the Salon in 1834 and exhibited there regularly until his death. He became a notable history painter, working for the Musée de l'Histoire at Versailles, established by Louis-Philippe to enshrine the official art of France and to record the glorious episodes of history from the time of Charlemagne. Muller was successful both with the public and with the art establishment. He received medals at the Salon and became a *chevalier* of the Légion d'honneur in 1849. His best-known picture *L'Appel des derniers victimes de la Terreur* was exhibited at the Salon in the following year and subsequently became part of the collection at Versailles. Muller painted Orientalist subjects and genre pictures as well as the history paintings.

NEUVILLE, Alphonse Marie de
b. 1835 Saint-Omer (Pas-de-Calais), d. 1885 Paris
Having overcome the opposition of his parents to his chosen career, de Neuville studied painting under Picot and Delacroix. He made his début at the Salon in 1859 and immediately found his place amongst the successful military painters of the period. He was scrupulous in his attention to detail and his studio housed a considerable collection of militaria which de Neuville used in setting the groups for his pictures. The Franco-Prussian war of 1870 provided him with a rich source of subject matter and, with his pictures of episodes from the conflict, he became one of the most popular painters in this genre. He collaborated with his fellow military painter Edouard Detaille on the huge panoramas of the *Bataille de Rezonville* and the *Bataille de Champigny*, which is now in the Musée Historique at Versailles.

C. L. Müller *Marie Antoinette dans la Conciergerie*/Marie Antoinette in the Conciergerie, n.d. Oil on panel 57.7 × 45 cm.

D. Papety *La Tentation de Saint Hilarion*/The Temptation of Saint Hilary, Salon 1844. Oil on panel 50 × 65 cm.

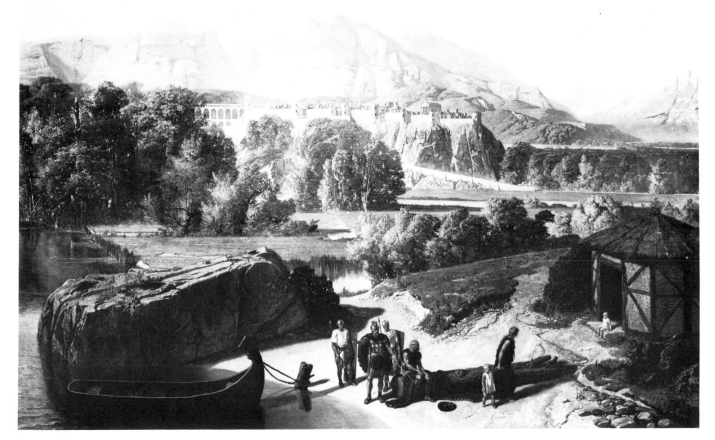

O. Penguilly l'Haridon *Ville romaine bâtie aux pieds des Alpes dauphinoises*/Roman Town built at the Foot of the Dauphiné Alps, 1870. Oil on canvas 131 × 268 cm.

PAPETY, Dominique Louis
b. 1815 Marseilles, d. 1849 Marseilles

Papety studied painting under Léon Cogniet and won the Grand Prix de Rome in 1836. During his stay at the Villa Medici in Rome he came under the influence of Ingres. He made his début at the Salon in 1843. In 1845 in his review of the Salon Baudelaire said of him: 'Papety promettait beaucoup. Son retour d'Italie fut precédé par des éloges imprudents. (Papety promised much. His return from Italy was preceded by imprudent eulogies), and went on to criticise his over-academic approach. Papety was to have little time to show if he was capable of throwing off the academic yoke – an uneasy legacy of his admiration for Ingres – as he contracted a disease while travelling in the East and died aged only thirty-four.

PENGUILLY L'HARIDON, Octave
b. 1811 Paris, d. 1870 Paris

After having served as an artillery officer, Penguilly L'Haridon became a pupil of the Bonapartist military painter Nicolas Charlet. He made his début at the Salon in 1835, and exhibited there until his death. He was admired by Baudelaire who wrote of his *Les petites mouettes; rivage de Belle-Isle-en-Mer, Port Douan* (Salon 1859):

> L'azur intense du ciel et de l'eau, deux quartiers de roche qui font une porte ouverte sur l'infini (vous savez que l'infini parait plus profond quand il est plus reserré), une nuée, un multitude, une avalanche, une plaie [sic] d'oiseaux blancs, et la solitude! Considerez cela, mon cher ami, et dites-moi ensuite si vous croyez que M. Penguilly soit dénué d'esprit poetique.
>
> (The intense blue of the sky and the water, the two rocks which form a door open upon the infinite (you must realise that the infinite seems all the more intense the more it is restricted), a cloud, a multitude, an avalanche, a *plague* of white birds – and solitude! Reflect on that, my dear friend, and tell me then if you think that M. Penguilly's mind is devoid of poetry).

PILS, Isidore Alexandre Augustin
b. 1813 Paris, d. 1875 Douarnenez

Having studied at the Ecole des Beaux-Arts under Lethière and Picot,

Pils won the Grand Prix de Rome in 1838. He started as a painter of religious genre scenes without a very original talent, but during the Crimean War he found his true *métier* as a military painter, and in this genre he was very successful.

PROTAIS, Alexandre
b. 1826 Paris, d. 1890 Paris

A pupil of A. Desmoulins, Protais exhibited at the Salon from 1857. Like Pils he found the inspiration for his pictures in the Crimean War, when he followed the French Army during the campaign. An extremely courageous man, he was three times wounded through taking up a position of considerable danger in order to see the incident he wished to paint more clearly. His picture, *Avant l'attaque*, had a great success at the Salon of 1863(?)

Henry James described the picture in glowing terms:

> Everything is admirably rendered – the cold dawn, the half-scared, half-alert expression of the younger soldiers, and the comparative indifference of the elder. It is plain that M. Protais knows his subject. (In a review of *Contemporary French Painters* by P. G. Hamerton, which appeared in the *North American Review*, in April 1868.)

REGNAULT, Henri Alexandre Georges
b. 1843 Paris, d. 1871 Buzenval

Son of the chemist, Victor Regnault, who was the Director of the National Porcelain Manufactory at Sèvres, Regnault entered the Ecole des Beaux-Arts at the age of seventeen and studied with Lamothe (himself a pupil of Ingres) and Cabanel. He won the Grand Prix de Rome in 1866, having received a *mention* in 1862. He competed again in 1865 without success, before achieving the prize in the following year. He left for Rome in 1867, but was advised to leave for reasons of health and in 1868 he went to Madrid where he made contact with the most widely known contemporary Spanish artist, Mariano Fortuny. He travelled to Morocco by way of Andalucia and Granada where, inspired by the Alhambra, he painted his savage image of the Moorish rule in Spain, the *Exécution sans jugement*.

Regnault acquired a plot of land in Tangier and built himself a studio

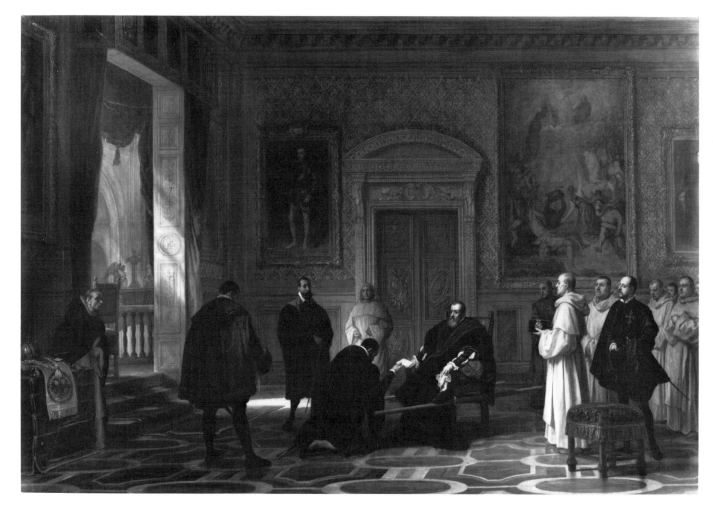

J. N. Robert-Fleury *Charles-Quint au monastère de Yuste*/Charles V at the Monastery of Yuste, 1856.
Oil on canvas 102 × 146 cm.

in which to execute the masterpiece of his dreams – a great Oriental subject. However, the thought of Paris besieged by the Prussians made him decide to return to France to join the army, in spite of the fact that as a *pensionnaire* of the Académie de France in Rome he was exempt from military duty. He was killed in the village of Buzenval in January 1871, just before Paris capitulated to the victorious German troops. A posthumous exhibition of his work was mounted in 1872.

ROBERT-FLEURY, Joseph Nicolas
b. 1797 Cologne, d. 1890 Paris
Robert-Fleury was sent to Paris to study painting by his family, and he worked in the *ateliers* of Girodet, Gros and Horace Vernet respectively. He travelled in Italy before exhibiting at the Salon, making his début there in 1824 and winning a second-class medal in the same year. He had considerable success at the time of the restoration of the monarchy when his style of vigorous and accurately rendered history painting was approved by the King and the State. Robert-Fleury was awarded the Légion d'honneur in 1836, and became a *commandeur* in 1867. In 1855 he became a professor at the Ecole des Beaux-Arts, rising to be director in 1863. He became director of the French Academy in Rome in 1865.

ROBERT-FLEURY, Tony
b. 1837 Paris, d. 1911 Viroflay
Son of Joseph Nicolas Robert-Fleury, he studied with Paul Delaroche and Léon Cogniet, and became a history and genre painter in the academic tradition. His career almost repeats that of his father. He was awarded the Légion d'honneur in 1884 and in 1907 he became a *commandeur*, a high honour which was rarely bestowed. Robert-Fleury became an influential teacher at the Académie Julian, a painting school started in 1873 by the minor genre and portrait painter, Rodolphe Julian. Both Bouguereau and Jules Lefebvre, winners of the Grand Prix

de Rome, taught there but the bias was often away from the academic tradition – one of the branches of the Académie having nurtured the talents of the leading Nabi painters. He carried out a number of commissions for mural-painting, notably in the Hotel de Ville in Paris. His work was considered to be backward-looking, even in 1870, and he long out-lived the relevance of the tradition of painting in which he worked.

SCHEFFER, Ary
b. 1795 Dordrecht, d. 1858 Argenteuil
Scheffer was born in Holland, the son of a genre and portrait painter of German origin who had married Cornelia Lamme of Dordrecht, herself an amateur artist. Both parents promoted the artistic activities of their children and two of them, Ary and Henry, became painters. Ary showed an exceptional talent for painting at an early age and when his father's premature death in 1809 caused the family to move to Paris, he entered the studio of Pierre Paul Prud'hon. Scheffer stayed there for only a short time before going, in 1811, to study under Pierre Narcisse Guérin and at the Ecole des Beaux-Arts. He exhibited at Salon from 1814 specialising, at this period, in small genre paintings and a series of history pictures based on the life of St. Louis – which had considerable success with both public and critics.

In the 1820s Scheffer moved towards a broader and more ambitious treatment, influenced by the work of Géricault and Delacroix, emulating the latter in his choice of subject matter from incidents in the Greek war of Independence. As a history painter Scheffer inevitably came to the notice of Louis-Philippe. He became one of the King's favourite painters and drawing-master to his children. At this period Scheffer's work began to show the influence of the religious and literary themes for which he is now best known. The popularity of these pictures can be assessed, to some extent, by the number of versions which exist of the most famous subjects such as *St Augustin et Ste. Monique* and *Francesca da Rimini*.

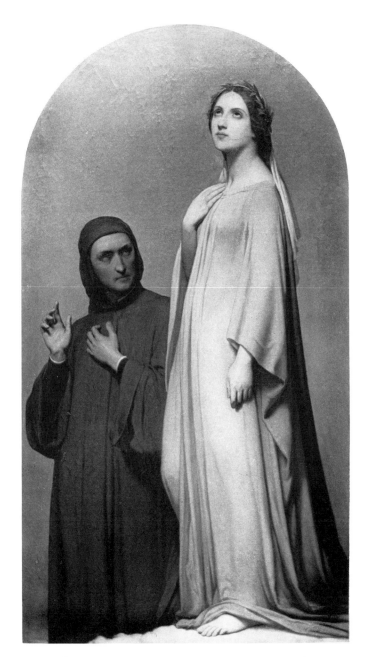

A. Scheffer *La Vision de Dante et Béatrice*/The Vision of Dante and Beatrice, 1846.
Oil on canvas (arched top) 200.6 × 109.8 cm.

Thoré-Burger wrote of *Saint Augustin et Sainte Monique* in his *Salon de 1846*:

> Il est impossible de mieux exprimer par la physionomie l'extase religieuse. L'âme de la sainte paraît détachée de son enveloppe terrestre et montant vers Dieu sur le rayon du regard.
> (It is impossible to express religious ecstasy more successfully through the facial expression. The soul of the saint appears to have left its earthly envelope and to be floating towards God on the light from her eyes.)

This was not an experience shared by either Baudelaire or Etex – Baudelaire found the picture absurd and Etex revealed that the models for the two figures were Scheffer himself and his mother – therefore believing that he had demonstrated the basic flaw in this attempt to portray a state of ecstasy. In fact Etex was mistaken. In this picture, which is now in the National Gallery in London, the model for the figure of Sainte Monique was actually Mrs. Hollond, wife of Robert Hollond, M.P. for Hastings, herself a distinguished writer and philanthropist. The Hollonds lived for part of each year in Paris where Mrs. Hollond presided over a Salon, with a decided literary bias, which was also a Royalist meeting place. In her patronage of – and thus by definition –

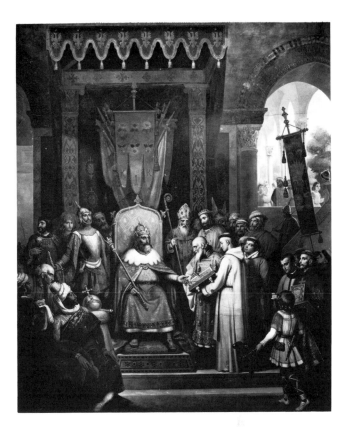

J.-V. Schnetz *Charlemagne entouré de ses principaux officiers reçoit Alcuin*/Charlemagne and his Principal Officers receive Alcuin.
Ceiling of the hall of antique ceramics, Musée du Louvre.

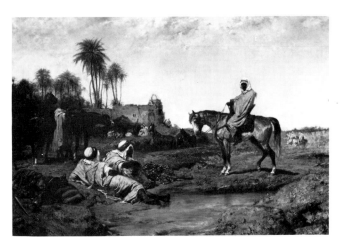

A. Schreyer *La Halte aux puits*/The Halt at the Well, 1862.
Oil on canvas 110.8 × 159.1 cm.

admiration for Scheffer, she would qualify as one of Baudelaire's 'femmes esthétiques qui se vengent de leurs fleurs blanches en faisant de la musique religieuse' (aesthetic women who take their revenge on the curse of their sex by making sacred music).

Scheffer's German ancestry is commemorated in his obsessive interest in German romantic poetry, many of his subjects being taken from the work of Goethe and Schiller. He died in 1858.

SCHNETZ, Jean Victor
b. 1787 Versailles, d. 1870 Paris
Schnetz studied with the leading Neo-Classical painters of the day – J. B. Regnault and J.-L. David, and also briefly with Baron Gros and François Gérard. He entered the Prix de Rome competition in 1816 and won a second prize. In the following year he travelled to Rome. He met Léopold Robert in 1818. Robert had a profound influence on his style

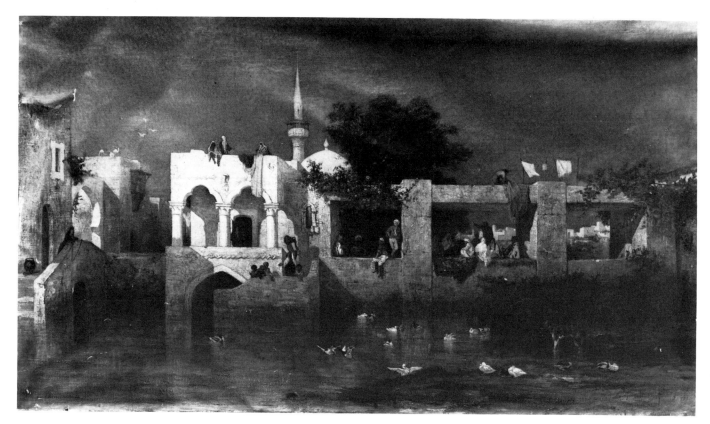

C.-E. V. de Tournemine *Habitations turques près
d'Adalia*/Turkish Buildings near Adalia, 1859.
Oil on canvas 69 × 124 cm.

and many of Schnetz's pictures use Italian peasants in their traditional
dress as models. Schnetz was made a *chevalier* of the Légion d'honneur
in 1835 and a *commandeur* in 1866. He was director of the Ecole des
Beaux-Arts from 1837 to 1841 and twice director of the French
Academy in Rome during the years 1841–47 and 1853–66.

SCHREYER, Adolf
b. 1828 Frankfurt, d. 1899 Gronberg
An artist of German origin who worked in Paris, Schreyer studied first at
the Institute Staedel in Frankfurt and then at the Düsseldorf Academy.
He lived in Vienna from 1849 and travelled in North Africa after having
followed the Crimean campaign as an official war artist. Schreyer
became fascinated by the East and painted a number of Orientalist
subjects in addition to the military pictures and landscapes which
occupied him at the beginning of his career. He lived in Paris from 1862
until 1870, and was awarded a medal at the Salon in 1864 and 1865,
attracting the attention of Théophile Gautier at the same time. His work
was also greatly appreciated in Holland and he was made a member of
the Académies in Rotterdam and Amsterdam.

TOURNEMINE, Charles-Emile Vacher de
b. 1812/4(?) Toulon, d. 1872/3(?) Toulon
De Tournemine, the son of a general, was born into an aristocratic
French family. He began his career as an artist by painting landscapes in
Normandy and Brittany, but he found his true vocation as an Orientalist
after travelling in Turkey, Egypt and Africa.
 Ernest Chesneau, the critic, wrote of his work at the time of the
Exposition Universelle in 1867:–

> Les tableaux de M. de Tournemine sont depuis longtemps en possession
> de la faveur publique. Je ne sais si l'Orient est aussi pimpant, aussi pavé,
> aussi charmant qu'il nous le présente... M. de Tournemine s'est taillé son
> royaume de peintre dans la Turquie d'Asie. Il n'y a pas d'artiste qui ait
> plus que lui le don de vous faire aimer le pays qui l'a charmé.
> (M. de Tournemine's pictures have been in favour with the public for a
> long time. I don't know that the Orient is really so elegant, so decorative,
> so charming as it is here presented... M. de Tournemine has quarried his
> kingdom of art in Turkey. There is no other artist who has, to a greater
> extent than him, the gift of making you love the land which has fascinated
> him).

J.-L. Gérôme *Joueurs de dames*/The Draughts
Players, 1859.
Oil on panel 43 × 29 cm.

E. J. H. Vernet *La Bataille de Valmy, 1792*/The
Battle of Valmy, 1792, 1826.
Oil on canvas 175 × 287 cm.

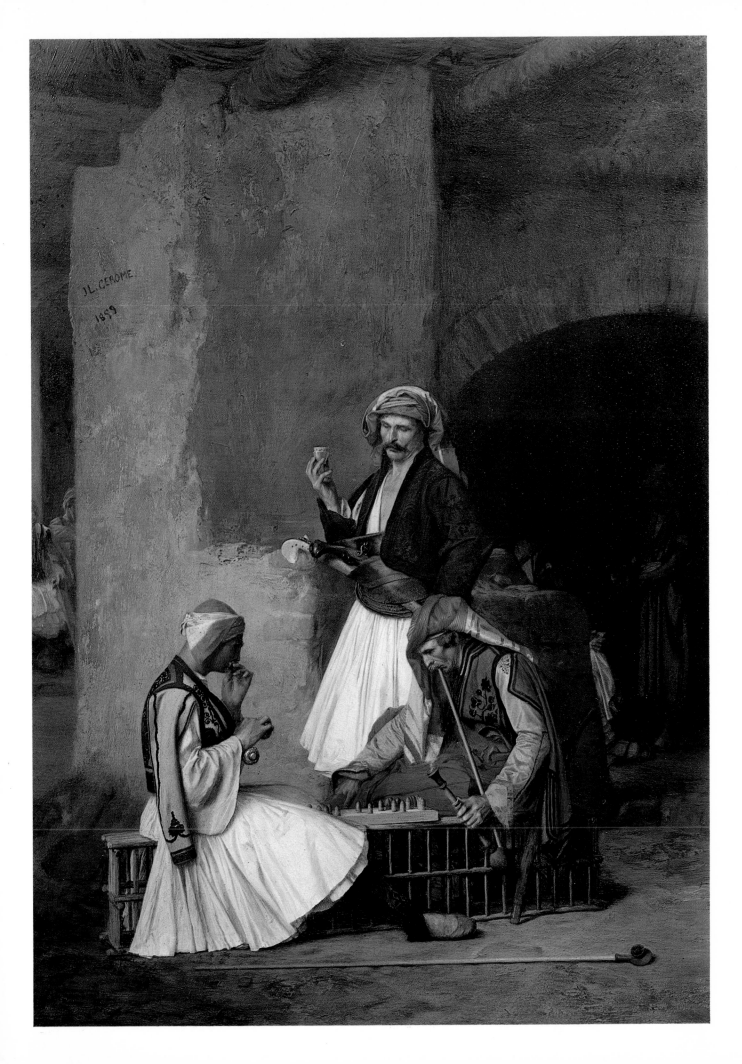

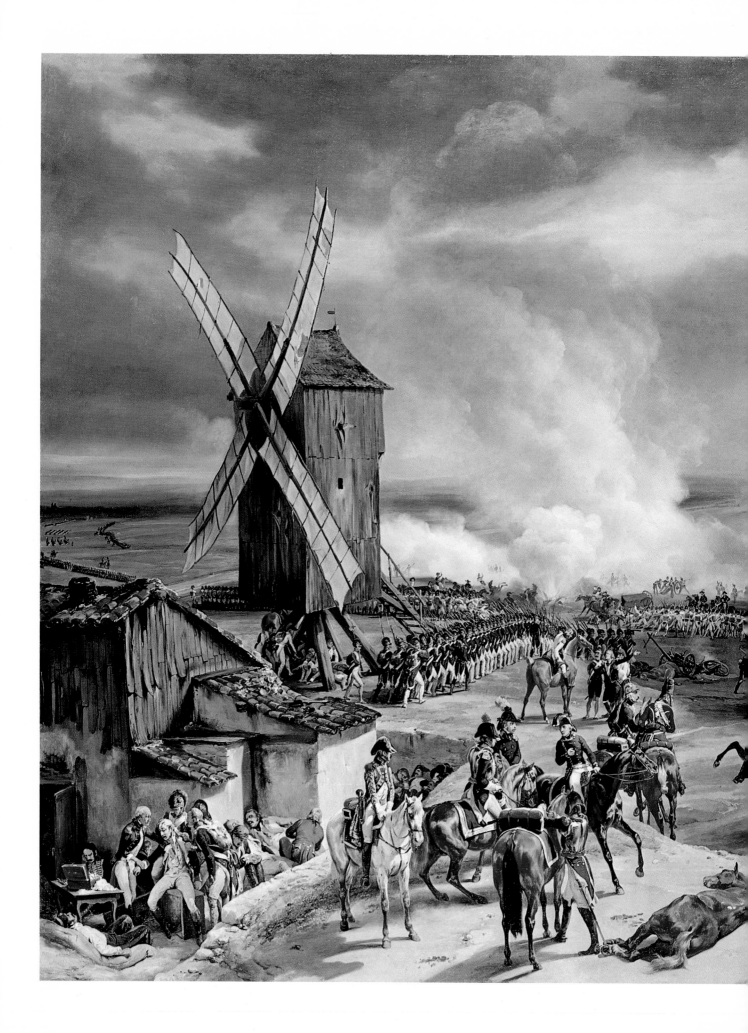

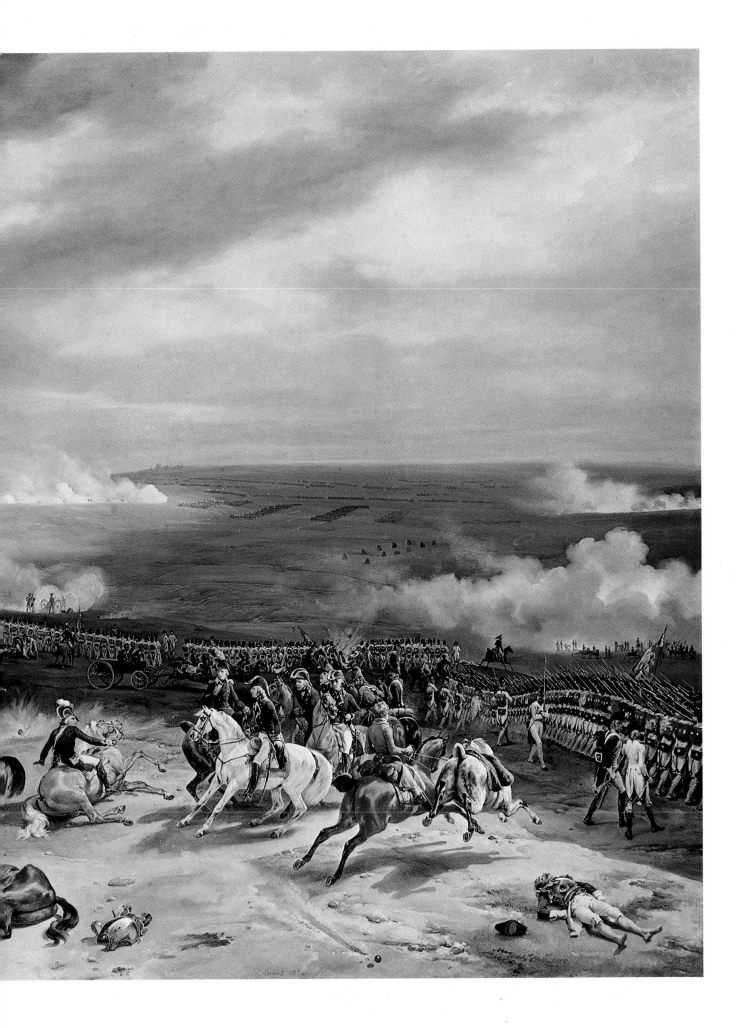

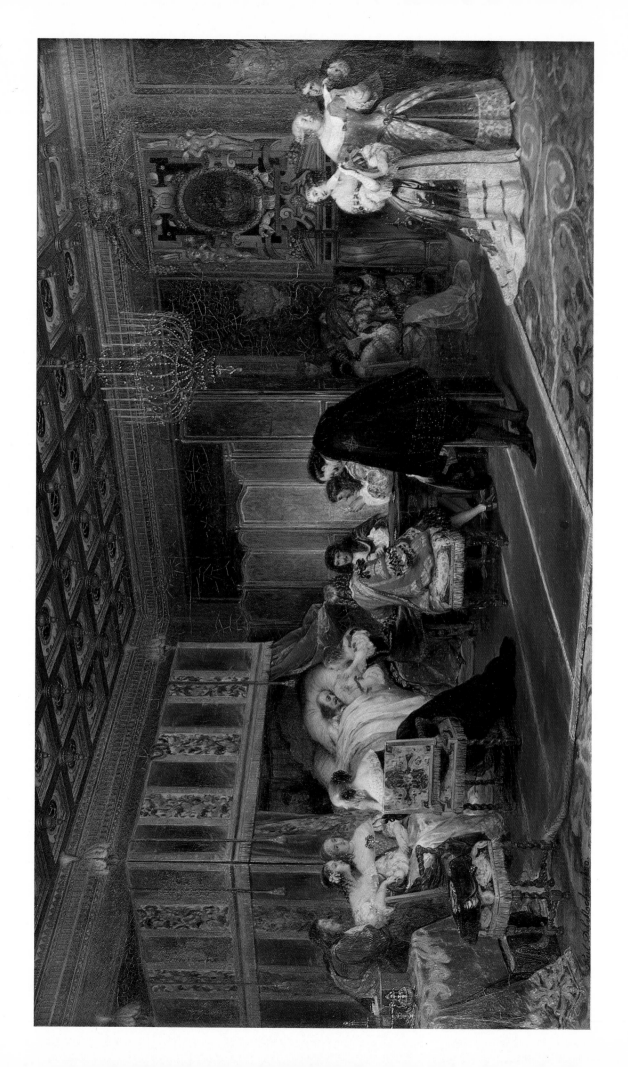

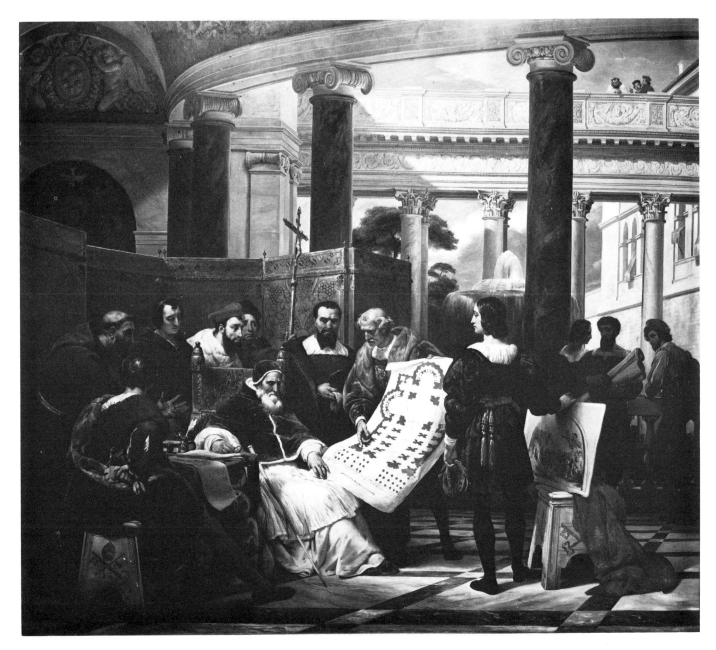

E. J. H. Vernet *Jules II ordonnant les travaux du Vatican et de Saint-Pierre à Brumante, Michel-Ange et Raphael*/Julius II giving Orders for the Building of the Vatican and Saint Peter's to Brumante, Michaelangelo and Raphael, 1827.
Ceiling of Hall B of Egyptian antiquities, Musée du Louvre.

VERNET, Emile Jean Horace
b. 1789 Paris, d. 1863 Paris
Son and grandson of successful artists, Horace Vernet was born in the Louvre where his father, Carle Vernet, was then living. His grandfather was the eminent landscape painter Joseph Vernet. Vernet studied with his father and with François-André Vincent. He made his début at the Salon in 1810 with a military subject taken from an incident in the Napoleonic wars, an interest he could hardly avoid as he had known his country in a state of warfare since his early childhood. Having identified himself as a Bonapartist through his choice of subject matter, the restoration of the Bourbon monarchy in 1815 resulted in a temporary loss of official support. Fortunately his work continued to find favour with the duc d'Orléans (the future King Louis-Philippe) and his intervention on Vernet's behalf eventually re-established him in official favour.

In 1820 Vernet travelled to Rome with his father and on his return he exhibited pictures which had been rejected in 1822 by the Salon for political reasons. In 1826 he was elected a member of the Institute and in 1827 he became director of the French Academy in Rome. He followed the French campaign in Algiers in 1833, looking for subject matter, and became fascinated with the East. He made two more trips to North Africa in 1839 and 1844 and his first Orientalist subject, *Chasse au lion*, was exhibited in 1835, the year of his return from Rome. Back in Paris he was to play a leading role in the creation of Louis Philippe's Musée Historique at Versailles. The enormous *Prise de Smalah de Abd-el-Kader* (1845) was painted for the Musée. Vernet visited Russia twice, in 1836 and 1842–3, to work for the Czar. He was made an *officier* of the Légion d'honneur in 1825, rising to *grand officier* in 1862. After 1848, in spite of the overthrow of the monarchy, he remained in favour and in 1849 was commissioned by the President of the new Republic to make a painting of the Siege of Rome. At the Exposition Universelle in 1855 a whole room was devoted to his work.

P. Delaroche *Le Cardinal Mazarin mourant*/Cardinal Mazarin's Last Sickness, 1830.
Oil on canvas 57 × 98 cm.

Bibliography

The following brief bibliography cannot claim to provide more than an introduction to the further reading on this subject. A comprehensive survey of the available literature, including both contemporary publications and recent studies of the period and the artists concerned, would run to many hundreds of entries. Most of the artists discussed in this book were well-known and popular during their careers and consequently attracted extensive discussion in the form of monographs and articles in periodical publications.

The books and catalogues listed below will provide a good general picture of the artists and their milieu. For the reader who would like a more extensive survey, many of the exhibition catalogues included here contain excellent and comprehensive bibliographies relating to their subject.

Books

Bénédite, Léonce *La peinture au XIXe siècle*, Paris 1909
Boime, Albert *The Academy and French Painting in the Nineteenth Century*, Oxford 1971
Cĕlĕbonovič, Aleska *The Heyday of Salon Painting, Masterpieces of Bourgeois Realism*, London 1974
Crespelle, J. P. *Les Maîtres de la Belle Epoque*, Paris 1966
Dunlop, Ian *The Shock of the New*, London 1972
Finke, Ulrich (ed.) *French Nineteenth Century Painting and Literature*, Manchester 1972
Francastel, Pierre *Histoire de la Peinture Française – du Classicisme au Cubisme*, Paris 1967
Hanson, Anne Coffin *Manet and the Modern Tradition*, 1977
Haskell, Francis *Rediscoveries in Art. Some Aspects of Taste and Fashion in Collecting in England*, Oxford 1976
James, Henry *The Painter's Eye*, New York 1957
Jullian, Philippe *The Orientalists*, Oxford 1977
Lanoux, Armand *1900, La Bourgeoisie Absolue*, Paris 1973
La Pauze, A. *Historie de l'académie de France à Rome*, Paris 1923
Lenoir, Paul *Le Fayoum, le Sinai et Petra*, Paris 1872
Leroy, A. *Histoire de la peinture française, 1800–1933*, Paris, 1934
Lethève, Jacques *La vie quotidienne des artistes français au XIXe siècle*, Paris 1968
Mayne, Jonathan (ed.) *The Mirror of Art. Critical Studies by Charles Baudelaire*, Oxford 1955
Nochlin, Linda *Realism and Tradition in Art, 1848–1900*, New York, 1966

BIBLIOGRAPHY

Nochlin, Linda *Realism*, in the *Style and Civilisation* series Harmondsworth 1971

Nochlin, Linda and Hess, Thomas (eds.) *Woman as a Sex Object*, Harmondsworth, 1973

Norman, Geraldine *Nineteenth Century Painters and Painting, A Dictionary*, London 1977

Praz, Mario *On Neoclassicism*, London 1969

Rewald, John *The History of Impressionism*, New York 1946

Saarinen, Aline B. *The Proud Possessors*, London 1959

Scharf, Aaron *Art and Photography*, London 1968

Sloan, Joseph *French Painting between the Past and the Present, 1848–1870*, Princeton 1951

Spencer, M. C. *The Art Criticism of Théophile Gautier*, London 1969

Sterling, Charles and Salinger, Margaretta, *French Paintings II*, Metropolitan Museum, 1966

Sterling, Charles and Adhémar, Hélène *Catalogue de Peintures du Louvre, école française du XIXe siècle*, Paris 1958–1961

Tabarant, A. *La vie artistique au temps de Baudelaire*, Paris 1963

Wallace Collection *Catalogue of the Pictures and Drawings*, London 1928

Wharton, Edith *A Backward Glance*, New York 1933

Wharton, Edith and Codman, Ogden *The Decoration of Houses*, New York 1897

Whitford, Frank *Japanese Prints and Western Painters* London 1977

EXHIBITION CATALOGUES

1963 *Centennaire d'Eugène Delacroix*, Musèe du Louvre, Paris

1967 *Ingres*, Petit Palais, Paris

1967 *Jean-Léon Gérôme*, Hôtel Meurice, Paris (introduction by Salvador Dali)

1968 *Le Salon Imaginaire*, Berlin

1968 *James Jacques Joseph Tissot*, Art Gallery of Ontario, Toronto

1969 *Baudelaire*, Petit Palais, Paris

1972 *Jean-Léon Gérôme*, Dayton Art Institute, Ohio

1972 *The Age of Neo-Classicism*, Royal Academy & Victoria and Albert Museum, London

1973 *Equivoques, Peintures Françaises du XIXe siècle*, Musée des Arts Decoratifs, Paris

1974 *Le Musée du Luxembourg en 1874*, Grand Palais, Paris

1974 *Charles Gleyre ou les Illusions Perdues*, Kunstmuseum. Winterthur

1974 *Art Pompier: Anti-Impressionism*, Hofstra University, Long Island

1975 *William-Adolphe Bouguereau*, New York Cultural Centre

1975 *L'Orient en question*, Musée Cantini, Marseilles

1975/6 *Mahmal et Attatichs*, Galerie Soustiel, Paris

1978 *From Revolution to Second Republic*, Hazlitt, Gooden & Fox London

1978 *Gustave Courbet*, Arts Council, Royal Academy, London

1978 *Eastern Encounters*, Fine Art Society, London

Collections

Roman figures refer to pages containing black and white illustrations, italics to pages containing colour illustrations

The illustrations contained in this book are from the following collections: Amiens, Musée de Picardie 105, 112 (top); Baltimore, The Walters Art gallery 42 (below); Bordeaux, Musée des Beaux-Arts 20 (right), 55 (top), 61 (below), 118; Brest, Musée Municipal 30; Chantilly, Musée Condé 66 (below), 113; Compiègne, Musée National 42 (middle); Fontainebleau, Musée National du Château *frontispiece*; Hamburg, Kunsthalle 19, 20 (left), 77, 120 (top right); Lausanne, Musée Cantonal des Beaux-Arts 43, 73, 82, 112 (below); Liverpool, The Walker Art Gallery 32, 60 (below), 111 (below); London – Christie, Manson and Woods Ltd. 84, *85*; The Fine Art Society Ltd. *18*, *75*, 78, 80 (top), *98*, 123 (below right); Hazlitt, Gooden and Fox Ltd. 52; M. Newman Ltd. 38, *57*, 65, 79; The National Gallery 40–41, *126–127*; Roy Miles Fine Paintings Ltd. 28, 106 (below); The Wallace Collection *17*, 34 (top and below), *35*, 37, 39, 59, 62 (below), 68, 72, *76*, 81, *88*, 104, 107, 108 (below), 110 (top), 111 (middle), *115*, 117, 119 (below), 120 (below), *125*, *128*; Lyon, Musée des Beaux-Arts 56, 114 (below); Montpellier, Musée Fabre 67; Montreal, Museum of Fine Arts 74; Nancy, Musée des Beaux-Arts 61 (top); Nantes, Musée des Beaux-Arts *86*, 90, *97*, 103, 110 (below); New Haven, Connecticut, Yale University Art Gallery 44 (top); Paris – Ecole des Beaux-Arts 44 (below), 50, 114 (top), 119 (top); Musée du Louvre 8 (top and below), 10, 11, 12, 13, 15, 16, 22, 23, 24, 25, 27, 33 (below), *36*, 42 (top), *45*, *46*, *47*, *48*, 49, 51, 55 (below), 60 (top), 62 (top), 63, 66 (top), 70, 80 (below), 87, 102, 106 (top), 108 (top), 111 (top), *116*, 120 (top left), 121, 122, 123 (top right), 124, 129; Pau, Musée des Beaux-Arts 109; Versailles, Musée National du Château 33 (top), *58*, 71; Williamstown, Mass., Sterling and Francine Clark Institute 6, 21, 83, 89; Wolverhampton Art Gallery 64, 123 (left).

Photographic Acknowledgements

Numbers in italics denote pages containing colour illustrations

Bordeaux, Alain Danvers 20 (right), 55 (top), 61 (below), 118; Ecublens, Andre Held 43, 73, 82, 112 (below); London – John R. Freeman and Co. Photographers Ltd. *17*, *35*, *88*, *115*, *125*, *128*; Photostudios Ltd. 38, *57*, 65, 79; Prudence Cuming Associates Ltd. 52; Montpellier, Claude O'Sughrue 67; Nancy, Gilbert Mangin 61 (top); Nantes, Studio Madec *86*, 90, *97*, 103, 110 (below); Paris – Clichés Musées Nationaux *frontispiece*, 8 (top and below), 10, 11, 12, 13, 15, 16, 22, 23, 24, 25, 27, 30, 33 (top and below), *36*, 42 (top and middle), 49, 51, 55 (below), *59*, 60 (top), 62, 63, 66 (top), 70, 71, 80 (below), 87, 102, 106 (top), 108 (top), 111 (top), *116*, 120 (top left), 121, 123 (top right), 124, 129; Photographie Giraudon 44 (below), 50, 66 (below), 113, 114 (top), 119 (top); Pau, M.L. Pérony 109.

Index

6200